D1213627

Cyril Barrett

OP ART

A Studio Book
The Viking Press
New York

To E. M. and J. B.

Copyright © 1970 by Cyril Barrett
All rights reserved
Published in 1970 by The Viking Press Inc.
625 Madison Avenue, New York, N.Y. 10022
Published in Great Britain by Studio Vista Limited
Designed by Gillian Greenwood
SBN 670–52685–1
Library of Congress catalog card number: 70–109217
Printed and bound in Great Britain

Contents

Author's note

When Op art first reached the attention of the public about 1964, it was greeted with a sort of dubious acclaim by the press and general public but received somewhat more coolly by many critics. We were told that it was trickery and illusionism; that it was merely glorified basic design or psychology textbook illustration; and that, anyway, it had all been done long before. There is certainly something suspect about an art form that is an immediate popular success. But it is also possible that both the critics and the public were quite literally dazzled by the more superficial aspects of the works or by the more superficially exciting works themselves. Now that the dust has settled a little, it seems that the time has come for a reappraisal. So far Op art has usually been treated in connection with Kinetic or Constructivist art; I have tried to isolate Op and consider it in its own right. The book is not intended to be more than an attempt to survey the field. It is in any case too early to attempt an exhaustive, much less a definitive study of a movement which is wide in its ramifications and which has by no means worked itself out.

I would like to thank all those who have helped me to compile this book or improve it when it was written: this includes the galleries and institutions which have made their resources available, as well as artists and friends who have borne with patience my importunate demands. I should especially like to thank Professor W. D. Wright of Imperial College, London, for kindly reading the chapter on optical effects.

DUBLIN 1969 D.C.B.

Introduction

The story is told—though it is probably apocryphal—that in 1964 a reporter from *Time* magazine visited a painter and asked him if he considered himself a 'Pop' artist. 'No,' replied the painter, 'but you might call me an "Op" artist.' Whether this story is true or not, it seems certain that the term 'Op' (short for optical) was first used in an article in *Time* magazine in October, 1964. Like the term 'Pop' it seemed appropriate. It is in fact much more appropriate than 'Pop'. Both the name and the art immediately caught on. Indeed 'Op' art is unique in that it appealed to the popular imagination almost before the critics and even the artists themselves were aware of it. This brought with it certain unfortunate consequences.

One of these arose from the very aptness of the name. Some names which we give to art tell us very little about the kind of art in question; Fauvism is an obvious example. Others, such as Cubism, are derived from certain superficial aspects of a particular kind of art. No one is misled into thinking that a Cubist artist is one who paints cubes or that all artists who paint cubes are Cubists. But there is a danger that people may think that an Op artist is one whose main or even sole interest is to produce optical illusions or optical effects and that every artist who is concerned with optical effects is an Op artist. A superficial glance at the illustrations in this book would probably confirm such a view. Indeed, it will be one of the main tasks of the book to show that this is not so. Had some less apt title been found—or a more obscure one, like Suprematism—this task would have been easier.

The term Op is misleading in other ways too because it suggests that this kind of art produces an optical physiological response only. Certainly the latter plays a more important part in Op than in other kinds of art, but it does not play an exclusive part. As Albers rightly says, the response is psychological and this 'happens behind the retina, where all optics end'. For the same reason the term 'Retinal' art, which is sometimes used, is even more misleading. William C. Seitz favours the term 'Perceptual Abstraction'. This has the merit of including the psychological element, but it is less accurate than Op. It is too broad. In the Responsive Eye exhibition organized by Seitz in 1965 the term justified the inclusion of a number of works which could not be regarded as strictly Op. So, for all its defects, Op is perhaps as good a word as any to designate this kind of art.

What then is the art we call 'Op'?

There are no easily defined characteristics which distinguish it from any other kind of art. One is almost tempted to say that it is what Op artists do and then name them! There are, however, good reasons for calling one artist an Op artist and not another.

At the outset it must be said that one of the distinguishing features of this art is the use made of certain optical effects. In recent years much scientific research has been going on in this field and certain findings have become standardized. In Chapters 2 and 3 will be found an analysis of the optical effects used by Op artists, grouped under headings given to them by psychologists and physiologists. In these and later chapters I will examine in some detail what Op artists actually do and then see whether common characteristics emerge.

But before attempting to clarify further the way these effects are used by Op artists, it is necessary to look back and try to discover the roots from which the movement grew.

1 Historical background

Since all painters are concerned with optical effects, the historical background to Op art might well be the whole history of art up to the 1950s. Here, however, we must confine ourselves to those artists or movements which either prepared for or directly influenced the development of Op art, and in particular to those which Op artists have acknowledged as having been in some way relevant to its development.

Why, it may be asked, when artists have always been conscious of optical effects to some extent, did Op art not evolve earlier? To this, the short answer is that, as long as painting was concerned with pictorial representation and the painting's elements —colour, shape, etc.—were not used for their own sake, any concern with their optical properties was likely to be subservient to representation also. So the evolution of abstract art was a preliminary step towards the development of optical painting. Within that evolution certain directions lead more immediately towards Op painting, and it is with these that I shall be concerned.

Impressionism and Neo-Impressionism

Most writers on this subject trace the origins of Op art back to Turner and the Impressionists. It could, it might be said, be traced back further still, to Delacroix at least. Their contribution consisted in the partial emancipation of colour from form, that is, the breaking up of form in light. In this respect, the Op artist Soto sees Turner as someone far in advance of the Impressionists. He says:

He wanted to show the total destruction of solids and all figurative matter by light. Turner is the first and greatest of the Impressionists . . . I see him as altogether more remarkable than the Impressionists who were still attached to figuration. In fact, after Turner one can move directly to pure abstraction, to Kandinsky, for example.

Soto may be right about this. However much the Impressionists were interested in light and colour,

they were predominantly concerned with figuration, with the colour of *objects*, with light as reflected *from* objects. But it is not always possible to *see* Impressionist paintings like that. Whatever Monet himself may have had in mind when he painted his 'Rouen Cathedral' or 'Water-lily' series, whatever Seurat may have had in mind when he painted *La Tour Eiffel* or *La Poseuse en Profil* (plate 1), we cannot help seeing them as disembodied and autonomous colour and light, as well as buildings, plants or the human form. The techniques which the Impressionists and Neo-Impressionists devised in order to give greater brilliance and luminosity to their pictures have been a more fruitful source of inspiration to Op painters than Turner's achievement. A word must therefore be said about these techniques.

It has been said of Monet that he 'exalts and divides pure colour with unbelievable boldness . . . to express in concrete terms the transparency and vibrancy of space'. If a date were to be given to the beginning of this technical innovation it would be 1869, the year in which he and Renoir were working together at La Grenouillière. It was at that time that they abandoned the use of 'local' colours and of blacks and browns for shadows, and began to use pure colours—the primaries and their complementaries—and colour contrasts. The influence of the scientist Chevreul's researches (which had already been noted by Delacroix) is obvious and admitted. Much later Pissaro was to write:

Surely it is clear that we should not pursue our studies of light with much assurance if we did not have as a guide the discoveries of Chevreul and other scientists. I would not have distinguished between local colour and light if science had not given us the hint; the same holds true for complementary colours, contrasting colours, etc.

However, the Impressionists' grasp of these matters, as has frequently been pointed out, was intuitive rather than theoretical. It was Seurat and the

Neo-Impressionists who applied them in a systematic manner.

Seurat was acquainted not only with the work of Chevreul but also with more recent developments in optical theory: Charles Blanc's *Grammaire des arts du dessin* (1867); Ogden Nicholas Rood's *Modern Chromatics* (1879, French translation 1881); David Sutter's *Phenomena of Vision*. Blanc, whose book includes many references to Chevreul and an analysis of Delacroix, suggested to Seurat the idea of colour mixture. Small quantities of different colours, such as red and green, will reinforce one another and increase intensity if seen from a certain distance. When looked at from a greater distance, they will fuse to form a common colour—in this case, grey. Blanc illustrated this by two diagrams (figs. 10 and 11 in his book) which are of some significance in the history of Op. The first consists of vertical pairs of colours; the second of dots; in other words, periodic structures of contrasted colours. Rood also emphasized the effect of using lines or dots of colour to produce colour mixture, and the advantage of gradations of analogous colours—for instance, blue-green, turquoise, green-blue, green—for greater intensity. He drew attention to the additive properties of coloured light as against the subtractive properties of coloured pigments. His approach was more scientific than that of either Chevreul or Blanc, and Seurat came to rely on it increasingly.

Seurat did not apply these ideas all at once. In *La Grande Jatte* optical mixture is not an essential feature. There he employed 'the methodical separation of elements' or what came to be known as 'divisionism'. Local colours—the green of the grass, the blue of the river—were separated from the illuminating light; strokes of blue were added for shadow and strokes of yellow-orange for the light areas. But, as he remarked in a letter to Fénéon, Seurat was in search of 'a formula for optical painting', a systematic and scientific method of painting. 'The Impressionists', wrote Fénéon,

practised the decomposition of colour; but they practised it in an arbitrary fashion . . . MM. Georges Seurat, Camille and Lucien Pissaro, Dubois-Pillet and Signac are painters who, on the contrary, practise divisionism consciously and scientifically.

This systematic use of colour was called 'pointillism', and it consisted in the use of tiny dots of colour, unrelated to local colour, which fuse or mix optically to produce the required chromatic effect.

Seurat practised the pointillist technique in his later paintings. As a means of producing fresh and vibrant colours it was not a success. The fusion of the dots gave the picture an overall grey tone, suitable enough for a misty land- or sea-scape, but quite unsatisfactory for capturing the brilliance of objects in sunlight. It is not on his use of the pointillist technique that Seurat's fame as a painter rests, nor was his use of it particularly relevant to subsequent development of the artistic use of pure colour. As Robert Delaunay remarked, the dot was 'merely a technical device, in no respect comparable to the law of colour-contrast, which is a means of pure expression'. Seurat was caught in a dilemma. To achieve the brilliance of colour which he sought, he would have had to make his dots much larger as Van Gogh did in some of his later pictures, especially the self-portraits; but then the forms would have disintegrated and the painting would have become semi-abstract. To maintain form he had to make the dots small enough to fuse; but fusion brought with it a loss of brilliance. Seurat's significance in the development of colour harmonies, apart from the prominence he gave to colour-contrast, lies in his almost abstract use of colour, his disregard for local colour. That he could not combine this with his concern for form in a way which did justice to both colour and form may have been a loss to the development of an art of pure colour, but led to gains, more important gains perhaps, in other directions.

It was through the Post-Impressionists, particularly Van Gogh, Matisse and the Fauves, Delaunay

and Kandinsky, that the exploration of pure colour, which would eventually lead to Op, was made. Op art, however, is not concerned with colour alone. It is also concerned with form and structure. This aspect of Op art grew out of the geometrical abstractions of Mondrian and Constructivism generally. The part played by Cubism was indirect, and is relevant only to the extent that it introduced a new psychological outlook and led to abstraction. In itself its interests lay in a somewhat different direction from Op. Futurism, on the other hand, both theoretically—by its insistence on the importance of movement—and by its techniques had a direct bearing, and perhaps the earliest Op paintings were made by the Futurist Balla.

One could say that during the decade 1910–20, the foundations of Op art were laid. There is a space here only for a brief survey of the more important (from the point of view of Op) developments which took place during that period; the contributions of the Post-Impressionists, Fauves and Cubists will have to be omitted. I shall begin with Orphism, since it is most directly linked with Seurat and Neo-Impressionism.

Orphism and Synchromism

The artists in question are the Delaunays, Robert and Sonia, Picabia and Kupka. Their form of Cubism was given the title 'Orphism' or 'Orphic Cubism' by Apollinaire. Two American artists closely associated with them, Morgan Russell and MacDonald-Wright, called theirs 'Synchromism'.

The feature of Orphism which distinguished it from other forms of Cubism was, according to Apollinaire, its purity. It was a pure art. By 'pure art' he meant 'an art of painting new structures which have not been borrowed from the visual sphere, but have been created by the artist himself'—what we would call abstract art. Delaunay for his part 'began inventing in silence an art of pure colour'. And so we are moving to an entirely new art which will be to painting, as hitherto envisaged, what music is to poetry. It will be pure painting. In analytic and synthetic Cubist paintings we can, with greater or less ease, recognize objects such as wine glasses and guitars, but in some Orphist paintings it is extremely difficult to make such identifications, if not impossible. What we find are areas of colour or structures of lines.

The Orphists seldom enough attained this purity, however. Their compositions usually had a figurative underpinning. The Eiffel Tower and the aeroplane propeller blade were favourite motifs of Delaunay. But they were striving for purity, and striving along the lines of Seurat. Delaunay had been influenced by Seurat, and he and some of the other Orphists were familiar with Chevreul's theory of simultaneous contrast. Delaunay gave the name *Simultanéisme* to his work; and, though this term meant a variety of different things for the Cubists and even for Delaunay himself—simultaneous viewpoints, the juxtaposition of heterogeneous objects from memory, etc.—it retained a reference to simultaneous contrast of colours.

Around 1912–13 I had the idea of a type of painting which would be technically dependent on colour alone, and on colour contrast, but would develop in time and offer itself to simultaneous perception all at once. I used Chevreul's scientific term of *simultaneous contrasts* to describe this.

Delaunay was aware of the kinetic quality of colour and of its power to convey an impression of movement more directly than was possible with cubist or futurist techniques.

Everything is colour in movement (depth), that is, the construction of what I call *simultaneous representation*. There are qualities of colour movement for all degrees of force: for *slow* movement, complementary colours, and for *quick* movement, dissonant colours. This is not the *descriptive* movement of the Cubists and Futurists which painters refer to as dynamism. The movements which I mention are actually felt—I do not simply

describe them. They are simultaneous, working by contrast, and not successive.

In spite of this description of his work, which, though obscure in spots (the distinction between successive and simultaneous movements is not altogether clear), might fit a contemporary Op work, yet Delaunay himself was far from achieving what he describes here. The 'first germ of colour for colour's sake', he tells us, is to be found in *Fenêtres sur la ville* (1911–12); 'colour was used in terms of gyration: the form developed in a dynamic circular rhythm of colour' in *Solar Discs* and *Sun* (1912) and *Circular Forms* (1912–13, plate 6); and the 'constructive mobility of the solar spectrum' is represented in the simultaneous solar discs in *Hommage à Bleriot* (1914). But vivid though the colouring is there is a strong sense of form which prevents the colours vibrating in the way they do in colour Op. After 1914 the forms became still more firm and Delaunay returned to figuration until 1930. His wife, Sonia, who began making 'violettes simultanées' in 1912, still continues the exploration of colour, using solar discs. She has carried colour abstraction in a painterly geometric style far beyond anything that he had achieved, though not quite in the direction of colour Op. As her husband said of her:

It is to Sonia Delaunay that we owe the new art which owes nothing to the past but which characterizes our epoch. She invents an art all of a piece in starting from the laws governing colour, which were discovered in 1912. In these pictures of Sonia's of that period, you see the first coloured elements called simultaneous contrasts which are the basis and essence of this new art of colour.

Kupka, whose abstractions antedate those of Delaunay, shared Delaunay's ideas. He too had been influenced by Seurat and was familiar with Chevreul's work. In a statement in *The New York Times* in October, 1913, he gives a description of his aims which seems to echo—though presumably without actually repeating—Apollinaire's description earlier that year. He rejects the notion that the artist must follow the forms and colours of nature, simply because it is in nature that we come to know form and colour. Architecture, music, language, inventions such as the aeroplane and locomotive have been created by man, though they do not exist in nature. 'Therefore,' he asks, 'why may he not create in painting and sculpture independently of the forms and colours of the world around him?' It was his aim, then, to create as music creates. Colours, he says, must be either in the major or minor key. And, he adds: 'I am still groping in the dark, but I believe that I can find something between sight and hearing and I can produce a figure in colours as Bach has done in music.'

This groping went on, with *Nocturne*, through 1910 and 1911, but in the following year he produced three works in which the free and rhythmic use of colour fully justified the musical analogy. These were *Disques de Newton* (1911–12), which anticipates Delaunay's discs and reveals Kupka's interest in the science of colour, *Plans Verticaux* (1912) and *Amorpha, Fugue in Two Colours* (1912). Some of these resemble the much later programmed structures of Lohse. But Kupka was not interested exclusively in colour. He also made pure linear abstractions (1930–5) and some of these, particularly those involving concentric circles (1930–3), sometimes come close to certain Op paintings and in some ways anticipated Duchamp's 'Rotoreliefs.'

The 'Synchromies' of the little known Americans Stanton MacDonald-Wright and Morgan Russell, come very close to the work of the Orphists. Russell for his part was making diaphanous colour discs in 1913 which are not unlike those of the Delaunays, only far more abstract. MacDonald-Wright's 'Synchromies' of the same period were still more abstract—there was not even a suggestion of discs or propeller blades. But though more abstract, they were also more chunky, more Cubist—

like blocks of coloured stone closely packed to-gether—and thus prevented any colour vibration from permeating the surface.

Suprematism and Rayonism

Meanwhile similar developments were taking place in Russia. Here there was a proliferation of move-ments and '-isms'. Of these, two have a bearing on the evolution of Op: the Suprematism of Malevich and Lissitsky, and Rayonism, associated with the names of Larionov and Natalia Goncharova. About another of these movements, Constructivism, which is generally held to be a direct forerunner, if not the parent body of Op, more will be said else-where.

Malevich describes Suprematism as 'the suprem-acy of pure sensibility in art'. Like the Orphists he rejects representation and motifs drawn from nature as irrelevant to art, though, he concedes, their presence may not preclude a work from having high artistic value. But what counts is sensibility, and this, he says, is the last thing the public looks for. If the sensibility expressed in great works of art could be drawn off from it, the public would not notice its absence. Only by eliminating the object, that is, representation, can pure sensibility be expressed. Malevich believed in a primitive, innocent artistic sensibility which has been lost. 'Suprematism is the rediscovery of pure art which, in the course of time, had become hidden by the accumulation of objects. . . . Sensibility is the decisive factor . . . and thus art arrives at non-objective representation [sic]—at suprematism.'

In 1913 Malevich gave what he considered the purest expression of his sensibility when he painted a black square on a white canvas (plate 2). He gives rather contradictory accounts of the significance of that black square. In one place he says that the pure essence of art is in a square blackened in with pencil because it is the clearest assertion of man's

mastery over nature. In another place, having said that Suprematism compresses all painting into a black square on a white canvas, he adds: 'I did not have to invent anything.' Presumably what he means is that this expression of man's mastery over nature was spontaneous ('It was the absolute night I felt in me: in that, I perceived the creation') and not contrived. His most amusing account deserves to be quoted at length because it hits off the reaction to his square very accurately:

When, in 1913, I made my desperate attempt to deliver art from the dead weight of the object, I sought refuge in the shape of the square. . . . The critics, and with them the public, burst into lamentation, crying: 'All that we loved is lost—we are in a desert, faced with a black square on a white ground!'

Malevich's black square and his subsequent white square on a white ground, painted in 1918 (Rod-chenko was painting black circles about the same time), had a profound, if not immediate, effect on the development of abstract art. Here was abstract art bold and unequivocal. To some it was the very ultimate limit of abstraction—they had yet to see Yves Klein's and Ad Reinhardt's monochrome paintings. There was nothing tentative or groping about it. If abstraction was a prerequisite for the evolution of Op—and a hard-edged geometrical abstraction with forms lying flat on the surface, not the painterly brush-strokes of the Orphists—then the place of Malevich in that evolution is obvious. But while Malevich's Suprematist works prepared the ground for Op, it was ultimately to be against them that the Op artists reacted most strongly. Visually, it was felt, they were dead and marked a dead end; where surface and structure coincide there is no tension. As Vasarely put it, Malevich's square is, in the end, only a stage-set without drama. Not all Op artists agree with this, however. Soto takes a very different view:

It was the *synthesis* which astonished me. By painting white on white Malevich was saying: *Let us paint light*

as light. Let us put light directly onto the canvas. There is no need to make use of the go-between of objects by which light is normally represented. It was this very proposition which Yves Klein took up in his *blue monochromes.* He took hold of reality and put it on his canvas. It is the sign of reality which he gives us; not the naturalist rendering of it.

How faithfully this represents Malevich's intentions does not really matter. That his work had this significance for Soto is in itself a contribution towards the development of Op since Soto was one of its pioneers.

Rayonism would probably be described by Soto as an attempt to represent light naturalistically rather than by putting it on the canvas. Nevertheless, in conception at least, it was not far from Soto's own idea of the dematerialization of objects. It was an attempt, as Larionov described it, to 'create spatial forms which are obtained through the crossing of reflected rays from various objects'. A work of art should give the impression of being 'perceived out of time and space' in a sort of fourth dimension. It should appear to our eyes within the presumed limits of space between a source of light and the objects which intercept it.

Larionov had been interested in this idea ever since he saw the Turners in the London exhibition of 1909. His attempts to apply what he learnt from them led him to abstraction as early as 1910, thus anticipating Malevich, though in a less bold and uncompromising manner. But, although both he and Natalia Gonchorova used lines of contrasting colours as Op artists were later to do, they never really succeeded in creating the kind of luminous space they sought. Like so many of their contemporaries their approach was far too direct and literal: merely drawing lines which look like light rays was not the way to convey an impression of the vibrancy of light. Rayonism, like many ideas of that time, remains on the level of theory; the techniques for achieving its aims were lacking.

With the Orphists exploring abstract colour contrasts and the Suprematists placing geometrical shapes flat on the canvas (not amorphous brushstrokes or washes or vague lines) we have, by 1913 at least, the ingredients which were to go into the making of Op. Some of these ingredients are also to be found in the geometric abstractions of Neo-Plasticism, which deserves mention if for no other reason than on account of the influence on Op artists of the leader of the movement, Mondrian.

Neo-Plasticism

Unlike the Suprematists and Orphists Mondrian's progress towards abstraction was gradual, if relentless. He did not reject nature and naturalistic representation in the brusque way they did; nature, particular natural forms, seem rather to fade slowly out of his pictures over a period of years (1911–18), and never, perhaps, quite disappear. Mondrian arrived at abstraction in an attempt to reach nature at its most universal. 'The task of art,' he writes, 'is to express a clear vision of reality . . . particularities of form obscure pure reality'. For this reason

Neo-Plasticism cannot assume the form of a natural or concrete representation which, it is true, always indicates to a certain extent the universal, or at least carries it hidden within itself. Neither could it take on the appearance of things which characterize the particular, that is, natural form and natural colour. It must, on the contrary, find its expression in the abstraction of all form and all colour, that is, in the straight line and in clearly defined primary colour.

Mondrian was one of the most thoroughgoing Platonists in the history of art!

But, however he arrived at it, Mondrian, by the 'twenties, had reached a form of pure abstraction:

FIG I
Piet Mondrian *Composition of Lines* 1917, 42½ × 42½ in. Kröller-Müller Museum, Otterlo

intersecting black lines and areas of pure colour on a flat surface. These structures were not, as might be imagined (and as they sometimes were in the works of others associated with him in the De Stijl group), dead and static; they were held in a state of tension, a balance or equilibrium of forces and directly contrasting elements, verticals against horizontals, black against white. Although in feeling these calm, cool compositions are worlds apart from the turbulence and agitation of Op, in many respects the line which divides these two kinds of painting is not all that great. At three points in his career he came very close to Op, though, the first time at least, with very different motives. I am referring to the period between 1914 and 1917, when he made a series consisting of little crosses, the period 1918–19, when he painted grids of lines on lozenge-shaped canvases, and the period 1941–4, that is just before his death, when the black lines become coloured— the period of the 'New York City' and 'Boogie-Woogie' series. Interestingly enough, in this last period he returned to the lozenge-shaped canvases.

The small crosses have been much admired by Op painters, though they were in fact the abstract equivalents of either pier and ocean or church façades (*Composition of Lines*). It is the utter simplicity of the means of expression which appeals to Op artists, who themselves seek to get the maximum effect from the simplest means. Soto shows his understanding of these pictures when he writes:

I said to myself: there he has summed up the world in two signs. . . . His work is not the juxtaposition of happily balanced surfaces but an attempt to synthesize the opposite forces of the real world with the simplest possible graphic expression.

Unlike most of Mondrian's work before 1941, these have something of an optical flicker. The same is true to a much lesser extent of some of Van der Leck's structures with little lines (1917) or Van Doesburg's *Russian Dancer* (1918). The lozenges, for instance *Lozenge with Grey Lines* (1918, plate 3), are among the earliest linear periodic structures. But it is chiefly the late paintings which have inspired Op artists. They find in the *Broadway Boogie-Woogie* (1942–3, plate 7), and *Victory Boogie-Woogie* (1943–4) (lozenge-shaped and left unfinished), with their verticals and horizontals broken up into areas of contrasting colour, that optical vibration, at least at an initial stage, which they themselves pursue. Vasarely considers Mondrian both 'the apotheosis and the end'. His pictures, beautiful though they are, became repetitive and slightly boring. 'It took America to put life into them again.' And Soto:

Mondrian's last works—*The Victory Boogie-Woogie*— those lights! There one sees the beginnings of vibration in painting. . . . It seemed to me that he had made a sudden leap in the direction of purely dynamic painting, realized through optical means . . . that he was about to make the image move optically.

Kandinsky

No account of the background to Op would be complete without some mention of Kandinsky, yet his influence on Op was far less direct than that of Orphism, Suprematism or Neo-Plasticism. True, he was painting semi-abstract compositions using autonomous masses of intense colour from about 1909. But it was not until his visit to Russia from 1914 to 1921 that he painted geometrical abstractions, and even these have none of the simplicity of adhesion to the surface which characterized the work of Malevich and Mondrian and to a lesser extent the Orphists. Only a painting like *Square* (1927), done during his Bauhaus period, has any direct relation to Op, but it seems to have been a kind of sport. If anything it is to his ideas, expressed in *On the Spiritual in Art*, written in 1910 and published in 1913, that one must look, if any direct influence

is to be found. Vasarely says of him: 'By his works, of a fecundity and richness unequalled, and by his writings no less fundamental, he is the starting point of the greatest plastic adventure of all time.'

This book had a profound influence on the development of abstract art all over Europe. It summed up in its own peculiar way and gave expression to many of the ideas which were in the air at the period. Much of what Kandinsky says—as opposed to what he meant—could be taken as having a bearing on Op. He speaks about the 'repetition of colour tones and the dynamism of colour'. He works out in great detail the analogy between colour and musical tone, and sums up in a famous passage:

Colour is the key, the eye the hammer which strikes it, the soul the instrument with a thousand strings. The artist is the hand which, with the aid of such and such a key, obtains from the soul the vibration which is appropriate. It is therefore evident that the harmony of colours rests solely on the principle of effective contact.

But the harmony and vibration which Kandinsky has in mind is not the harmony and vibrancy between the colours themselves but between them and the soul. Doubtless the one does not exclude the other, but Kandinsky seems to have had in mind an 'inner resonance', for he believed that each colour had its own particular resonance: blue is restful and calm, yellow is acute, aggressive and even manic, etc. Blue and yellow also form the opposite poles of cold and warm towards which all colours tend. When contrasted they set up a movement: the warm colours approach the spectator and the cold recede. The same is true of clear tones, which approach white and advance towards the spectator, and the dark which approach black and recede. Kandinsky called these the first and second great contrasts, and the movement they generate he called internal, that is, movement without any external motivation, like the movements of a dance.

Some of these ideas are to be found in the writings of the Futurists. Boccioni wrote in 1911: 'the easel picture will no longer be adequate and colours will be perceived as sentiments themselves and one will paint with coloured gases'. He foresaw a form of painting which would attain the dematerialized condition of music. Of Michelangelo he says: 'For him anatomy becomes music . . . the melodic lines of muscles follow each other according to musical principles, not the law of logical representation.' Both artists were influenced by Scriabin's *Prometheus*, written in 1909–10 and performed in Moscow in 1911, which was scored for coloured light. Boccioni was later to take Kandinsky to task for his use of music as an analogy for colour, but by that time, 1913, Futurism was more firmly under the influence of Cubism. It is in the earlier Futurism, however, that we find the tentative beginnings of Op.

Futurism and the beginnings of Op

With the Futurists we pick up again the threads which led from Chevreul and the Neo-Impressionists to Orphism. The Futurists began their artistic careers as Divisionists, whether the Divisionism of Seurat and his followers, or the Italian variety imported by Vittore Grubicy de Dragon and practised by Segantini and Previati. They were also acquainted at first hand with the work of Delaunay.

Balla introduced Severini and Boccioni to Divisionism. Severini writes:

I would like to recall that in 1910 a group of painters, taking Seurat as their point of departure, expressed the wish to put into practice certain aims which were based precisely on colour: these were the Futurists. They believed in 1910—though their researches had begun in 1909—that the doctrine of complementaries should be taken as the essential basis of their research. This research into colour was soon supplemented by studies in the expression of movement. . . . Ultimately, this research into movement was directed towards the experience in plastic terms of the linear contrast of colours. Today the most important element in the dynamism and movement is colour.

This statement may come as a surprise to those who are familiar with the Futurists in their 'cubist' phase, when they attempted to represent movement and force by many faceted objects and multiple viewpoints. Yet there is hardly any trace of this technique in the work of Boccioni, Severini, Carrà, Russolo or Balla before 1911 and it was only in 1912 that it became firmly established.

Boccioni used Divisionism in *Riot in the Gallery* (1910) and *The Raid* (1911) and most effectively in the luminous *The City Rises* (1910–11). Marianne Martin writes of this work:

While still adhering to the disciplinary principles of Divisionism, Boccioni adapted the small, regular brush-strokes of *Rissa* to slightly longer lines which intimately follow the directional drive of each form. His method was so skilful that these strokes vibrate and shift before one's eyes, like metal shavings that have entered a magnetic field. . . . Every element in *Città* is geared to the artist's desire to create 'a great synthesis of work, light and movement'. (*Futurist Art and Theory*)

In his 'States of Mind' series of the same year he moves momentarily a step further in the direction of Op, particularly in *Those who Remain* where the canvas is covered with flickering vertical lines.

Carrà's *Nocturne in the Piazza Beccaria* (1910) and *Leaving the Theatre* (1910–11), both using the Divisionist technique, have a similar optical flicker. Russolo's *Speeding Train* (1911) has something of an optical flicker in his use of long, diagonal brush-strokes, the forerunners of his 'lines of force' which appear in *The Revolt* of the same year. It was Severini, however, who made the most effective use of Divisionism.

Unlike the other Futurists, Severini spent most of his life in Paris where he was in close touch with Delaunay. Many of Severini's paintings come far nearer to the optical use of simultaneous contrast of colour than anything by Delaunay. This is particularly true of two paintings which he did in 1913 and 1914 to which he gave the title *Spherical Expansion of Light*. They were his only incursions into abstract painting. They are precisely what their title claims: an expansion of light. The use of Divisionism gives them a scintillating, radiant effect of colour as well as the translucence of Orphist colour washes, but the underlying structures of these pictures prevent any real Op effects from taking place. They are in some ways less vibrant than the Boccionis mentioned above or his own earlier pictures such as *Window Overlooking the City* (1910–11), *Town, Black Cat* and *The Haunting Dancer* (1911). In these, dots or squares of colour, overlaid on more solid structures and highly stylized figuration, act as a sort of luminous coloured gauze through which the underlying structure flickers and in certain areas of the picture seems to dissolve. It is as if Cubism had made a tentative move towards Op and then sheered away again.

With Balla the step is taken. In spite of being years senior to the other Futurists and taking little part in their meetings, it was Balla who carried through their programme in the most daring and successful manner—a fact which is only now beginning to be appreciated. In his *Electric Lamp* (1909) he used arrow-heads of both centripetal, and divided concentric, brushstrokes to suggest the vibrancy of light. So strong is the optical flicker in this picture that, if the lamp-standard and crescent moon could be eliminated, the central section might pass for an Op painting. In 1912 his investigations into the pictorial equivalence of light and motion culminated in three paintings, now famous, *Leash in Motion, Rhythm of the Bow* and *Girl Running along a Balcony*.

The first of these is an amusing picture of a dachshund trotting beside its owner. Movement is suggested by the equivalent of a multiple-exposure in photography. Balla was familiar with the studies of men and animals in motion, birds in flight, etc., made by Muybridge, Marey (there are echoes of his terminology in some titles) and Bragaglia. The

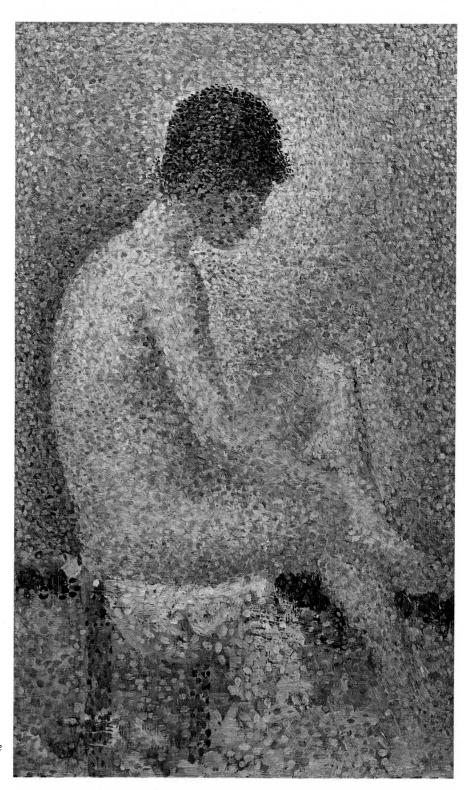

1 Georges Seurat *La Poseuse
en Profil* 1887 $9\frac{1}{2} \times 5\frac{7}{8}$ in.
Jeu de Paume, Paris

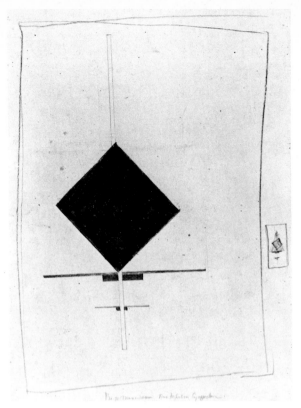

2 Kasimir Malevich *Black Square*
1917 $16\frac{1}{8} \times 11\frac{3}{4}$ in.
Stedelijk Museum, Amsterdam

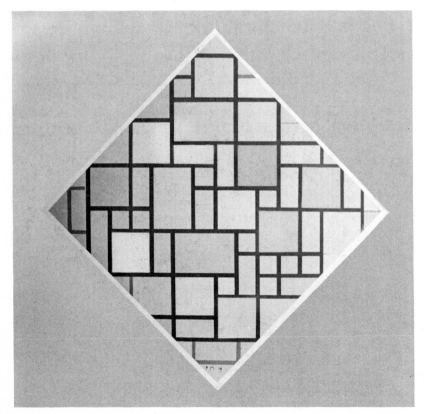

3 Piet Mondrian *Lozenge with Grey
Lines* 1918 $47\frac{1}{2}$ in. diagonal
Gemeentemuseum, The Hague

4 Giacomo Balla *Girl Running along a Balcony* 1912 49¼ × 49¼ in. Gallery of Modern Art, Milan. Grassi Collection

5 Richard Lohse *Fifteen Systematic Series of Colours* 1950-67 59 × 59 in. Denise René Gallery, Paris

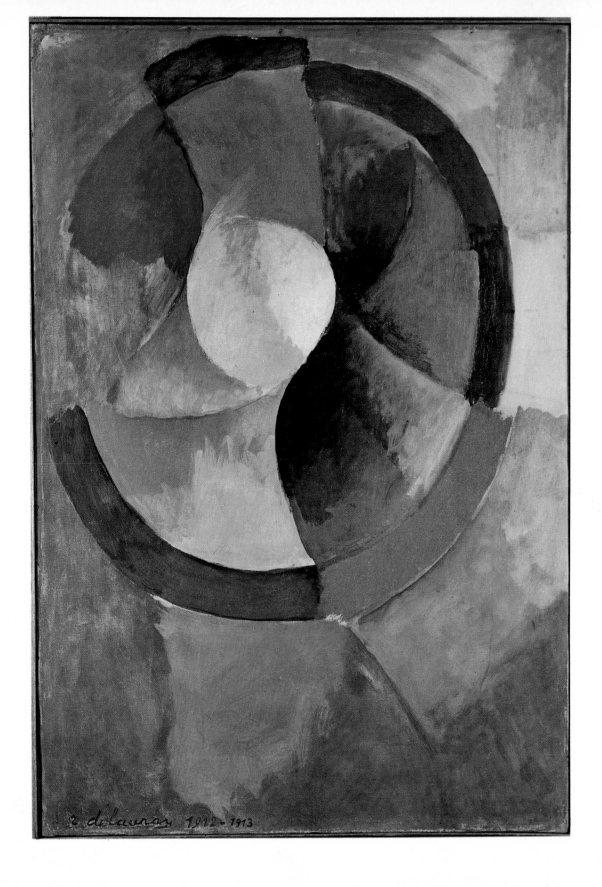

◀6 Robert Delaunay *Circular Forms*
1912-13 39½ × 27 in.
Private Collection

7 Piet Mondrian *Broadway Boogie
Woogie* 1942-3 50 × 50 in.
Museum of Modern Art, New York

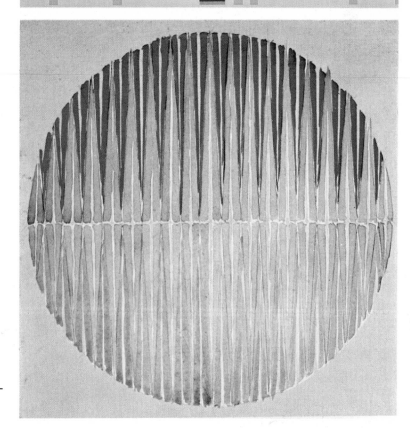

8 Giacomo Balla *Iridescent Compenet-
ration no. 2* 1912 30⅜ × 30⅜ in.
Private collection

9 Tadasky *A101* 1964 52 in. diameter
 Museum of Modern Art, New York

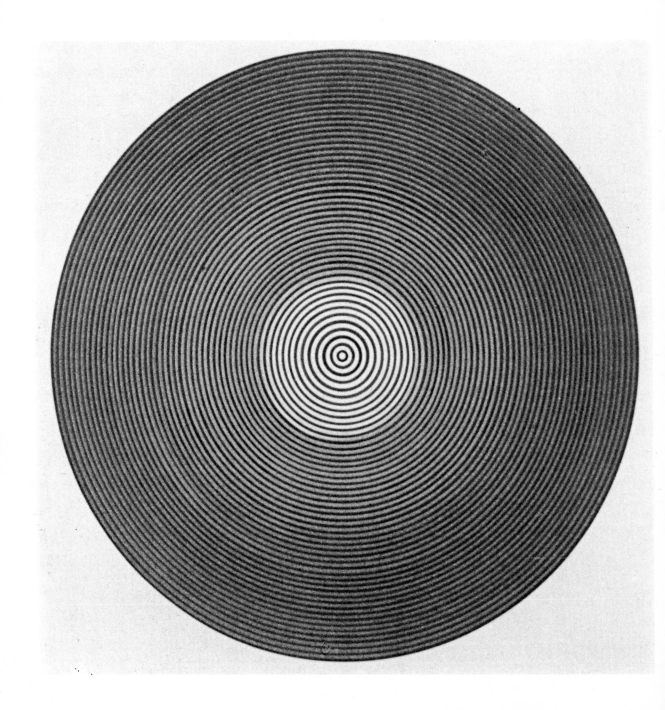

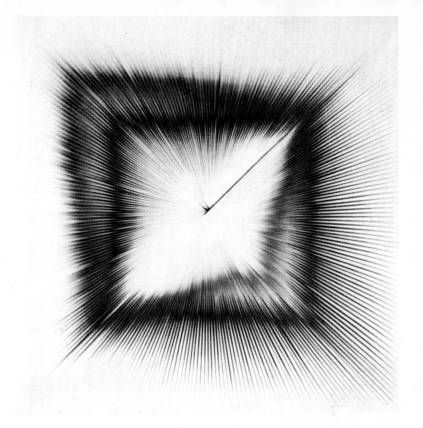

10 Toni Costa *Optical-Dynamic
Structure* polyethylene and wood
1961 $35\frac{1}{2} \times 35\frac{1}{2} \times 2\frac{3}{8}$ in.
Private collection

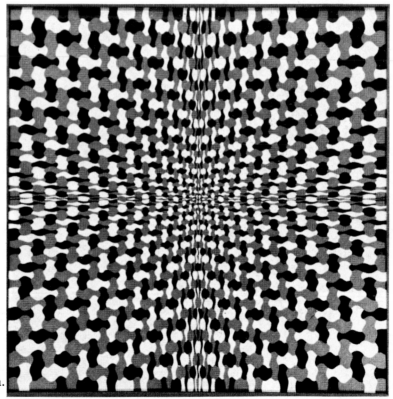

11 Angel Duarte *C17* 1961 $31\frac{1}{2} \times 31\frac{1}{2}$ in.
Artist's collection

12 Marcel Duchamp *Fluttering Hearts*
1936 13 × 20 in.
Gimpel Fils, London

13 Max Bill *Transcoloration* 1966
$16\frac{1}{2} \times 16\frac{1}{2}$ in.
Hanover Gallery, London

14 Peter Sedgley *Lazar* 1966 36 × 36 in.
Private collection

15 J.–R. Soto *Metamorphosis* 1954
plexiglass
Denise René Gallery, Paris

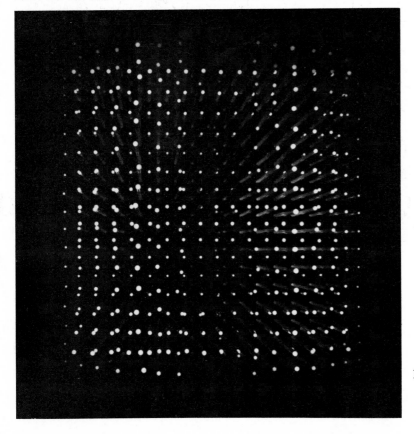

16 Horacio Garcia Rossi *Unstable
Light Structure* 1965
$39\frac{1}{2} \times 39\frac{1}{2} \times 15\frac{3}{4}$ in.
Denise René Gallery, Paris

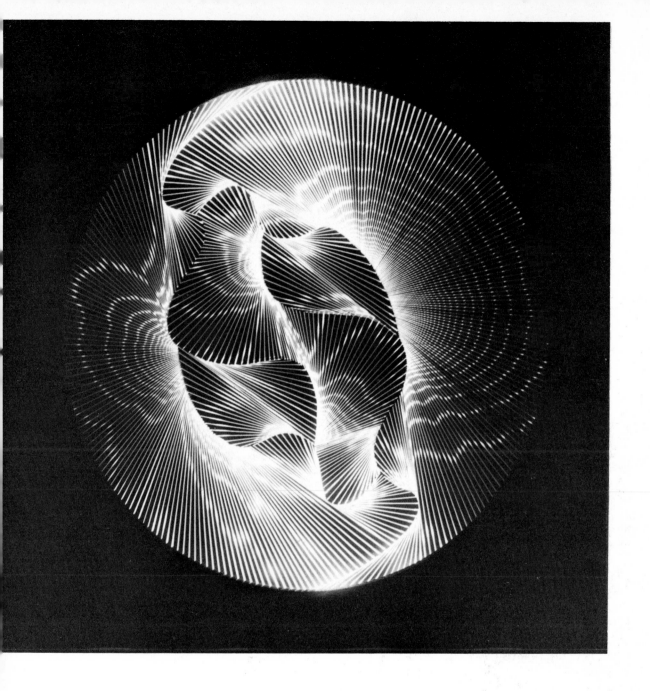

17 Angel Duarte *V10* 1963 glass, neon and aluminium $27\frac{1}{2} \times 27\frac{1}{2}$ in.
Artist's collection

18 Wojciech Fangor *E10* 1966 50 × 50 in.
 Gabrowski Gallery, London

movement of the leash is particularly interesting. One is reminded of Gabo's *Kinetic Construction* of 1920. But in *Leash in Motion* each form—dog, leash and woman's skirt and feet—keeps its identity. In *Rhythm of the Bow* on the other hand, the hands, cuffs, bow and violin tend to merge into one another, and into the background and dissolve as the eye struggles to come to terms with the repetition of thin parallel lines. The contrasts of colours, muted though they are, produce a vibrancy which sets the whole picture in motion.

In *Girl Running along a Balcony* (plate 4) an almost total dissolution of the figure takes place. In this picture Balla reverts to a stricter Divisionism, using fairly large squares of bright colours. Not only is movement suggested but also the scintillating effect of sunlight on a moving object. The size of the blocks of colour prevents the fusion and consequent loss of brilliance which characterized the Neo-Impressionist pointillist technique. The railing acts as a sort of slow beat breaking across the rapid movement. This quite spectacular development on the two previous pictures, particularly in the direction of colour contrast, was probably due to certain experiments which Balla had been carrying out earlier in the year, experiments of great interest to our present study since with them Balla produced what might be considered the first works of Op art.

These experimental works, of which he did a great number between 1912 and 1915, were called 'Iridescent Compenetrations' (plate 8). They were entirely abstract, and consisted mainly of repetitions of triangles of contrasting colours. Balla made them while he was staying with his former pupil, Casa Löwenstein, and they seem to have originated as part of a decorative project. He certainly used them to decorate a bedroom for the Löwensteins (in black and white), as well as a music-hall and a corridor for the Secessionist Exhibition (1913). Although the work of Delaunay was well known in Germany at the time,

and Previati had discussed iridescence and geometric colour patterns in his *Scientific Principles of Divisionism*, it is likely that they developed out of the lozenge-shaped studies of legs in movement made for *Motion of the Leash*. They were what he later called 'abstract equivalents'. In a letter to his family, decorated with iridescent triangles, he wrote:

First enjoy a bit of iridescence because I am certain that you will like it; it is the result of an infinite number of trials and experiments and the pleasure it gives was finally found in its simplicity . . . the rainbow will be capable—through my observation of reality—of possessing and giving an infinity of colour sensations.

But he also wrote:

the lakes, with the great mountains reflected in their waters, in iridescent colours, produce the kind of effect it is better to think unpaintable when you stop to consider and see how small man is in proportion to the things around him.

George Rickey maintains that Balla did not succeed in eliminating the figure-ground relationship—'he *nearly* succeeded in flattening the space completely'—and if this were so he would not quite qualify as an Op painter. This may be true of some of the examples which are extant, but there are many which act exactly like any other Op painting with a periodic structure. What is true, however, is that the colour contrasts are not as effective as those of, say, Bridget Riley, especially where Balla uses nearly adjacent colours. It is important to stress that Balla regarded these merely as experiments; he had no intention of developing further in the direction of abstraction. But he believed that they were immensely important for the evolution of his own art—'The study which went into this work will bring about changes in my work . . . from observing reality, the iris will obtain and give back infinite sensations of colour.' We have already seen the immediate effect it had in *Girl Running along a Balcony*. (In 1912 he designed an 'iridescent' tie!) In the years which followed he carried through the

C

notion of the interpenetration of light, the dissolution of the object in light and the impression of movement that this gives, in a remarkable series of paintings and drawings: *Dynamic Penetration of an Automobile, Densities of the Atmosphere* (1913) and *Mercury passing before the Sun as seen through a Telescope* (1914). But in each case it is a *represented object*—a motor-car, a bird—that is dissolved and penetrated with light, not the painting itself.

Duchamp

Of all the Cubists the closest to the Futurists in technique were Marcel Duchamp, and his brother, Duchamp-Villon. So it is not surprising that the next manifestation of Op should come from Duchamp. He had become interested in depicting the successive stages of movement in 1911, and in that and the following year painted *Nude Descending a Staircase*. He was familiar with Futurist theory and with the work of the Futurists at that time, though his own preoccupations lay in a quite different direction. Where they sought the means of celebrating everything they considered truly contemporary, he remained ironically detached from both contemporary life and art. But he was incredibly quick at seizing on the implications of every development in contemporary art and carrying them through to their, often absurd, conclusions. He had some theoretical interest in investigating light, movement as well as the other things which so absorbed his contemporaries. There may be something faintly ridiculous, perhaps, in treating Duchamp with all solemnity as a pioneer of Op and Kinetic art. But even if his contributions to these movements were often irrelevant to his own intentions, they were contributions for all that. If he did not take them too seriously, others did. Besides, it would be wrong to conclude that, because many of his works were produced in a spirit of mockery or of fun, he was not fully aware of what he was doing.

That he knew quite well what he was doing is clear from what he says of his first ready-made, *Bicycle Wheel* (1913)—an upturned bicycle wheel mounted on a kitchen stool: 'It came about as a pleasure, something to have in my room. . . . It was a pleasant gadget, *pleasant for the movement it gave.*' It is also pleasant for the optical effect produced by the rotating spokes. Perhaps this was a happy accident, something done on impulse, but nevertheless appreciated for what it had to offer, the quality of movement. If we pass over *To Be Looked at with One Eye, Close To, for Nearly an Hour* (1918), and *Témoins Oculistes* (1920), which, on account of a certain flicker produced by some hatched lines, have been regarded as Op, the next works which concern us are more than happy accidents, and they are quite definitely Op. These are the *Revolving Glass* of 1920, the *Rotary Demi-Sphere* (*Precision Optics*) of 1925, and the six 'Rotoreliefs' of 1935.

The first, it is true, was the result of the accidental discovery that when two spirals slightly off centre are revolved on a common axis, one appears to come forward and the other to move back. But this discovery was not applied till later. It led Duchamp, however, to experiment with the *Revolving Glass* which consisted of five rectangular glass plates varying in size, attached to a central rod powered by a motor. When rotated, they form a continuous slightly conical circle. (When first used the motor went out of control, the glass shattered and Duchamp and Man Ray, who was photographing the performance, narrowly escaped the flying fragments.) The *Rotary Demi-Sphere* (1925) as its name implies, consists of half a globe covered with eccentric circles and mounted on a circular board covered with black velvet. When the board is rotated, the circles advance, recede, spiral and reverse direction. In 1926, Duchamp collaborated with Man Ray on a film with the anagramatic title *Anemic Cinema* in which rotating drawings and spirals of inscriptions on discs were interspersed. In 1935 these discs

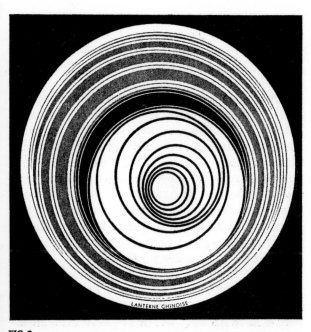

FIG 2
Marcel Duchamp *Rotoreliefs: Lanterne Chinoise* 1935, 7⅞ in. diameter
Museum of Modern Art, New York

colours brings about a pulsating effect—heart beat, in fact—by means of flicker, after-image and advance and recession of colours. This is the only representational picture which is completely Op that I have come across—it was designed for the cover of *Cahier d'Art*—and it is one of the earliest unquestionable Op pictures.

There is no doubt that Duchamp's interest in Op was serious, yet if any Op works are open to the objections which are levelled against Op art it is these: they are experimental—scientific almost—and designed to give a pleasurable sense of surprise, or simply to amuse. No very strenuous attempt is made to explore the artistic and aesthetic possibilities inherent in these discoveries. No criticism of Duchamp is meant by this. His genius lay elsewhere and is not under discussion here. It was for others to exploit these experiments and develop them into a new art form. It is a tribute to Duchamp (a tribute he may not, or perhaps should not have accepted) that he was so far in advance of his time in what he so light-heartedly threw off.

Bauhaus

One group of artists who continued Duchamp's experiments in a more systematic and less puckish (though not always a less light-hearted) manner were the artists who taught at the various Bauhauses from the 'twenties on. The Bauhaus brought together many of the trends in modern painting and is generally accepted as one of the immediate points of origin of the Op art movement. Perhaps its most fundamental contribution to the evolution of Op was the attitude to art which was inculcated in the preliminary courses. This is stated clearly by Albers, who took over the course from Itten in 1923 and became the director of the course when the Bauhaus moved to Dessau in 1925 (he had been a student from 1920, the year after the Bauhaus was founded in Weimar):

appeared in a modified version to be used this time on a gramophone turntable ('Rotoreliefs'). According to Duchamp's instructions, when turned at approximately 33 revolutions per minute they 'will give an impression of depth and the optical illusion will be more intense with one eye than with two'. Some of these contained figurative elements—a fish, an electric light bulb, a balloon—the rest were abstract. There were six of these 'Rotoreliefs' in all, with drawings on both sides.

So far Duchamp had employed some form of movement in order to achieve optical effects, but in 1936 he made a truly Op work which was static. This was called *Fluttering Hearts* (plate 12). Four hearts, alternately red and blue, are enclosed within one another. The construction of the forms as well as the juxtaposition of strongly contrasted

Our start is not retrospection, nor the ambition to illustrate, to embellish or to express something. We try to learn, i.e. to see, that every visible thing has form and that every form has meaning—and we learn this by producing form. Therefore our workshops are laboratories rather than ateliers, studios or lecture rooms.

Art was, thus, initially investigation and experiment. The point of departure was not nature but materials and the basic elements of a picture, form and colour. The immediate object was not to reproduce or analyse nature, nor to express an idea, nor was it self-expression, nor even creative expression, but the discovery of what can be done with the materials and basic elements.

Itten, who inaugurated the preliminary course, had studied under Hölzel at Stuttgart in 1913–16 and had produced a number of abstract studies during that period. Hölzel, a member of the new Dachau Jugendstil group, had long been interested in colour harmony and the expressive qualities of colour and had made a number of experiments in the application of abstract colour in design and decoration. To these ideas Itten added those of Kandinsky, and as a result the early years of the Bauhaus were considerably affected by Expressionism, and had not the cool detachment implied in the quotation from Albers. However, Itten's investigations into the possibilities of colour relations published in *The Art of Color* (1961) were and still are of interest even for those who do not share his romanticism.

With the arrival of Van Doesburg in 1921 and Moholy-Nagy in 1923—as well as contact with Lissitzky, Gabo and Malevich—the balance was gradually tipped in favour of geometrical abstraction and some of the Expressionists, including Itten, left. Even under Itten a number of experiments in optical effects had been carried out. (Itten himself later declared: 'Studies of materials serve to extend the power of optical observation.') A relief by Willi Dieckman in 1922 explores the optical effects of periodic structures, while two

studies by Hirschfeld-Mack made with a spray technique about the same time have all the look of soft-edged target paintings by Fangor or Sedgely. Hirschfeld-Mack had himself, incidentally, studied under Hölzel.

But it was under Albers that most of the optical experiments were done. Josef Albers was born in Bottrop, Westphalia, in 1888. He studied in Berlin, Essen and Munich (1913–20) and at the Bauhaus, where he became a master in 1925, when it moved to Dessau. In 1933, when the Bauhaus was dissolved by the Nazis, he went to America and was professor at Black Mountain College, North Carolina, till 1949. From 1950–9 he was professor at Yale. During the winter of 1953–4 and again in 1955 he directed a course at the Hochschule für Gestaltung at Ulm.

Some of Albers's work will later be discussed, in particular, the 'Graphic Tectonics', 'Structural Constellations' and 'Homage to the Square', all of which were done in America, but he had been experimenting with ambiguous figures throughout the 'twenties working with glass and other materials, culminating in the fourteen woodcuts (tents, white circle, sea, etc.) published in 1933. Whether or not these should properly be considered Op, they have certainly influenced its development, particularly in the United States where some of the leading American Op painters studied under him: Anuszkiewicz and Stanczak attended his courses at Yale. The influence of his ideas has been even more widespread.

In 1939 he began to make his famous series of ambiguous figures beginning with 'Equal and Unequal', followed by 'Graphic Tectonics' (1941), 'Linear Optics' (1942), 'Vice Versa' (1943), 'Kinetic' (1945) and 'Indicating Solids' (1949). 'As you see,' he says, 'I can make a picture move without real movement.'

He began working in colour in 1947 with a series of 'Variants' on graph paper, each colour occupying the same area. He made his first *Homage to the Square* in 1949, treating colour contrast in a thoroughly experimental way, that is, as a psychic

phenomenon in its own right, with no reference to either its expressive use or its romantic and mystical overtones. Describing his course at Ulm, he says that it was a laboratory study aiming at specific psychic effects and not at the application of theory or rules.

After having recognized the physiological phenomenon of the after-image (simultaneous contrast), it is always a great excitement for the class to demonstrate that one and the same colour with changing conditions can look unbelievably different. In a similar discrepancy between physical fact and psychic effect we make very different colours look alike, we make opaque colours look transparent, change the temperature within one colour from warm to cold or vice versa, change dark to light and light to dark, make two colours look like three or three like two, etc.

The results of his experiences as a teacher are summed up in his book *Interaction of Color*.

His method, rather than the specific teaching of that book, has been adopted by many Op painters. Among his own pupils even in the Bauhaus days it produced many interesting results which are not easy to date precisely: *Construction Exercise with a Typewriter, Typography with Space Illusion, Alignment of Equal Circles, Illusion of Various Movements, Construction from Drawn Circles* by Georg Neidenberger, and an interesting interrupted system *Black and White Stripes Cut into Concentric Stripes and Displaced*. There are also some reliefs made of folded paper which resemble works by Castellani and Tomasello.

Of the other teachers at the Bauhaus mention has already been made of Kandinsky. The importance of Moholy-Nagy from our point of view lies chiefly in his experiments with what he called his *Light-Space Modulator (Lichtrequist)* which he worked on from 1922 till 1930. This construction, which was a forerunner of kinetic light works, consisted of glass or perspex, perforated metal discs, metal rods and coloured light bulbs. As it moved it was permeated by and reflected light. It is an optical work in the broader sense. But the importance of Moholy-Nagy extends beyond his influence at the Bauhaus. In 1922, before he arrived at Weimar, he and Kemeny had published a manifesto, 'The Dynamic-Constructive System of Forces', in which the idea of spectator participation was tentatively proposed:

FIG 3
Bauhaus experiment *Black and White Stripes Cut into Concentric Stripes and Displaced c.* 1928–33

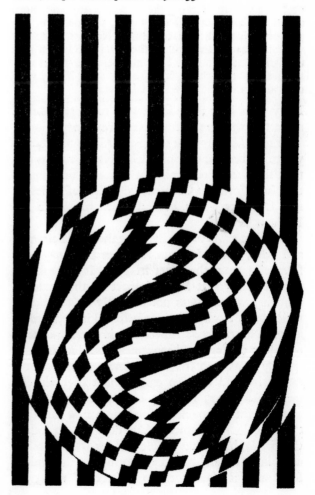

The first projects looking toward the dynamic-constructive system of forces can only be experimental, demonstrative devices for the *testing of the relations between man, material, power and space*. Next comes the utilization of the experimental results for the creation of freely-moving (free from mechanical and technical movement) works of art.

And in an elaborated version of the manifesto *The New Vision* (1938) he puts forward the idea of the anonymous artist:

My desire was to go beyond vanity into the realm of objective validity, serving the public as an anonymous agent. An airbrush and spray gun, for example, can produce a smooth and impersonal surface treatment which is beyond the skill of the hand . . . I even give up signing my paintings. I put numbers and letters with necessary data on the back of the canvas, as if they were cars, airplanes or other industrial products.

Forty years later these ideas were to be proclaimed as part of the creed of the New Tendency.

In 1937 Moholy-Nagy followed Albers to America where he directed the short-lived New Bauhaus and then the School of Design in Chicago, bringing to the New World the Constructivist ideas of Malevich and Lissitzky which he had first brought to the Bauhaus in 1923.

Orphism came to the Bauhaus through Feininger and Klee, both of whom had met Delaunay—the former in 1911, the latter in 1912. It is probably correct to say that Klee's impact on the students, though profound, was not precisely in a direction which leads towards Op. He believed in experiment as wholeheartedly as Albers and in the importance of colour contrast and movement, but like Itten he quickly moved on from experiment to use, to the expressive and creative employment of basic elements. However, remarks like 'I and colour are one', 'Light is capable of fulfilling a new function, that of colour movement', 'Art does not reproduce the visible, but makes visible' (which was to find an echo in Soto) and above all 'formation determines form and is therefore the greater of the two',

remarks capable of various interpretations, helped build up a theoretical background favourable to an art of colour changes, light and flux.

Experiments in optical effects were not confined to the preliminary courses. Gunta Stölzl made some near Op textiles in the late 'twenties. Georg Adams-Teltscher introduced an optical spiral into a design for a ballet in 1923, and there was an Op motif in Roman Clemens's *Metal Masque* design of 1928–9.

With the dispersal of the Bauhaus, its teaching methods were propagated over northern and eastern Europe as well as the United States. As early as 1928 Bortnyik had founded the so-called 'Budapest Bauhaus' or *mühely* (workshop) where Vasarely was soon to become a pupil. Another establishment to become important for the future development of Op, was the Hochschule für Gestaltung at Ulm, with Max Bill, a former pupil at Dessau, as a co-founder.

The 'School of Paris'

Where the Bauhaus had been a rallying ground for abstract artists in the 'twenties, Paris became their focal point in the 'thirties and 'forties. Here every variety of abstraction met. Groups were formed and reviews founded. They flourished briefly and were replaced by others with almost the same membership. In 1930 Van Doesburg founded a short-lived movement around the magazine *Art Concret*. In 1929–30 the Cercle et Carré group was founded by Seuphor and Torres-Garcia. Its large membership included Albers, Klee, Herbin, Hélion, Magnelli and Stazewski. Finally, in 1931 the longest surviving group, Abstraction-Création, was founded by Vantongerloo, Herbin and Hélion. It lasted till 1936. By this time Mondrian, Kandinsky, Gabo, Pevsner, Arp and Sophie Taeuber-Arp had all been in Paris for varying lengths of time. It was in this climate that Op art was nurtured, and it was from here that it was to emerge after the war.

Among the artists either living or exhibiting in

Paris during the 'thirties and 'forties whose work had a bearing on the emergence of Op, one can name Herbin, Bill, Lohse, Mortensen, Baertling, Magnelli, Berlewi, Dewasne and Sophie Taeuber-Arp, though there are many others.

Herbin's work will later be considered in some detail. From Cubism through a more fluid abstraction he arrived at the strict geometrical abstraction exemplified in *Nude* (plate 55). His ideas can be summed up in the phrase: 'a colour must be conceived strictly on the surface in two dimensions, related to a form equally in two dimensions . . . without any reference to the idea of "object".' The resemblance of some of his paintings to those of Vasarely is quite striking, and Vasarely admits that Herbin discovered the essential feature of his own work, colour-form, but he justly believes that Herbin 'retains a spatial orientation proper to figurative painting, "vertical vision".'

Bill, though fundamentally opposed to Op and Kinetic art—'the subordination of fine art to the laws of change contradicts the meaning of fine art'; 'Kinetic artists are jugglers and conjurors'—has had a direct influence on many Op artists, mainly through the Ulm Hochshule and his visit to Latin America in 1951. They admire the precision and the systematic approach which he brings to geometrical abstraction.

Bill wishes to avoid as far as possible the intuitive approach to painting and replace it by some principle of order following the model of mathematics:

I am of the opinion that it is possible to develop an art which is fundamentally based on a mathematical approach. . . . The mathematical approach in contemporary art is not mathematics in itself and hardly makes any use of what is known as exact mathematics. It is primarily a use of processes of logical thought towards the plastic expression of rhythms and relationships.

He works with simple, precise geometrical shapes—the square, the triangle and the rectangle—on a plane surface. With the systematic deployment of these shapes goes an equally systematic deployment of complementary colours. The result, says Bill, is not formalism nor mimeticism 'but a new system conveying elementary powers [the structures of world-order] in a way that renders them perceptible through the senses'.

Here we have many of the characteristics of Op art: the repetition of simple elements, calculation, the use of complementary colours, the exclusion of perspective devices and spatial ambiguities, and a direct perceptual appeal without symbolism or association. One important characteristic is missing, of course, the disruption of the picture surface. This effectively distinguishes Bill from Op painters. Yet in many of his pictures—the *77 Black Squares* (or *White Square*) of 1946, *Transcoloration* (1966, plate 13) and *Four Complementary Coloured Groups in the Blue Field* (1966)—Bill comes very close to producing an optical effect. Hence, by carrying his principles a stage further in one direction—the wrong direction he would probably say—optical effects can be obtained.

Richard Lohse, who like Bill is a native of Zurich, also builds up his compositions systematically, in his case according to progressions, or, as he terms it, series and modules. He began working in this manner in 1942. From De Stijl and Suprematism he took the idea of using anonymous pictorial elements of similar dimensions added to one another in groups. The construction of a picture consists in determining beforehand certain rules, basic themes and sub-themes, to be observed in the location and number of colours, and the dimensions of the forms (where these are not identical) on the analogy of serial music. For instance, one rule might be that no colour can be repeated horizontally or vertically. Once a system has been adopted it is not modified. The basic principles of construction do not evolve in the course of the work, as they do in Constructivism. But within the system there is unlimited flexibility and scope for development, or rather,

precisely because a system has been adopted, un-limited expansion is possible. Moreover, like those verbs which are regularly irregular, Lohse's pictures can be symmetrically asymmetrical—symmetry is preserved by the system which, though present, may not be immediately apparent (*Fifteen Systematic Series of Colours in Vertical and Horizontal Condensation* 1950–67, plate 5).

Following a system of this kind can, as in paintings by Bridget Riley and Jeffrey Steele, lead to the production of optical effects, even though with Lohse it does not. Moreover, the emphasis on anonymous geometrical units, the additive principle of picture construction, repetition of a limited number of forms and colours, colour contrast and gradation, etc., are all essential though not exclusive features, of Op. It should be added, however, that many Op painters would part company with Lohse on one fundamental point, namely, the need for a system as opposed to free exploration and discovery.

The contributions of Mortensen, Baertling, Magnelli, Berlewi, Dewasne and Sophie Taeuber-Arp towards the evolution of Op are much less direct than those of Bill and Lohse. The paintings of Bill and Lohse, because the forms and colours lie on the picture plane and do not move to any great extent in pictorial space, are often only a hair's breadth away from Op (though in other ways they may be worlds apart). But the paintings of these others have very definite spatial properties and belong within what I shall loosely call the cubist tradition. Something will later be said about Mortensen's work. Olle Baertling, a fellow Scandinavian, produces a strong sense of movement in his paintings but not by optical effects. It is rather by the dynamic thrust of diagonals graphically described by Alberto Sartoris: 'In his staggering clear-cut paintings flashes of colour of an extraordinary purity... seem to tear apart the space and fleshliness of a metallic sky'. Magnelli's painting is far less dynamic than Baertling's. It is nearer to

Mortensen's ambiguous forms, but it has the hard-edged quality of both. He came to Paris in 1914 and in the following year produced his first abstract paintings which Seuphor says were 'a series of violent colours which became known only much later'. From 1918 to 1931 he returned to figuration, and since then has painted abstracts, which like Herbin's are spatially akin to figurative art. Dewasne, the youngest of the group, began painting abstracts in 1943 and ever since *La Joie de Vivre* (1948) has painted with hard-edged, vivid, unmodulated colours, using industrial paints, with strong emphasis on light and shade (positive/negative). Arp said of him: 'In the years 1917 to 1920 or 25, Sophie and I fought for an indefinable precision.... Like us, Dewasne seeks precision. He thus continues the tradition, in a sense, through the monstrous confusion of our days.'

It is here above all that the contribution of these artists to the evolution of Op is to be found. After the war, when so many painters were working with abstract expressionist or tachist techniques, these artists offered an alternative form of abstraction which was not strictly constructivist. It combined the precision of clear-cut geometrical forms with strong contrast of colour and a sense of movement and ambiguous figures. Though the most direct road to Op may lie through the repetition of simple elements on a plane surface, another may lie through an acceleration of the movement brought about by the use of ambiguous figures. It must be added, however, that their use of ambiguous figures (and perhaps the fact that Baertling makes moving sculpture) may have led people to associate them too closely with Op.

Of the two remaining artists mentioned above, Sophie Taeuber-Arp and Berlewi, it can be said that the former (who was a more strictly geometrical abstract artist than her husband) produced at least one work, *Systematic Construction in Multiple Circles and Rectangles* (1933), which has something of

an optical effect, while the latter produced quite a few such works as early as 1923. Henryk Berlewi, who was born in Warsaw in 1894, came to Berlin in 1922 where he met Lissitzky, Richter and Eggeling. He was impressed by the works of Leger in which machine forms were assembled, and by the Dadaist juxtaposition of heterogeneous elements. His first reaction, however, was to substitute for their irrational, chaotic assemblages, 'another "facture" which was flat, ordered and constructed, and based on equivalence'. In his manifesto 'Mechano-Factura' of 1924, on the occasion of an exhibition in a motor-car show room, he says, anticipating many of the pronouncements of the New Tendency:

the materials as such lose their significance, in a word: they are dematerialized. They are transformed in our minds. It is not the materials which are important but their equivalents.

Although he wished to be 'true to the two-dimensional principle of the picture' and believed that his pictures 'do not exercise on us a direct optical impression', at least two works, *Elements of Mechano-Facture*, painted in 1923, do have a decided optical movement. They consist of black dots imposed on white or white on black. Though Berlewi returned to figuration in 1926 and did not take up abstraction again till 1957 (he had settled in Paris in 1928), he was to revert to his 'Mechano-Facture' again in 1962 and produce some more works which give an optical impression. But by then optical art had become accepted.

A word must be said before closing this chapter about the abstract films made during the pre-war period. As we have seen, Duchamp's 'Rotoreliefs' of 1935 were based on his *Anemic Cinema* of 1926. Len Lye, who later went on to make kinetic sculpture, was drawing abstract films in 1935. The earliest abstract films seem to have been made by Survage in 1912, and throughout the 'twenties and 'thirties Leger, Man Ray, Eggeling and Richter also made

some. Although Op art is an attempt to produce pictures which give an impression of movement without actually moving, these films may have had some influence, subconscious perhaps, on its evolution, since they were based on the idea of successive and rhythmic relationships of colour and form.

FIG 4
Henryk Berlewi *Elements of Mechano-Facture* 1923, $21\frac{5}{8} \times 21\frac{1}{4}$ in.

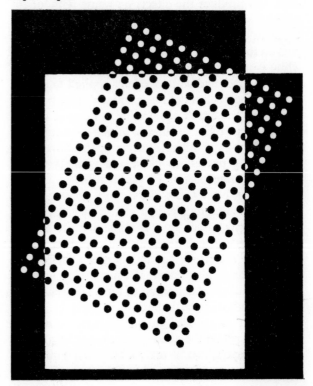

2 Optical effects: black and white

The use to which Op artists put their visual effects can most easily be demonstrated in black and white. 'No stronger evidence of the new level of visual sensibility,' writes Seitz, 'could be presented than the recent and quite unprecedented wave of painting without colour.' Whether the use of black and white is evidence of a heightened visual sensitivity or not may be questioned. What is not in doubt is the extent to which artists have restricted themselves to these two tones. The earlier works of many Op artists, such as Vasarely, Soto and Bridget Riley are in black and white. Others, like some of the Groupe de Recherche and until recently Steele, seldom work in anything else.

The reason for this is twofold.

First, most optical effects can be achieved by the use of black and white alone. By excluding colour the artist can produce the effects he wants without the added complexities which colour brings with it. Once he has mastered black and white, he can then pass on to colour. This does not mean that black and white is a poor relation of colour or that the skills learnt in black and white are later applied to colour. Some of the qualities of black and white are peculiar to it alone and are of equal value to those of colour. Techniques proper to the use of one cannot simply be applied to the other. But one of the advantages of confining oneself to black and white is that it limits the complexities of a problem.

Secondly, black and white is more dramatic in its effect. It is more dynamic; it carries more punch; it affords a greater contrast. Black and white act like complementary colours but with greater effect because of the strong contrast between them. This contrast also helps to make the forms clear-cut and incisive, and clear definition of form is essential for certain kinds of optical effect.

In order to proceed in a systematic manner, I propose to group the effects under the titles given to them in psychologists' textbooks. This is purely a convenient way of going about things and has no theoretical or aesthetic implications. A beginning can most easily be made with what are called 'periodic structures'.

Periodic structures

These are defined as functions which repeat the same values at regular intervals, as the variable increases or decreases uniformly. In less technical language, they consist of a repetition of simple geometrical elements—lines, squares, circles, triangles, etc. The characteristic feature of a periodic structure is that the elements are virtually anonymous; that is, one can observe them individually with difficulty or not at all.

The most familiar form of periodic structure is the kind of photograph found in a newspaper. It is composed of tiny dots, but one is normally unaware of them. They merge or fuse together to form a recognizable image in black and white and various shades of grey. Where the elements are larger and can be observed more easily—fusion still taking place because of the repetition but not in the stable fashion of the newspaper photograph—the elements tend to group, break up and regroup in different combinations. Where irregularities occur in the system the process is accelerated and the surface begins to buckle and warp.

Fig. 5 is a good example of a periodic structure of concentric circles. Grey, thickish lines or 'radii' shoot out from the centre of the concentric rings and begin to rotate like propeller blades in rapid motion, while the circles themselves move in the opposite direction. Faint traces of colour can also be detected. Further complications are introduced in fig. 6 by the spiral. The 'radii' become bent in the form of an S following the direction of the spiral and the impression of colour is greater.

Celentano's *Kinetic Painting no. 3* is a good example of the artistic use to which structures of this kind can be put. The movement is more

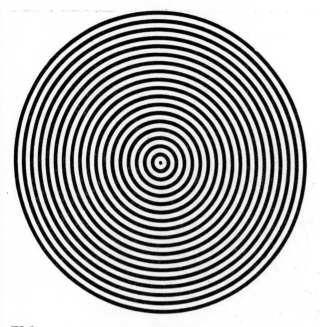

FIG 5
Periodic structure of concentric circles

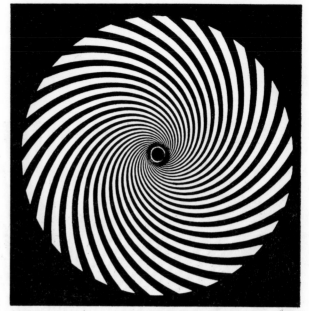

FIG 6
Periodic structure in a spiral

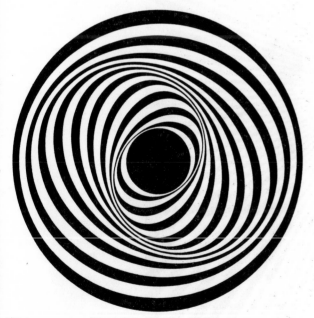

FIG 7
Francis Celentano *Kinetic Painting no. 3* 1967, 48 in. diameter
Howard Wise Gallery, New York

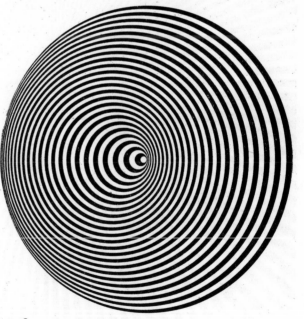

FIG 8
Marina Apollonio *Dynamic Circular 6S* 1966
Artist's collection

controlled and elaborate than in fig. 6. The eye moves inwards and outwards in an unending rhythmic dance around the gently expanding central black circle. Marina Apollonio's *Dynamic Circular* is much more rapid in its movement, with the

added complexity of faintly coloured rotating S-shaped 'radii'. An impression of a spiral is conveyed because the circles are off centre. This also gives the structure a solidity which fig. 5 lacks, and, as in Celentano's painting, but unlike fig. 5 the movement

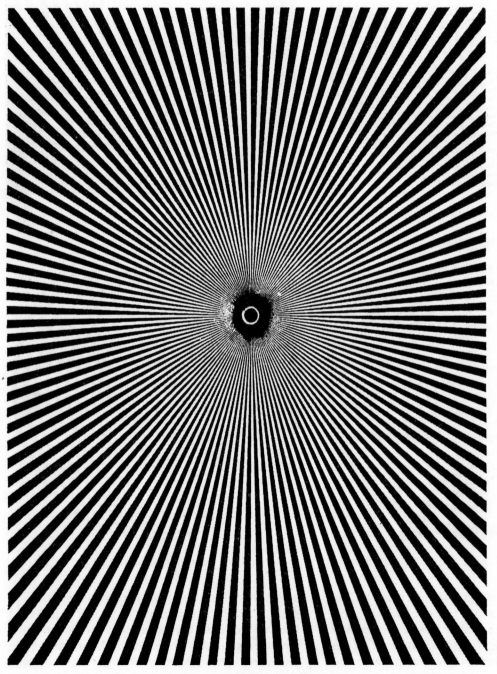

FIG 9
McKay figure

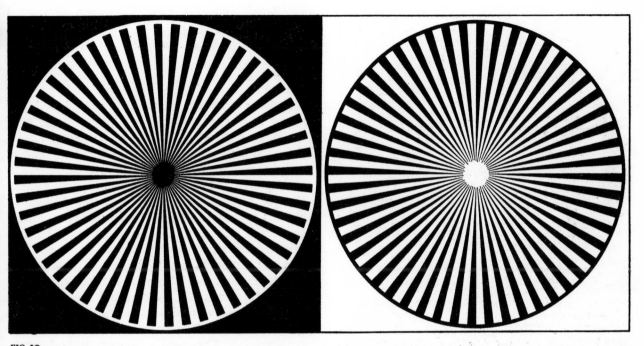

FIG 10
Wolfgang Ludwig *Cinematic Painting* 1964, 24⅛ × 48⅜ in
Artist's collection

does not end in the centre but returns to the outer circumference and continually changes direction. Another interesting example of this kind of periodic structure is Tadasky's *A101* (plate 9). The effect is much the same as that of fig. 5, but the addition of colour (white at the centre, passing through yellow to brown) gives the richness of simultaneous contrast and 'colour mixture'. The shadowy 'radii' are more numerous, thinner and more complex in their movement and counter-movement.

The McKay ray figure (fig. 9) is altogether more spectacular and immediate in its effect. It positively pulsates and radiates curved lines like those of a magnetic field. The impression of colour is so strong that it bursts outwards like an Aurora Borealis across the sky. Ludwig's *Cinematic Painting* exploits some of these effects, particularly the radiating colour, but with far greater delicacy and control, which is achieved by the regular spacing of the black and white 'spokes'. *Optical-Dynamic Structure*

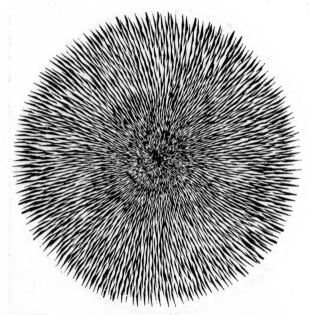

FIG 11
Miroslav Sutej *Bombardment of the Optic Nerve 2* 1963, 88¾ in. diameter

(plate 10) by Costa of Gruppo N makes use of the pulsating and irradiating effects of this figure and with even more variety and subtlety. The dark central square, for instance, has a distorted shadow which bends inwards and outwards. Since this is a relief made of strips of polyethylene the movement of the square and its shadow varies with the movement of the spectator in front of it. Sutej's *Bombardment of the Optic Nerve 2* is a variant on this figure. The colour aurora is absent. The centrifugal force is much less, presumably because of the breaking of the lines, and is balanced by a counter, centripetal attraction—the eye is alternately sucked into the centre and repelled, as though confronted with flying fragments from an explosion. The magnetic rings expand like the petals of some rapidly breathing flower.

Periodic structures of parallel, vertical or horizontal lines also produce secondary patterns and undulations of surface, though less spectacular than the concentric circles. Bridget Riley has done a series of paintings over the period 1961–4 in which she explores the optical possibilities of parallel lines. One of her earliest works *Horizontal Vibration*, consists of straight lines of varying thickness, which produce a vertical undulating movement. In this painting the horizontal lines remain stable and act as a sort of ground bass to the vertical undulation. Greater instability is introduced in a subsequent set of paintings in which thinner, and evenly spaced and undulating vertical lines are used. *Current* is a splendid example. The entire surface of the painting is in motion. The main movement is horizontal, continually changing direction and reaching its highest intensity around the centre of the canvas. It is counter-balanced by a vertical movement which dies away towards the upper and lower edges. At times, horizontal lines seem to detach themselves from the central area of activity and float upwards or downwards apparently in front of the canvas, gradually dying away as the more tranquil passages are reached. Faint lattice-work patterns of colour play across these quieter areas.

Part of the fascination of the periodic structures we have been considering (and the same is true of those which follow) is the complexity and richness of experience which very simple structures provide. So simple are they that it is quite easy to dismiss them as trivial until one has submitted oneself to them. Michael Compton in *Optical and Kinetic Art* has described this feature of Op art in writing about an earlier work of Bridget Riley, *Fall*, which closely resembles *Current*:

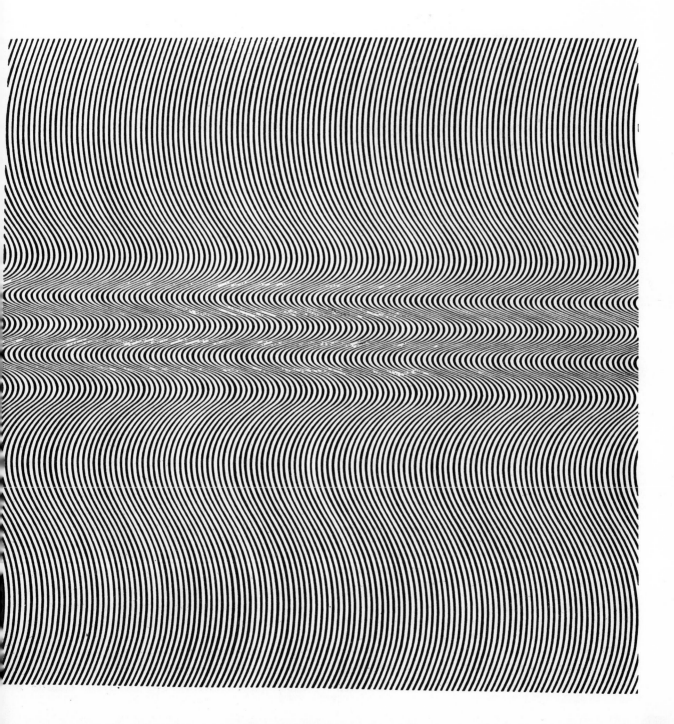

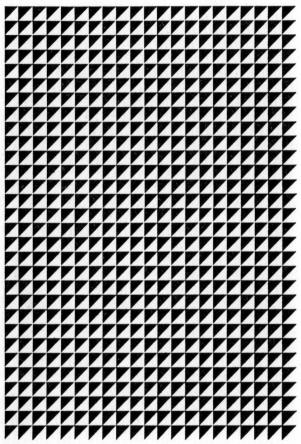

FIG 13
Periodic structure of triangles

FIG 14
Bridget Riley *Straight Curve* 1963, 28 × 24½ in.
Private collection

from the experience of the work, but a part of the total experience. As in figurative painting our attention may shift from the scene to the surface pattern and back again, so in Op there is a constant shifting of attention from the simple structure to the complex effects and back. This is one of the sources of our satisfaction in a work such as *Current*.

So far we have been considering periodic structures composed of lines. We must now turn to those composed of separate forms. Once again a comparison between a simple textbook diagram and a work by an Op artist may be illuminating. Fig. 13 is a typical example of a periodic structure in simple forms. In spite of its simplicity and the exact repetition of the forms throughout the whole area, a considerable amount of variations becomes apparent as soon as one concentrates on it for any length of time. The triangles group themselves into formations like birds or aeroplanes in flight moving diagonally across the surface. The white triangles continually change in tone. At times the squares formed by the sets of triangles appear to be hollow spaces like those high buildings, described as egg-boxes, seen in strong sunlight.

Bridget Riley's *Straight Curve* is very similar in structure to fig 13. It has been altered ever so slightly. The triangles have been flattened somewhat at the sides of the picture. But the effect of these changes is enormous. Although every line on the surface is straight, curves criss-cross in waves diagonally over the whole picture, bending in and out, merging, disappearing and reappearing. Against this movement there is another, horizontal and more staccato, varying in tempo according to the size of the triangles. The 'hollowing' 'egg-box' effect may appear momentarily, but it is quickly dispelled by the diagonal curves. An over-all rhythm controls all

The eye (and the mind) is threatened with a complete breakdown in its power to control or structure what it sees. It is overwhelmed with contradictory information, much of it created by its own mechanisms, which in less extreme conditions, serve to stabilize perception. . . . In quiet intervals one is saved from the threat of being overwhelmed by a periodical intellectual realization of the basic simplicity of the picture. There is no system in a picture by Bridget Riley that cannot be worked out quite easily.

The realization of the picture's simplicity, if intellectual, is not on that account an observation detached

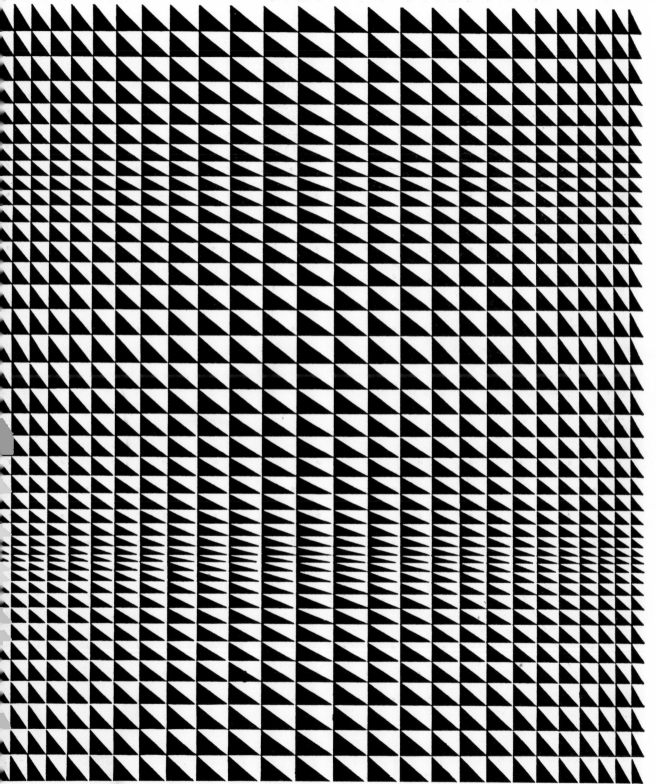

D

FIG 15
Bridget Riley *Static 3* 1966, 90½ × 90½ in.
Power Collection, Australia

FIG 16
Gotthart Müller *SD 65* 1962, seriograph 21⅝ × 21⅝ in.

FIG 17
François Morellet *Tirets* 0°–90° 1960, 55 × 55 in.
Private collection

these movements and relates them. It is this which marks off *Straight Curve* from fig. 13. Where the visual effects succeeded each other in a haphazard, arbitrary fashion, according to random movements of the eye or shifting interest, the effects in *Straight Curve* are programmed and unified: the spectator is led from one to the other. Although the elements in this painting are quite simple, the picture itself has a baroque richness compared with some others, particularly those in which the unit is the square or small circle.

Let us begin with some austere and unpromising examples. *Static 3* by Bridget Riley is nothing more than a square made up of 625 (25 × 25) minute ovals. One may be surprised at first at the painter's description of the origin of this picture:

I thought of the painting when I was going up a mountain in France which had a vast expanse of shale at the top. It was an extremely hot day. Visually it was total confusion; I felt that there was no possibility of understanding the space of this situation. You couldn't tell whether this shimmering shale was far or near, flat or round . . . We found it so alarming that we got out of the car, which of course intensified the sensation. But it was much cooler on top and into my mind came the beginning of *Static*, a mass of tiny glittering units like a rain of arrows.

What Bridget Riley is giving us is the visual equivalent of a sensation: 'Static' refers to static electricity.

If we concentrate on these tiny dots we begin to experience the intense prickly sensation, the failure to come to terms with the spatial location of these undifferentiated, pulsating sources of energy. At the same time we are aware that the source of all this confusion is something simple and regular. As she says, 'Michelangelo said that he let a figure out of stone, so I have let the energy out of the forms, the elements, via the relationships.'

The same sort of sensation may be experienced with Gotthart Muller's seriograph *SD 65* or Morellet's *Tirets* 0°–90°. At first sight *SD 65* is quite as austere as *Static 3* but on closer examination it will be found that the 'shadows' cast by the white lines on which the black are superimposed are sometimes T-shaped and sometimes shaped like inverted Ls facing to right or left. This subtle change accelerates the optical effect but also keeps it closer to the picture surface. After a short time the whole field is covered with an intricate pattern of delicate colours and almost simultaneously one receives the impression of downward movement like that of gently falling rain. A similar impression is conveyed by Morellet's *Tirets*. After a short time, what seems a banal repetitive structure comes to life; units float about and interweave, and faint colours or areas of brilliance and darkness appear and disappear.

FIG 18
Dieter Hacker *Cubes* 1963, seriograph 25 × 25 in.

Moving a stage further, Dieter Hacker's *Cubes* have greater individual identity. They rely for their effect not only on repetition of almost identical elements but also on the reversible figure illusion: the front and back walls of each cube alternate. They have been so arranged, however—the darker lines are alternately on the left and on the right—that the switch of viewpoint is facilitated and encouraged. The result is that the cubes pop in and out in a rhythmic movement with ever-increasing tempo. Hacker speaks of 'conscious manipulation' of the cubes. One normally thinks of manipulation as something done by hand but there is a sense in which one may be said to 'manipulate' Hacker's cubes by reading them now one way, now another.

Simple though these structures are, they allow for endless variety in the shape, size, number and spacing of the units, and hence in the effects produced. Distortions of the basic units, as we have just seen, add further variety. Hacker's distortions are regular and repeated. A good example of irregular distortion which does not destroy the basic structure is Vasarely's *Eridan-C no. 33*. Here we have movement in many directions; a procession around the central squares and an oscillating movement inwards and outwards. The latter movement is caused by the diamond-shaped units which are seen as squares bending inwards or outwards in space. The whole effect is like that of a tidal river with currents, cross currents and counter currents, all contained within the confines of the square format.

The introduction of different colours adds still further to the variety of the effect. In *C17* by Angel Duarte (plate 11), as soon as the patches have let go each other's hands, so to speak, they begin to drift apart. There is also a centripetal rush of units along the axes as they become distorted.

Finally, by superimposing structures of very simple elements one on another as in Soto's *White Dots on Black Dots*, or his *Metamorphosis* (plate 15), still more varied effects can be produced:

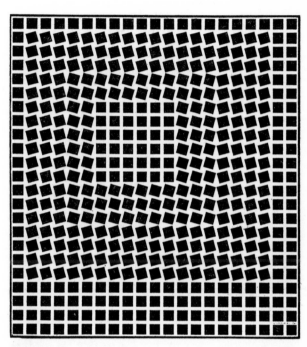

FIG 19
Victor Vasarely *Eridan–C no. 33* 1963, 25 × 28 in.
Denise René Gallery, Paris

With my *White Dots on Black Dots*... I created my first kinetic work. I fixed my transparent grill covered with dots, no longer directly onto the square background, but at a distance of approx. 8cm in front of it and directly above the square of black dots. Now the effect of *vibration* could be obtained by the movement of the spectator. As he moves laterally in front of them, the two grills somehow 'slip' before his eyes with enough speed to cause a retinal disturbance.

But, as Soto notes, an optical effect is produced even if one remains stationary before such a picture, or looks at a photograph of it. The effect, he says was achieved even by Cézanne—'he superimposed what he had, the layers of paint'.

There is one other kind of structure which may not be strictly periodic but is very close to the structures we have been considering. This is the grid as used by Dorazio and Morellet. There is no

FIG 20
François Morellet *Four Superimposed Webs* 1959 55⅛ × 55⅛ in.
Artist's collection

better way of concluding this section than with a brief study of Morellet's grids. In 1958 Morellet did a painting made up of black lines on a white ground. These lines, drawn at angles of 22·5°, 45° and 67·5° across a rectilinear grid are so numerous and so fine that they fuse to form a dark background. Against this background, circular shapes and concentric rings, some with bright, some with dark centres, make their appearance and then disappear again. Their appearance is so unstable that the eye cannot hold any one of them for long but is quickly drawn away to others clamouring for attention. The whole surface becomes a field studded with stars. Across this field runs the faintest suspicion of spectral tints. In subsequent grid structures Morellet has reversed the tones or colours making the background black and the lines white, but, though there is a gain in intensity of light (and these are easier to reproduce), the result is not quite so

effective as when the dark background is created optically by the fusion of the line.

Interrupted systems

'Interrupted systems' are closely related to 'periodic structures'. The pattern or system is broken or interrupted and rearranged. Three striking examples of this are *Blaze 1*, *Twist*, and *Disfigured Circle* by Bridget Riley. The abrupt change of direction of the diagonal lines in *Blaze* gives an almost brutal impression of ridges and hollows cut deeply into the surface. The whole structure gives an immense sense of solidity. But this impression is quickly dispelled as the eye travels round what appears to be, but in fact is not, a spiral. What at one moment appears to be a ridge, becomes either a hollow or disappears altogether. One is aware of an intense activity, as of cog-wheels furiously grinding around and into one another. This activity becomes almost physically painful as the wheels converge on the centre and here the energy seems to change from motion into light, radiating outwards, harsh and vibrant. The movement of *Twist* is somewhat quieter, presumably because it dissipates itself towards the edges and is not turned in on itself as in *Blaze*. The vibrancy of the light is more evenly distributed over the surface, and it plays over a structure of even greater 'solidity' than that of *Blaze*, a structure in which the elusive forms wonderfully interlock and settle into one another.

While these two pictures have pronounced optical effects, they also operate in ways similar to the ambiguous figures which will be considered later. The interrupted system in itself does not cause optical effects. It merely induces a shift of reading from one interpretation to another, that is, from ridge to trough, trough to ridge. It is the periodic structure, the repetition of identical units, which produces the optical effect.

This can be seen by contrasting *Disfigured Circle*

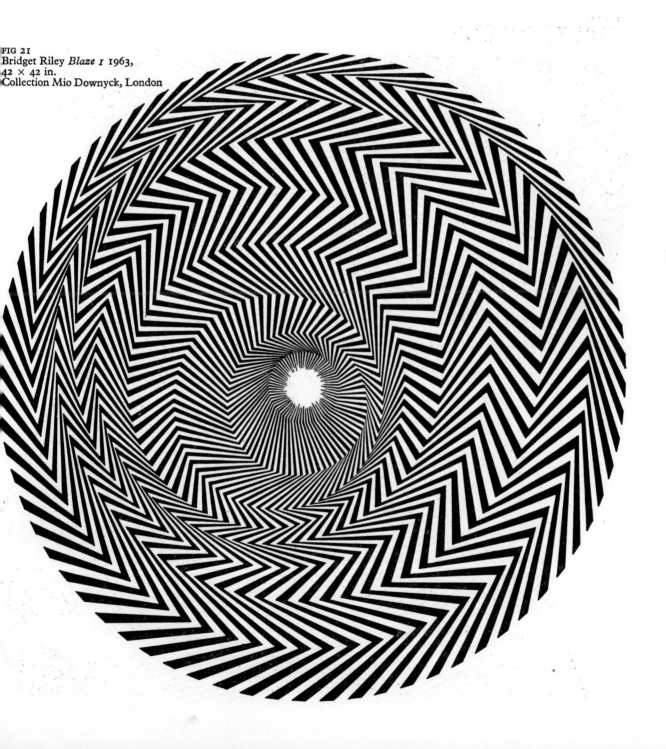

FIG 21
Bridget Riley *Blaze 1* 1963,
42 × 42 in.
Collection Mio Downyck, London

FIG 22
Bridget Riley *Twist* 1963, 48 × 45¾ in.
Collection Eric Estorick, London

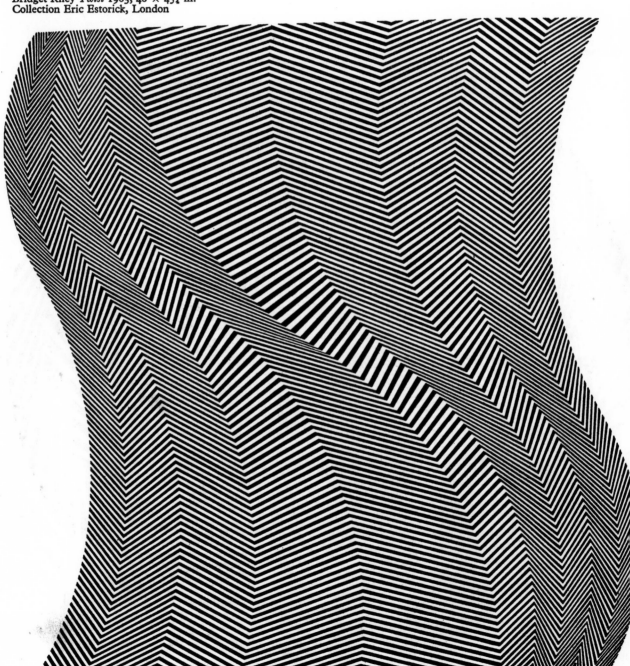

FIG 23
Bridget Riley *Disfigured Circle* 1963, 44½ × 43½ in.
Collection Eric Estorick, London

FIG 24
Reginald Neal *Square of Three* 1964, 32 × 32 in.
Amel Gallery, New York

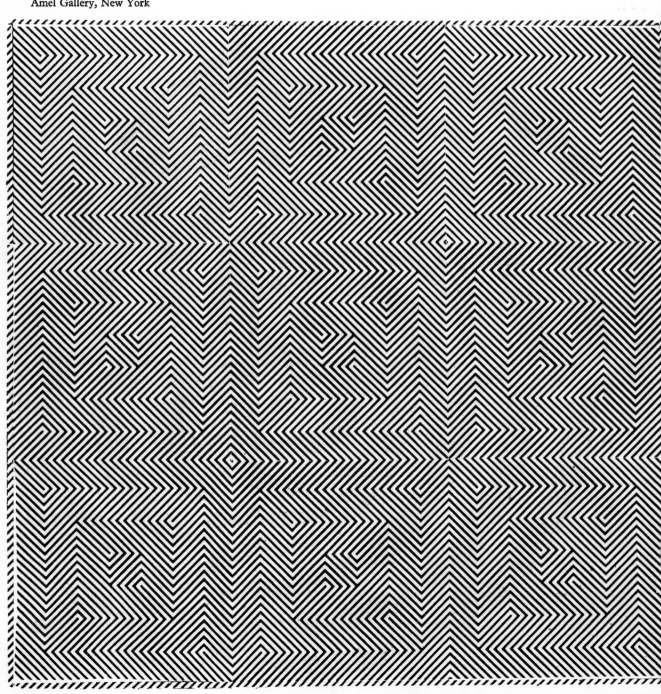

with *Blaze* and *Twist*. The movement here is much calmer than in either of the others. The eye shifts in a more leisurely fashion from one layer of the circle to another. There is, however, a sense—particularly around the centre—that the circle is struggling to right itself, though all it can achieve is an equilibrium of tension, a balance of surge and thrust.

V 10 (plate 17) by Duarte is another example of an interrupted system in which optical effects play over a fairly stable structure, this time far more stable than either *Twist* or *Distorted Circle*. By contrast Reginald Neal's *Square of Three* is almost entirely optical in its effect. Although the herringbone pattern is similar to that of *Blaze* and *Twist*, the overall pattern is regular and angular, and this prevents the development of deep furrowing. The result is a rapid movement in shallow space with an extraordinary degree of flicker and dazzle.

After-images

In considering some periodic structures, we have come across a phenomenon which may form an integral part of their effect but which can be used separately, at least to the extent that it can be given greater prominence. This is the so-called 'after-image'. (The spokes which radiate from the concentric circles and spirals of figs. 5 and 6 and the horizontal lines which detach themselves from the centre of Bridget Riley's *Current* if not after-images are after-effects of stimulation, a new pattern interacting with the hangover of the previous pattern.)

Gregory has described the after-image as follows in *Eye and Brain*:

When the eye has been adapted to a bright light (e.g. a lamp bulb viewed with the eye held steady, or better, a photographic flash) a dark shape, of the same form as the adapting light, is seen hovering in space. It is dark when seen against a light surface such as a wall, but for the few seconds after stimulation by the adapting light, it will look bright in darkness. This is called a positive

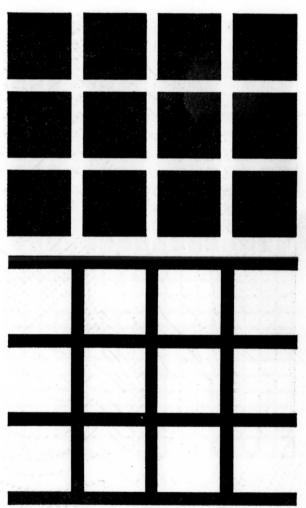

FIG 25
After-image

after-image and represents continuing firing of the retina and the optic nerve after the stimulation. The dark one is called a negative after-image, and represents the relatively reduced sensitivity of the stimulated part of the retina due to bleaching of the photopigment.

A simple and very obvious example of the sort of after-image one meets in art is shown in fig. 25. If you look steadily at any point of intersection of the

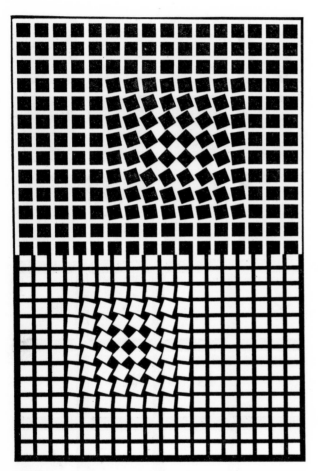

FIG 26
Victor Vasarely *Eridan III* 1956, 76¾ × 51 in.
Denise René Gallery, Paris

white lines, grey squares will appear at the other points of intersection. As soon as you shift your gaze and try to catch one of these squares, it will disappear; instead another will appear immediately at the point from which your gaze has shifted. Two other peculiarities of after-images should be noted. First, if a figure, such as a spiral, appears to move in one direction, its after-image will appear to move in the opposite direction. Secondly, a strong after-image projected on to a system of lines in perspective

(such as converging diagonals) will become distorted. The after-image adapts itself to the perspective. This may contribute to some of the effects which were encountered when studying structures.

Vasarely's *Eridan III* is a good example of the use of positive and negative after-images. The upper, darker section of the picture is flecked with grey squares, while tiny spots of white flash on and off in the lower section. This movement appears to be independent of the general movement of the picture, and acts as a sort of counterpoint to it.

In Bridget Riley's *Fragment 6/9* the after-image plays a more integrated role in the composition. The black dots and circles are relatively static until white after-images begin to dance in and out among them. Then the whole surface becomes animated and the black shapes, still relatively stable, float through an indeterminate space with their after-images literally dancing attendance on them.

After-images play a prominent part in colour Op and we shall be returning to them in the next chapter.

The phi phenomenon

In the preceding pages we have frequently encountered the displacement of elements, their movement about the surface, their disappearance and sudden reappearance in another place. We know that no such displacement is occurring. The lines, squares and dots remain on the canvas where the artist placed them. After-images are a different matter; the artist did not put them there however much he may have induced their appearance. It may help our understanding of what is happening if we consider at this stage what psychologists have to say about our perception of movement.

FIG 27
Bridget Riley *Fragment no. 6/9* 1965, 29¼ × 29 in.
Robert Fraser Gallery, London

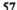

In 1912, Wertheimer, the father of Gestalt psychology, published a study of apparent movement. He observed that if two objects (say, two lights in a darkened room) are placed at the right distance apart and one appears immediately after the other has begun to disappear (assuming that each remains visible for the right length of time), the spectator will observe not two separate objects but a single object moving from the position of the first to that of the second. Wertheimer called this the 'phi phenomenon'.

Since Wertheimer's day many other instances of apparent movement have been observed and given the titles of other letters of the Greek alphabet— alpha, beta, gamma, delta, epsilon, gamma-pi, theta and (hopefully the last?) omega. In some cases the object does not appear to move but to expand and contract while remaining in the same place (gamma movement). In other cases objects of different sizes and shapes move towards each other and return together to the original position of one or other of them. It is worth noting that, though these various kinds of movement are described as 'apparent', they do not differ perceptually from our observation of real movement. We determine whether a movement is real or apparent by other considerations, not by visual perception alone. For instance it is not merely by looking at it that we tell whether or not the moon is racing through the clouds or the departing train on the next track is stationary and ours moving.

In applying the phi and other phenomena to Op art I am stretching the notion a little; objects do not always suddenly appear and disappear (after-images excepted). Such appearance and disappearance does occur in moving optical works such as Garcia Rossi's *Unstable Light Structure* (plate 16) in which plexiglass tubes are lit in a random fashion and spots of light appear to hop about, and Von Graevenitz's *Object with White Moving Discs* where the discs move (if they do not actually appear and disappear) and give the impression that they are

FIG 28
Gerhard von Graevenitz *Object with White Moving Discs* iron and wood 1965, 47¼ in. diameter

changing places. But in Op paintings no actual movement of any kind takes place. Nevertheless, there is an impression of movement, of hopping about and changing position, and I feel that here we have something not unlike the phi phenomenon.

After all, the essential feature of the phi phenomenon is that two objects are identified and treated as one simply on the grounds that they appear in close proximity in space and time. But this is precisely what happens in a periodic structure. The elements are so numerous and so close together that the eye cannot discriminate between them. It is easy for the eye—far easier in fact—to see a single unit or a fusion of units moving from one place to

another as to pass from one virtually indistinguishable unit to the next. Where the units become as numerous and as homogeneous as they are in Müller's *SD 65* or Bridget Riley's *Current* the movement seems to detach itself from the surface and take place in front of the picture in the form of 'falling rain' or slowly moving horizontal bars. (The after-image, as has been said, may play a part in this, but after-images may also be subject to the same laws which govern the perception of apparent movement.) The expansion which we noticed in the black centre of Celentano's picture—unusual in that black generally tends to contract—may be analogous to gamma movement; for, to the rapidly moving eye, the black circle may seem to appear suddenly and hence expand. Expansion and contraction also occurs in paintings like Sedgley's *Lazar* (plate 14) or Fangor's *E 10* (plate 18) and this too may be an instance of the phenomenon we are considering. Where a single figure consisting of concentric rings cannot change its place since there is no other figure to change places with, yet the rapid shifting of the eye forces us to see it as moving, it must either rotate, expand or contract.

The main purpose of this excursion into physiology and psychology is not to offer an explanation of these optical effects. Much less is there any suggestion that artists who employ these effects are merely carrying out psychological research into the perception of movement. The purpose of these considerations (as of the other references to psychology in this chapter) is to draw attention to certain features of Op art of which the artists themselves may have been unaware and in which they quite probably had no speculative interest.

Irradiation and diffusion

Mention of works by Sedgley and Fangor calls attention to an effect which has not been considered so far since it has little or nothing to do with periodic structures. This is diffusion or blurring. Periodic structures achieve an effect of apparent movement by the repetition of simple, clearly defined units in strong tonal contrast. But an impression of movement can also be achieved by blurring of edges. We are all familiar with this from multiple exposure photographs where the eye searches vainly for some outline on which to focus. In the case of pictures like Fangor's and Sedgely's, colour contrast heightens the effect, but it is apparent even in black and white reproduction.

Besides an impression of movement, diffusion also gives an impression of luminosity. The image becomes translucent, transfused with light. Luminosity is not confined to the blurred, soft edge, however. It is to be found in the hard-edged periodic structures too. But, as might be expected, where the edge is hard the light is harsher, painful even, as in Bridget Riley's *Blaze*. The luminous effect produced by strong contrast is roughly what the psychologists refer to as 'irradiation'. Although irradiation takes place in many of the works we have already considered, it plays a minor role; it is a sort of fringe benefit. In the works which I shall now consider it has a more important part in the total effect.

The work of Mavignier and Anuszkiewicz offers some splendid examples of irradiation. *Concave-Convex* by Mavignier seems to glow as if illuminated from within. He builds up the effect by making the circles progressively larger while still surrounding them with sufficient darkness to maintain the contrast. As the title suggests, there is an inward (concave) and outward (convex) movement which is brought about by the irradiation or expansion of the white and the shrinking of the black. The lateral movement is also interesting: areas of darkness balance areas of light and areas of light zig-zag across the page. *Division of Intensity* by Anuszkiewicz operates on a quite different principle. The structure is rigidly symmetrical but the rigidity is broken not only by the interweaving of the squares but more

FIG 29
Almir Mavignier *Concave-Convex* 1966, seriograph 24½ × 24½ in.

FIG 30
Richard Anuszkiewicz *Division of Intensity* 1964, 48 × 48 in.
Martha Jackson Gallery, New York

E

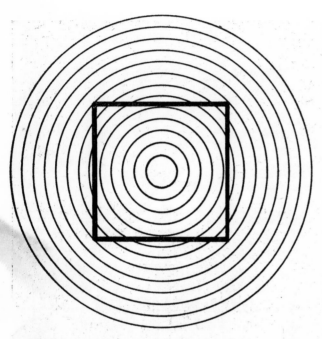

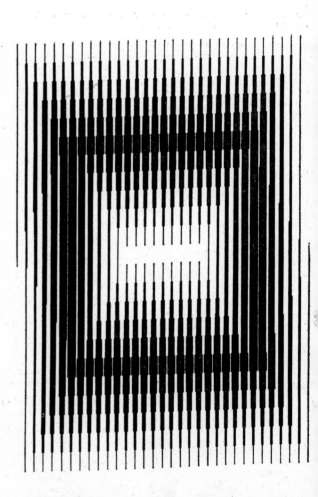

FIG 32
Jeffrey Steele *Divertissement* 1963, 30 × 22 in.
Private collection

particularly by the warping of their dark contours caused by the thin white chevrons. This is a classic textbook illusion known as the Hering figure or 'fan illusion' (fig. 31), where a square is distorted by superimposition on concentric circles. But the most striking feature of this picture is the irradiation which occurs on the midpoint of each side of the larger square and around the corners of the smaller one. This, of course, is produced by the converging of the bright lines. Anuszkiewicz, like Mavignier, builds up to the point of illumination, and this is probably the only way to secure the effect.

This seems an appropriate place to speak about the work of Steele, some of whose paintings are vibrantly luminous. *Divertissement*, for example, builds up an intensely luminous and pulsating centre which seems to lift and carry the square of darkness around it. There is a balance of tension between the expanding area of white and the contracting darker area. Unlike Mavignier, Steele does not allow the white to come forward or the black to sink back: he keeps the two in active equilibrium. This balance of tension is also evident in *Lavolta* (plate 20). The outward expansion of the white axes is checked by

the converging staccato lines, while these same lines seem to draw the black axes upwards. Other effects characteristic of periodic structures are also present: the whole picture seems to rotate about its centre and there is a pronounced flickering effect, probably caused by the 'echoes' of the dark axes which cut across the 'staccato' lines. Why precisely white areas should tend to expand and dark areas contract is not certain. It has been suggested that the eye is less selective in its response to white than to black and that eye movement may also play a part. About the fact itself there can be no doubt. Most people have experienced the difficulty of reading white type on black.

Before concluding this section a word must be said about Vasarely's use of irradiation. A straightforward example is *Metagalaxie* in which pools and haloes of radiant light balance each other and the effect spreads to the whole field which becomes luminous. As its name indicates, this painting suggests clusters of stars. The same effect is produced, but with somewhat reduced intensity, by *Supernovae*. As this magnificent picture contains almost every optical effect discussed so far and shows the use to which they can be put in the hands of a major artist, I shall analyse it in some detail. It is a periodic structure of the simplest kind: a grid of white lines, and a regular system of black squares. This in itself is sufficient to activate the whole surface. Additional impetus is given by the row of distorted squares or lozenges, turning in space and transforming the white grid into a white background. Lateral movement comes also from the black dots which grow in size to become black circles, or, as Michael Compton describes them, squares which become black discs and grow 'until they produce the intense blackness of a light which has suddenly gone out while one looks at it'. But the areas of most intense activity are in the upper part of the picture, areas of what might be described as active light and active darkness. Both areas are kept

in a state of tension. The dark area which is caused by the expansion of the black squares, is supported by them and hence does not sink backwards to become a deep well. It pulsates in unison with the area of light. The area of light in its turn, being the product of a stretching of the grid of white lines, is held back on to the surface, and does not burst outwards. Moreover, the areas balance each other as

FIG 33
Victor Vasarely *Supernovae* 1959–61, 95½ × 59¾ in. Tate Gallery, London

FIG 34
Single line moiré

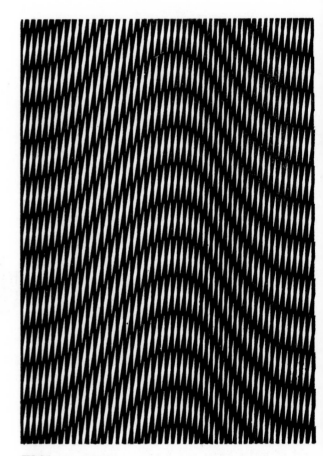

FIG 35
Gaussian curve moiré

mirror-images, and are counter balanced in the lower part of the picture by the white squares and black circles, which spread both the light and the darkness over a wider field. Finally, at the intersections of the white grid, faint after-images flicker and fade.

Supernovae obviously suggests the boundless darkness of space and the great galaxies which inhabit it. It does so, not by some literal representation of astro photography, but by acting on us in a way analogous to these phenomena themselves. But this picture should not be interpreted only in this sense. Vasarely has written:

Man is henceforth defined as a highly diversified summit of a material universe, in which every event, and therefore himself as well, proceeds from the wave-particle duality. An ambiguous world, enigmatic even, expressed in quanta by some, in plastic equivalents by others.

And again:

The artist can no longer be a familiar observer of beings and objects; he is involved by the very fact that he is a material albeit infinitesimal component of nature and, like a tree or a cloud, is drawn into the material whirlpool of energy and movement, time and waves.

In other words, looking at *Supernovae* is not like looking at an event as a detached observer but rather like being drawn into this event and forming part of it. We—the stellar galaxies and ourselves—become elements in that vast, complex, energized system, which embraces the infinitesimally small as well as the immeasurably great and is yet basically as simple as the black square or the white line.

FIG 36
Fresnel-Ring moiré

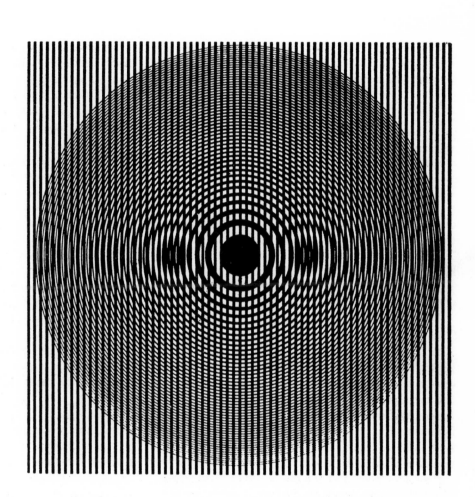

The moiré effect

'Moiré' is a French word meaning 'watered' and was first applied to fabrics known in English as 'watered-silk'. The water-like effect is produced by doubling a glossy fabric with a parallel weave so that the parallel cords are nearly aligned, and pressing the surfaces together. The same effect can be produced by superimposing two periodic structures—they need not be lines but there must be solid and open regions. The most spectacular moiré effects are those which have a sort of shock-wave or Gaussian curve (fig. 35) caused by the intersection of diagonal lines, or the Fresnel-Ring moiré in which Fresnel-zone-plates (where each ring is equal in area to the central spot) are superimposed on one another (fig. 36). Where the lines do not intersect, instead of a wave or rings, one gets 'composed beats'. Where a single line is placed across a system of parallel lines (fig. 34) the line appears to break at the point of intersection.

Gerald Oster, who has done an extensive study of moiré and has produced moiré works of considerable interest, offers the following explanation:

Apparently the eye is unable to resolve the intersection. When many parallel lines cross, as in the case of two overlapping grids, the eye unconsciously searches the field and ties together these preferred points of intersection.

But according to Professor Wright it is essentially a physical not a visual phenomenon: the intensity distribution can be calculated without reference to the eye. Moiré has practical applications in science. The moiré fringe magnifies the open areas and can be used as a microscope. Defects in replicas of grids can be detected by the presence of a moiré pattern, etc.

Most moiré works are reliefs or superimpositions. There are some moiré paintings by Schmidt and Neal. Sedgely's *Trace 7* (plate 21) is a cross between Fresnel-Ring moiré and the Gaussian curve. A series of concentric circles are cut by segments of concentric rectangles arranged in a sweeping curve across the canvas from upper right to lower left. The resulting moiré effect is a series of elegant shock-waves. We have three integrated movements: the apparent rotation of the concentric circles, the sweep of the 'curving' straight lines, and the moiré waves. Stanczak's *Nocturnal Interlude* is a good example of 'composed beats'. A series of vertical lines are placed slightly off alignment with the result that dark and light areas appear at fairly regular intervals—fairly regular, because the composition is intricate in comparison with a standard 'composed beat' moiré pattern. Though the moiré effect can be as easily obtained on a flat surface as in relief, the latter offer the possibility of a changing pattern as the spectator moves in front of them, and this presumably has induced more artists to use reliefs rather than flat moiré. It would be impossible to describe all the different aspects of moiré relief which has been done in recent years or

to mention all the artists working in this field. I shall, therefore, select a few of the best known.

Take first the lowest possible relief (hardly relief at all), that is, two superimposed surfaces. Among the artists who have produced interesting work of this kind are Vasarely, Cruz-Diez and Wilding. Vasarely began to make what he called 'Transparencies' as early as 1953, but the idea had occupied his mind since childhood. The transparencies consist of two identical patterns in black and white (sometimes one is the negative of the other) which can be superimposed and moved over one another. Since the upper sheet is made of transparent material, its pattern integrates with that on the sheet below and when they are moved ever-changing moiré patterns are formed. Vasarely has also made what he calls 'Deep Kinetic Works'. Though these are reliefs proper, they closely resemble, and operate in much the same way as the transparencies, except that instead of moving them, the spectator moves in front of them.

Cruz-Diez calls his superimpositions 'Transchromies' (plate 19). They behave in a way similar to Vasarely's, but since they are in colour the result is not merely a moiré effect but also a subtle change in hue and tonal value. Even the simplest composition—a system of interlocking circles superimposed on a similar structure—can give an incredible variety of patterns and colours: steel-blue, grey and silver, and a very cold pink.

Where Cruz-Diez creates delicate shades of colour, Wilding creates delicate patterns of minute lines. What is so remarkable about his work is that it is basically simple—two squares with radiating lines—and yet it becomes transformed into patterns of great complexity at the slightest touch. The reader has probably discovered this for himself by manipulating the cover illustration (*NR 27*). From almost classical simplicity it develops a great richness.

Turning to reliefs proper, the examples are so numerous that it is difficult to choose. It is difficult,

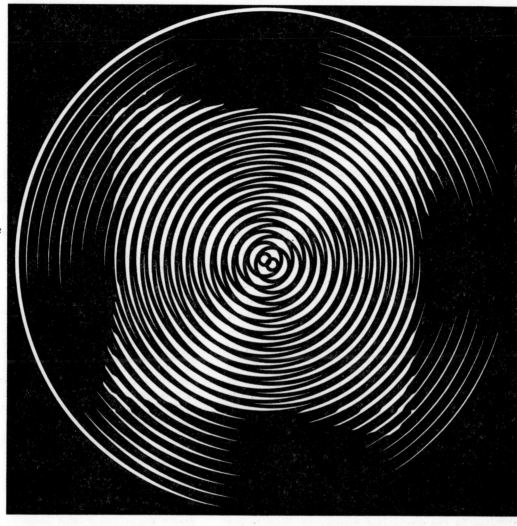

FIG 37
Victor Vasarely
Transparency 1953,
25½ × 19¾ in. Denise
René Gallery, Paris

too, to describe them even with the aid of photo-graphs, for obviously what is most interesting about them is the evolving, not the static, pattern. One can perhaps imagine how the pattern of Yvaral's *Inter-ference A* (plate 22) might develop: the petal rings unfolding as the black spots on the taut, curved white strings intersect with the black lines on the base. Here again one meets complexity of effect and simplicity of means, so characteristic of Op art, and the typical optical space, in which it is impossible to locate either the elements or their combined effects. Wilding's *Interference of Two Structures in Three Dimensions* (plate 23) starts out from a fairly intricate pattern of grids. The moiré waves which they

generate as the spectator moves in front of them are less immediately obvious. They act as a sort of orchestration. But in the long run they dissolve the regular pattern and bring an element of the un-predictable into what otherwise might appear regular and repetitive. Whereas simple periodic structures are unstable by their very simplicity and regularity, these compositions have sufficient complexity to maintain stability. It is the moiré effect which pro-vides the instability. If they are to work optically, movement is essential. Thus, the experience of the optical effect of these reliefs is of a different order from that derived from Op paintings.

For this reason, Soto regards his reliefs as Kinetic

rather than optical. As he put it, they *present* movement and time and the visual effects of movement, and do not merely *suggest* it. Nevertheless, Soto admits that the transformations and vibrations in which he is so passionately interested come about optically.

As we have seen, Soto began to use superimposed dots in 1954. Between then and 1957 he made a number of superimpositions, 'Kinetic Structures', composed of patterns of lines or squares of which *Spiral* (plate 27) is an excellent example. These sometimes produce a moiré pattern. In 1957 he made his first *Vibration Structure*, a very simple, almost crude, structure consisting of a moiré background—black and white lines evenly spaced—in front of which a few wires were stretched. The effect was something like that shown in fig. 34. The line of the wires appears to be broken as they cross the moiré background. If one moves in front of such a structure or if the wires are allowed to move, they seem to dissolve, and, in place of the solid ground and the superimposed wires, one sees a vibrating ethereal mist of light.

This use of moiré is far closer to Op painting (for all that it is in relief) than that of Yvaral, Asis and Wilding in the works just mentioned. Soto is not interested in pattern and indeed these works do not produce the moiré pattern of the Gaussian curve or Fresnel-Ring kind at all, as the earlier 'Kinetic Structures' did. With him, as with the artists we considered in the section on periodic structures, the forms are anonymous and are optically dissolved. Like these artists, he works with very simple elements, which in themselves are insignificant and uninteresting, but when brought together react on each other in strange ways. As he puts it, he is not interested in the relationships (rapport) between the elements as such (that is, the pattern they may form in combination) but in the effect which they produce when combined, which Soto calls their 'pure relations'. These relations are not strictly *between*

things. They take place in an indefinite, optical space: they act like light.

I use anonymous elements to emphasize the purity and sufficiency of the rhythm that may be revealed between them . . . Separately these things are nothing, but together something very strange happens. This is the sense in which I understand the 'immaterial'—a whole world of new meaning and possibility revealed by the combination of simple, neutral elements. Coming from the material it has immaterial existence, freedom, purity and precision.

and

My works keep their distance—the vibration is not felt as something tangible, as something that involves the body; it's purely optical, without physical substance. The elements I use, I use solely to realize an abstract world of pure relations, which has a different existence from the world of things. My aim is to free the material until it becomes as free as music—although here I mean music not in the sense of melody, but in the sense of pure relations.

This is what Soto means by the 'dematerialization' or 'transformation' of matter.

Since his first *Vibration* in 1957, Soto has produced many varieties of 'Vibration Structure' (plate 24). In some, metal structures hang in front of the moiré background. But more often movable rods, usually coloured blue, yellow or purple, as well as black and white, are suspended by almost invisible threads at various distances from the moiré screen (*Blue and Black Immaterial Curves*). Soto also uses black, white or coloured squares or rectangles placed in rows in front of the background. These he calls 'Relations'. Unlike the rods, they do not dematerialize as the spectator moves in front of them. Instead they flicker against the background, and seem to detach themselves from it and float away trailing their faint shadows (*Relationship of Contrasting Elements*, plate 28). In all these works the physical distance between the work and the spectator seems to dissolve. The work inhabits a world of its own as intangible as light itself.

3 Optical effects: colour

As we saw in the chapter on the historical background, an attempt to emancipate colour from its subservience to representational form can be traced back to Delacroix and the Impressionists. Though this was a development which took place within the art of painting itself, the scientific researches of M. E. Chevreul and O. N. Rood and others had some influence on it. In 1839 Chevreul published the results of his researches into the optical effects of colour in a book entitled *On the Law of Simultaneous Contrast of Colours and the Harmony of Coloured Objects*. Chevreul, as head of the dye laboratory at the Gobelin tapestry factory, had to answer complaints about the quality of certain dye colours. He found that, while in some cases the fault was due to defects in the dye pigment, in others—the loss of vigour of certain blacks—the Gobelin dye-stuffs were in no way inferior to those of other French factories. The fault was due, he discovered, to the juxtaposition of the blacks with other colours. This led him to make a more general investigation into the effects colours have on one another when juxtaposed. He found that in all cases the colours, including blacks and greys, modify one another. These discoveries were formulated in the laws of simultaneous, successive and mixed contrast of colours.

Simultaneous contrast

This occurs when two juxtaposed colours are viewed simultaneously. Each colour modifies the other in the direction of its own complementary. This can be most strikingly illustrated with black and white, which have the maximum contrast. A black square on a white ground looks more intensely black and a white square on a black ground more intensely white than either of them do if placed on a grey ground. What has happened is that the white modifies the black in the direction of its complementary (black), thus intensifying the black; and

the black modifies the white in the direction of white (the complementary of black) thus making it more intense. If, in place of the black and white squares, we place grey squares on a black and a white ground, we find that the grey on white is darker (modified in the direction of black), while the grey on black is lighter (modified in the direction of white) (plate 25a).

Before turning to the spectral colours, one other peculiarity of the simultaneous contrast of black, white and grey should be noted. If we look at a band of juxtaposed greys running from black and the darker greys at one end to the lighter greys and white at the other end, each segment will appear darker on the side nearest the white end and lighter on the side nearest the black end. This is not all. When looked at from a suitable distance, preferably in subdued light, the band will appear grooved or fluted like a doric column. The darkening and lightening effects in each segment appear as light and shadow, as though light from the white end were falling on concave surfaces.

Exactly the same thing happens when spectral colours or colours of the chromatic scale are juxtaposed, except that here the effects are not always easily determinable, nor is it easy to reach agreement as to which colours, even in a given context, are complementary to one another. However, with the use of black, white and grey, contrasts are relatively easy to observe. A yellow square on a light ground looks a dirty yellow (it has been modified in the direction of black); the same yellow on a black ground will look bright (it has been modified in the direction of white) (plate 25b). Grey on orange will look bluish, while grey on purple will look yellowish (in each case it is being modified in the direction of the complementary of these colours) (plate 25c).

So far only changes in the tonal value and saturation or chroma of the colours have been considered. If we compare a colour on its complementary and on two analogous or adjacent colours, that is, colours

adjacent to one another in the spectrum, can we detect a change of hue? Take a red, place it first on blue-green, its complementary, and then on the two adjacent colours, orange and purple. On the blue-green it is glowing, luminous and pure, since it is being affected in its own direction by its complementary (which also glows). On the orange it almost disappears and becomes faintly tinged with blue, taking on an appearance of pink. On the purple it also glows, this time with an orange tinge, but it is less pure than on the blue-green. (Plate 25d.) If we were to place it on blue it would take on a yellowish-red tinge; a blue on red would appear slightly greenish. And so on.

The relative areas of these colours, the presence or absence of white and black, the shape, texture and lighting, and the distance of the spectator from them will determine how the colours act on one another. For the effects to be noticeable the relationships between the colours have to be very carefully controlled. Even then it must be possible to compare a colour in one environment with a colour of the same pigment in another before one notices any change of tone or hue. Simultaneous contrast is used by all artists who are primarily interested in colour relationships, Albers, Bill, Lohse, Stella, Louis, Kelly, Noland, Poons, etc. There is nothing specifically Op about simultaneous contrast as such. It is only when it is combined with such things as periodic structure that it contributes to an optical effect.

Anuszkiewicz's *Union of the Four* (plate 29) is an example of how simultaneous contrast can intensify a periodic structure. It is composed of a grid of horizontal, vertical and diagonal lines on a uniform red ground. That the ground is uniformly red is more than an assumption, since it is possible, though with some difficulty, to compare the reds on different parts of the canvas by the eye alone. The grid, however, is not uniform in colour. It is partly blue-green, partly yellow-green and partly violet. As a result the red appears differently in different parts of

the picture. It is at its most intense in the presence of the blue-green lines, at its least intense where the lines are predominantly yellow-green, and slightly orange where there is violet. Because of the intricacy of the structure the eye travels rapidly over the surface. As a result the red seems to be continually changing in colour and so do the lines. What is more, although the violet forms four squares within a square, these shapes do not remain stable: they are continually broken up by the continuous change of colour.

It is hard to say whether this is merely simultaneous contrast or successive and mixed contrast as well. These other two can certainly produce noticeable optical effects.

Successive and mixed contrast

Successive contrasts were defined by Chevreul as 'the phenomena which are observed when the eyes, having looked at one or two objects for a certain length of time, perceive, on turning them away, the images of these objects, having the colour complementary to that which belongs to each of them'. Successive contrast is, in fact, after-image. It is not altogether clear why this is called 'contrast'; what is being contrasted with what? the after-image with its source or with the ground on which it lies? Presumably with its source, but if the colour is strong enough, the after-image will be positive, that is, the same colour as its source. Psychologists explain this phenomenon by saying that continued exposure to one colour decreases sensitivity to that colour and enhances sensitivity to the complementary colour which is present in the light reflected from the ground against which the after-image is seen.

If a green square is placed on a grey or white background, and looked at for some time, it will develop a pink edge (simultaneous contrast). If the gaze is then transferred to the background, a luminous pink square will appear (successive contrast).

If, on the other hand, the ground is of some colour other than grey or white, the after-image will appear as a combination of the complementary of the original colour and the ground colour. Thus the blue-green after-image caused by staring at a red square will appear greenish-yellow if seen against a yellow ground. This is known as 'mixed contrast'.

The optical mechanism at work in simultaneous, successive and mixed contrast seems to have something in common. Prolonged concentration on one colour decreases our sensitivity to that colour while sensitivity to light of the wavelengths of the complementary colour is unimpaired or enhanced. The difference between the three is that in simultaneous contrast the gaze is not noticeably shifted from one area of colour to another nor is it directed exclusively towards one colour and then turned towards another. There is mutual interaction but little or no positive awareness of an after-image. In successive and mixed contrast, on the other hand, where there is prolonged concentration on one colour and then a shift of gaze to another colour, the presence of the after-image becomes discernible. Successive and mixed contrast differ only in the nature of the ground, which in one case is white or grey, in the other chromatic colour.

Chevreul was quick to see the practical applications of all this. If a draper or buyer submits his client to a succession of red stuffs, the red will appear progressively duller as the blue-green after-image builds up. If scarlet or orange stuffs are displayed after a succession of yellow, the bluish after-image of the yellow will tinge them and they will appear crimson or amaranth-red. If, on the other hand, reds are alternated with greens, both will appear more brilliant, and so on.

It is sometimes forgotten that the process of successive and mixed contrast is cumulative, not static. A colour once modified will then produce modifications as a result of its new state, and thus a chain reaction of contrasts and changes will occur.

Artists are aware, either fully consciously or implicitly, of the effects of contrasts of colours from the moment they begin to use paint. There is probably only a difference in degree between the extent to which Op artists and other artists who are primarily interested in colour are prepared to exploit these effects. It is not even the difference between a dynamic and a static use of colour. The colours in an Albers, a Louis, a Bill or Stella are far from static. But, whereas these artists seldom allow the effects of contrast to disrupt the surface structure, Op artists do.

By using colour contrast with great economy and simplicity, the Op artists can attain a high degree of subtlety and complexity in colour relationship. Two or three colours can give the impression of a wide range of tones and hues. Indeed, the resulting range is greater than anything mixed pigment can offer. Moreover, working with the optical effects of colour is like using another medium. For one thing, optically induced colours have a greater delicacy than pigment colours, greater even than watercolours or thin oil washes. The colours seem to hover about the surface of the canvas like light. They do not lie on it in the way pigment ordinarily does. They also have the luminosity and translucency of light itself. On the other hand they are more manageable than projected light, since projected light usually plays over a large surface, whereas the area of optically induced colour can be precisely controlled.

Some of Bridget Riley's recent paintings such as *Late Morning* and *Chant* are excellent examples of this. *Chant II* (see the preliminary sketch, plate 30) is utterly simple, almost banal, in its composition. It consists of a periodic structure of primary red, white and primary blue vertical stripes. The pigment colours are identical throughout the picture, but only a close examination would reveal this. Viewed from a suitable distance it seems to glow with violet and orange; these colours are shot through with brilliant blues and reds; the white becomes tinged with pale

yellow or blue-green. Groups of the stripes seem to pair off across the canvas and the whole is in continuous movement; expanding, contracting, advancing, receding, bending and twisting. One is forcefully reminded of the glowing colours in the windows of Chartres. All this is achieved in the simplest possible way. The bands of colour are alternately red–blue–red and blue–red–blue. They vary in width from narrow at the sides to broad in the centre, with the whites remaining constant. Where the lines are thinnest, the colours tend to fuse and produce either violet, if the blue predominates, or scarlet, if the red is dominant. To get these effects the picture must be viewed at various distances, even from some feet away. The larger bands alternate between brilliant reds and blues, or orange and turquoise. Simultaneous and mixed contrasts are at work here. The red tends to affect the blue with its complementary, blue-green, and the blue to affect the red with its complementary, yellow. But a contrary reaction seems to set in as soon as the eye becomes accustomed to these effects. The yellow-tinged stripes now influence the green-tinged stripes in the direction of blue (their complementary), making the blue momentarily quite brilliant, while the green-tinged stripes influence their neighbour in the direction of red, thus momentarily intensifying the red. The yellowish and greenish tinging of the white is probably due to simultaneous contrast with the reds and blues when they are intense, and a spread of their after-images when they are modifying each other. The whole process, as I have said earlier, is cumulative: a chain-reaction of contrast and counter contrast is taking place, and this sometimes results in an explosion of colour right across the picture.

Spectacular though these effects are, they are outdone in richness and subtlety by another of Bridget Riley's recent works, *Late Morning*. There are eleven colours in this work: red, blue, green and eight hues between blue and green—blue-green, turquoise, etc. A detailed analysis of the interaction of these colours would be very lengthy. It must suffice to say that their combined effects range from a clear, cool brightness towards the edges to a golden haze at the centre, the lights of late morning. The gold comes partly from the yellow in some of the greens, but more particularly from the faint yellow after-image produced by the blue. Once again attention must be drawn to the control which is exercised over these effects. The steps in the scale between blue and green are used to mediate between these two colours and no optical effects are allowed to develop in isolated pockets; all contribute to the total combined impression. David Thompson justly says of it:

Late Morning has a majestic presence which is concentrated in one tremendous effect of disembodied colour gathered like an emanation of force across the centre of the painting. Structurally it is elaborate and highly disciplined. Perceptually, it has a clear, classical unity.

Optical colour mixture

We have already seen that the effects in Bridget Riley's work are not all due to contrast. In some cases the colours tend to form mixed colours; the reds and blues produce a violet. We saw the same sort of thing happening in Anuszkiewicz's painting. This seems to occur where small amounts of colour are used and it is probably a case of colour mixture or fusion such as is met with in a photographic cliché. Under certain conditions these fused colours can spread into a surrounding area, as, for instance, into the white in *Chant II*.

There is an interesting feature of this effect which has been noted by some psychologists. If a blue, for instance, is juxtaposed with white the overall impression is that of light blue; if it is juxtaposed with black, the overall effect is dark blue. A closer examination of the blues will reveal that the blue in proximity to white is duller than that of the blue in

the proximity of the black. If still more black is used, though the overall impression is that of a still darker blue, the areas of blue themselves appear more intense (plate 26a). (It is possible, even with the unaided eye, to see, on very close inspection that the blue is in fact the same in all cases.) The intensification of the blue may be attributed to simultaneous contrast and the overall effect to spread or colour mixture. Both, however, cannot be observed at the same time, and, of course, without different areas for contrast, such as we have in plate 26a, neither feature would be noticed. To see the same blue as now light, now dark, there must be something with which to compare it, something that it can be lighter or darker than.

Chevreul seems to have left optical colour mixture out of account altogether, or to have understood it imperfectly. In any case his investigations did not take scientific optics sufficiently into account. In this respect Ogden N. Rood's *Modern Chromatics* was a considerable advance on Chevreul's theory. What neither they nor most writers on colour have realized is that there is an essential difference between colour contrasts and colour mixture. Colour mixture takes place at a later stage, so to speak, or, better, at a greater distance. Once the spectator has reached a certain distance, instead of colour contrast, fusion or mixture begins. It must be added that mixture, to be effective, requires repetition of comparatively small areas of colour with the colours limited to two or three.

Colour mixture may be of two kinds: overall mixture or individual colour shifts. In overall mixture the colours fuse to form a single colour, intermediate between the two in hue and tonal value. Thus red and blue will mix to form a purple which is duller than either of the original colours (plate 26b). In individual colour shift or colour induction a single colour is affected in such a way that it appears quite different when viewed close to, but without loss of tone. A primary red may be made to look a strong magenta when in the proximity of a cobalt blue or orange in proximity with a malachite green. Pink in the presence of grey may be made to look yellow, white in the presence of yellow to look violet-blue, and yellow to look white or a dingy grey-pink in the presence of purple-blue.

Part of the effect of Bridget Riley's *Chant II* must be due to a combination of simultaneous contrast and colour mixture. Where the lines are broad, simultaneous contrast takes place; where they are thinner, optical mixture. Of course, if one stands back far enough, all the lines will mix.

An interesting example of the use of optical colour mixture is *Perm 4* (plate 34) by Sidney Harry, who has made considerable advances in this field and has recently begun to apply his discoveries to painting (I am indebted to him for making his hitherto unpublished research available to me). In this painting only three colours (orange, slightly blue-green and light purple) and black are used. Yet, with only these four, twenty-four overall colour mixtures—noticeably blues and pinks—and innumerable individual shifts, can be obtained. By arranging these twenty-four permutations concentrically an even greater number of effects is produced, since each permutation can act on its neighbour to effect further colour changes. Thus, as the spectator moves away from the picture, the colours change, fuse or shift, quite perceptibly. Harry refers to this as 'mobile colour'. In the next chapter we shall be considering works which change in colour as the spectator moves laterally in front of them. But these colours themselves often do not change; they merely appear from or disappear behind projecting slats of wood or plastic. In Harry's picture the colours themselves change, change continuously and spectacularly, glowing like jewels with an inner flame. The work unfolds and develops by the changing position of the spectator according to a logic of its own.

Growth and decay of colour

Besides colour contrast and colour mixture, another aspect of colour perception may be relevant to Op art, namely, the varying rates of growth and decay of different colours. The retina is not equally sensitive to all colours. (The periphery is much less sensitive to colour.) According to Luckiesh, blues rise very rapidly and overshoot their steady value. Green is the most sluggish. This is easily demonstrated by spinning a colour wheel. As the wheel gathers speed the colours begin to mix. At a certain speed they become a muddy grey. Given the right composition and speed, they may even appear white. This form of optical colour mixture has been used by Sedgley. One reason for the mixing of the colours (though others are possible) seems to be that the rapidly rising colours overtake and mix as light with the more sluggish.

The phenomenon of different rates of growth and decay may explain the appearance of faint spectral colours in certain black and white periodic structures such as Bridget Riley's *Current* or Ludwig's *Cinematic Painting*. Here I am extrapolating from what happens when a black and white disc, such as a Mason disc, is rotated. At an optimum speed and under favourable lighting conditions, coloured rings varying from reddish chocolate to blue-green will appear. Luckiesh in his book *Visual Illusion* says of this phenomenon:

The complete explanation of the phenomenon is not clear, owing to the doubt which exists concerning many of the phenomena of colour-vision, but it appears certain that the difference in the rates of growth and decay of the various colour-sensations (the white stimulant includes all the spectral hues of the illuminant) is at least partially, if not wholly, responsible.

If this is so, then it may be that the same explanation may cover the phenomenon as it is experienced in static works. Although the structure itself does not move, the eye movements induced by the repetition of identical forms is so rapid that the white light gets broken up and the spectral hues are separated according to the rate of their growth.

The different rates of growth and decay may also explain the phenomenon of advance and recession of certain colours which artists have to contend with, and which Op artists exploit. It is generally held that red tends to come forward and blue to recede though this depends a great deal on their background. A judicious combination of advancing and receding colours, such as the purple and orange lines of Stanczak's *Localized Sound* or the targets of Fangor and Sedgley accelerates the rate of pulsation of a periodic structure. So many factors are involved in this phenomenon, however, that it is perhaps unwise to concern oneself with an explanation. The phenomenon itself has been called in question. Not all spectators observe it, and some see recession where others see advance. Where the pupil of the eye is decentred outwards, red advances; where it is decentred inwards blue advances. It is a matter of geometrical optics linked with chromatic abberation of the eye.

Tone

One other feature of Op art calls for discussion, and this is probably as good a place to deal with it as any. This is the use of tonal variation. Tonal variation can have the same sort of effect as slight alterations in the size or position of the units of a periodic structure. The easiest way to demonstrate this is to take a painting like *Deny I* by Bridget Riley (plate 31).

Deny I consists of regularly spaced ovals lying along a rectilinear grid. The orientation of the ovals varies and this sets up a movement—a structural movement—in the painting: the ovals seem to swirl and eddy about the surface. But the ovals also vary in tone from light to dark grey. This in turn sets up another kind of movement, a movement in depth.

The lighter ovals, standing in strong contrast to the blue background, seem to lie nearer the surface of the picture; the darker ovals merge with the background and seem to sink into it. And the background itself seems to vary in depth, sinking with the darker ovals and coming forward with the lighter ones. There is also a change of colour. Where the greys are darker, the blue is more prominent and slight variations in tone produce quite marked changes in the colour. Where the greys are lighter, the blue is darker and not so prominent. This is due, presumably, to simultaneous contrast.

The use of tonal variation thus makes it possible to play off two types of movement against one another: tonal movement against structural movement. Bridget Riley refers to these as two different tempi. The tempo of the tonal movement can be varied according to the number of steps or gradations of tone. Black, mid-grey and white is a fast tempo in three beats; black, dark-grey, mid-grey, light-grey, and white is a slower tempo of five beats; and so on. The gradation need not range from black to white, but could be confined to the greys themselves. She has recently done a series of prints using nineteen greys.

Vasarely has also, in his more recent paintings, been taking into account the optical effects of tonal variation. *CTA 102 no. 4* (plate 36) is a very remarkable example. The reds at the heart of the picture glow like fire, while the reds at the edges take on a metallic sheen. It requires a very close examination of the picture to see that they are darker shades of red and not metallic paint. Presumably the simultaneous contrast of the complementaries, red and blue-green, play a part in producing this effect, but it is not clear precisely how they act on one another. Their reaction has become complex and subtle as a result of the tonal changes.

4 Reliefs, moving objects, light

Although we are mainly concerned with static optical works on a flat surface, some mention must be made of those forms of optical art which involve movement or the use of light. Though there may be important differences between these kinds of optical art, it is impossible to draw a clear boundary-line between them. In fact, when discussing the moiré effect, I was forced to say something about reliefs. The present chapter, however, will be nothing more than a brief survey of the different kinds of optical effects which can be obtained by reliefs, three-dimensional structures, moving objects and light.

Reliefs and three-dimensional structures

Under this heading are included relief structures which appear to change as the spectator walks in front of them and reliefs in which reflective surfaces are used.

The first kind of relief is most closely associated with the names of Agam and Cruz-Diez, though works by such artists as Leblanc, Goodyear and Costa must also be mentioned. The principle feature of these works is that they are composed of independent units in low relief placed close together so that their appearance continually changes as the spectator walks in front of them. Historically, this idea can be traced back to El Lissitzky's *Abstract Gallery* of 1926–7 which had thin strips of metal protruding a few inches from two of its walls. These strips were painted black on one side and white on the other. The wall appeared to change from black to white through various shades of grey as the spectator moved towards it. Unlike Lissitzky, Agam uses wedge-shaped units. These are painted in such a way that when the spectator looks at the work from one end, it displays a pattern totally different from that which is seen from the other end. Agam referred to these as 'contrapuntal'. In the simplest 'contrapuntal' work only two themes are used. They appear independently at each end of the work. As one moves towards the centre the second theme gradually emerges and at the centre the themes fuse. As one moves on towards the other end, the first theme begins to disappear. Where the themes can be identified throughout, the work is called 'polymorphic'. Where the number of themes is too great for them to be separately identified, the work is referred to as 'metapolymorphic'. *Homage to John Sebastian Bach* (plate 33) is 'metapolymorphic'. The integration of themes is so complete that an analysis, though rewarding—especially in following the rhythmic rise and fall, disintegration and re-grouping of forms—would be far too lengthy. *New Sol-Fa* passes from geometrical shapes on a blue ground to horizontal bands of alternate black and spectral colour. It is easy to identify the geometrical shapes—red oval and rectangle, green oval and triangle, etc.—as far as the frontal position, and even then they are still just about discernible. It is even easier to follow the emergence of the horizontal bands. The subsidiary theme of vertical spectral colours which change to white verticals with coloured patches is equally easy to follow.

The overall effect of moving in front of these pictures is that of an ordered confusion. The eye is baffled by the increasing complexity of dissolving forms and the disappearing or emerging themes, and yet the mind dimly perceives the presence of order and structure. It is only when the eye is baffled at the point of optimum fusion, however, that anything like an optical effect takes place; at the extremes, the themes assert themselves too strongly. The forms are not optically dissolved as they are in Soto's structures. They are merely broken up or displaced physically.

In this respect Cruz-Diez's structures, 'Physichromies' (plate 35) behave quite differently. The optical effect is unquestionable. Like Lissitzky, Cruz-Diez uses thin parallel stips instead of wedges. It is never possible, as it is with Agam, to see distinct themes: themes merge into one another. Nor is it

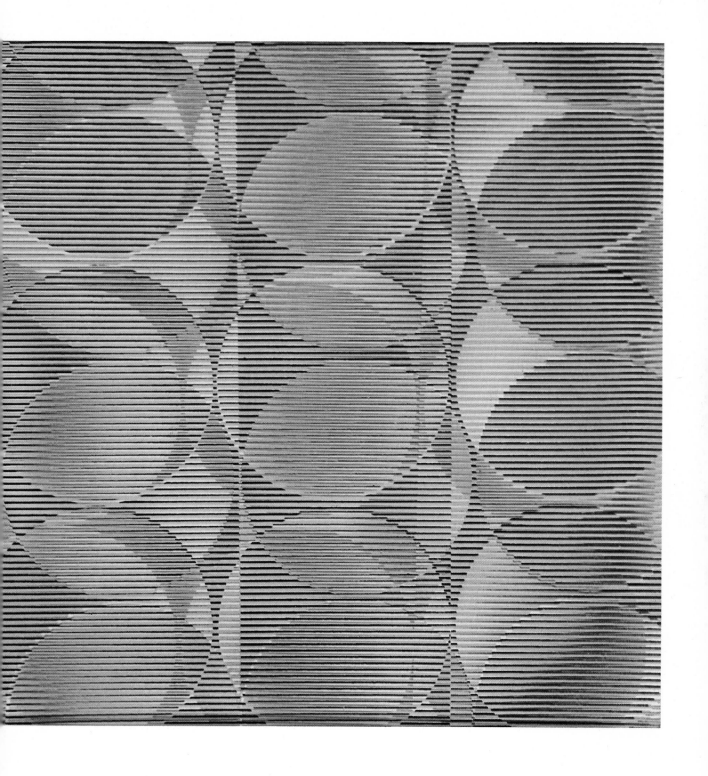

19 Carlos Cruz-Diez *Transchromie* 1965 $10\frac{1}{2} \times 11\frac{3}{8}$ in.
Signals, London

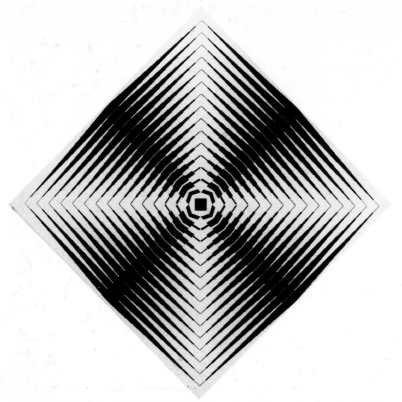

20 Jeffrey Steele *Lavolta* 1965
57 × 57 in.
Artist's collection

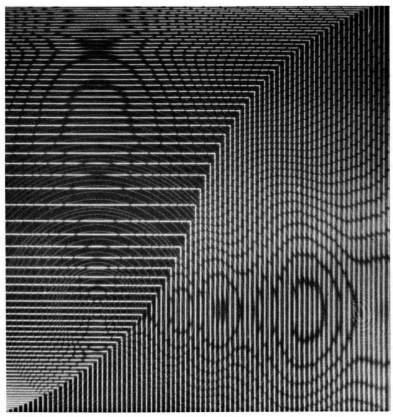

21 Peter Sedgley *Trace 7* 1964
63 × 63 in.
Private collection

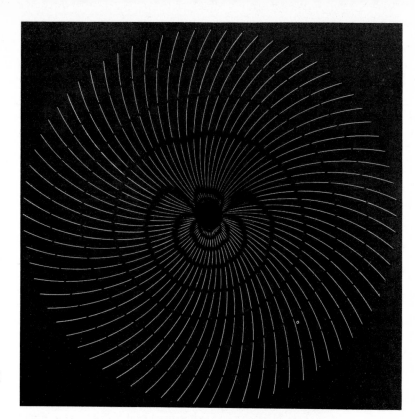

22 Jean-Pierre Yvaral *Interference A*
1966 47¼ × 47¼ in.
Denise René Gallery, Paris

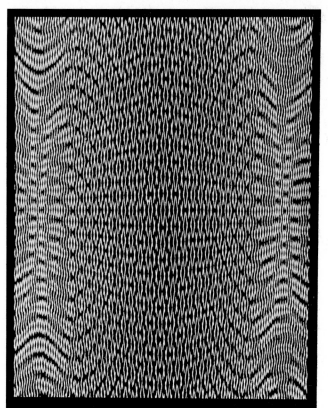

23 Ludwig Wilding *Interference of
Two Structures in Three
Dimensions* 1963 plexiglass, wood,
acryl 31½ × 25½ × 4¾ in.
Artist's collection

24　J.–R. Soto
Vibration Structure 19[
Denise René Gallery, Pa

A

B

C

D

25 Colour contrasts

26 Colour mixture

A

B

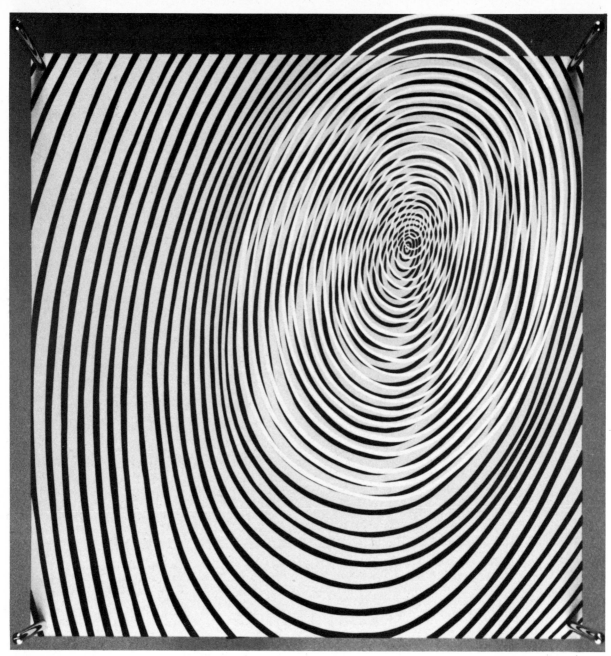

27 J.–R. Soto *Spiral* 1955 15¾ × 15¾ in.
Denise René Gallery, Paris

28 J.–R. Soto *Relationship of Contrasting Elements* 1965 62½ × 42 × 6 in.
Tate Gallery, London

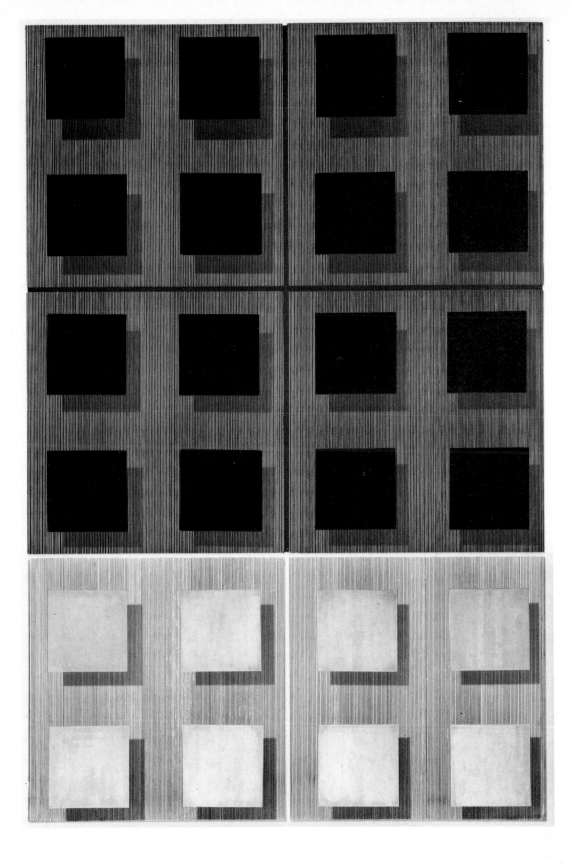

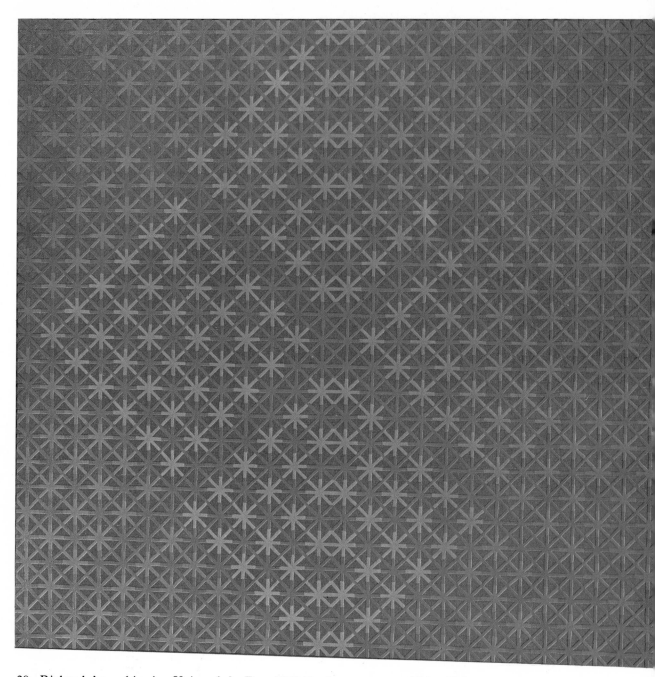

29 Richard Anuszkiewicz *Union of the Four* 1963 liquitex on canvas $52\frac{1}{2} \times 50$ in.
Collection Mrs Frederick Hilles, New Haven, Conn. Courtesy Sidney Janis
Gallery, New York

30 Bridget Riley *Study for Chant 11* 1968 $91 \times 90\frac{3}{8}$ in.
Rowan Gallery, London

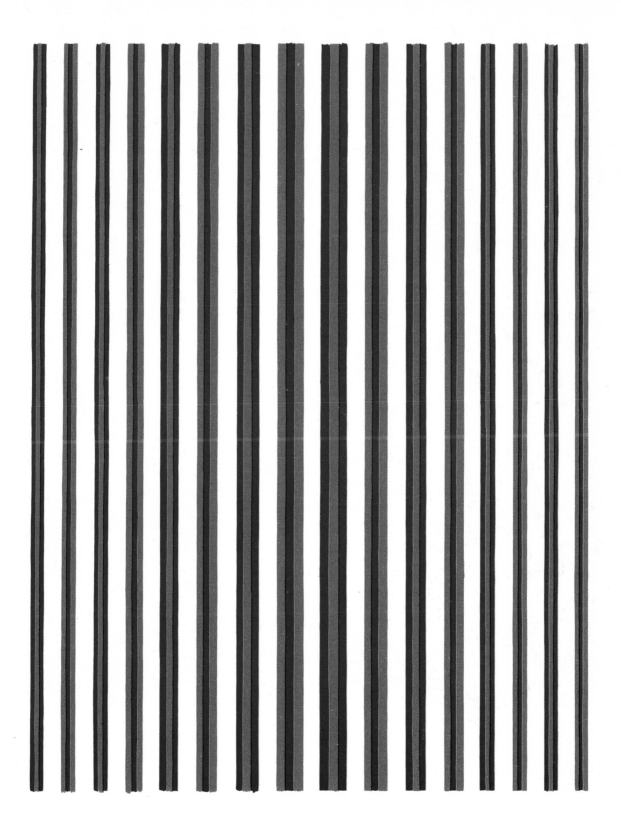

31 Bridget Riley *Deny I* 1966 85½ × 85½ in.
 Albright-Knox Gallery, Buffalo

32 Narcisco Debourg *Perception* 1967 painted
 wood $36\frac{5}{8} \times 36\frac{5}{8}$ in.
 Denise René Gallery, Paris

33 Yaacov Agam *Homage to John Sebastian
 Bach* 1965 $28\frac{3}{4} \times 66\frac{1}{4}$ in.
 Peter Stuyvesant Foundation, South Africa

34 Sidney Harry *Perm 4*
1967 18 × 18 in.
Artist's collection

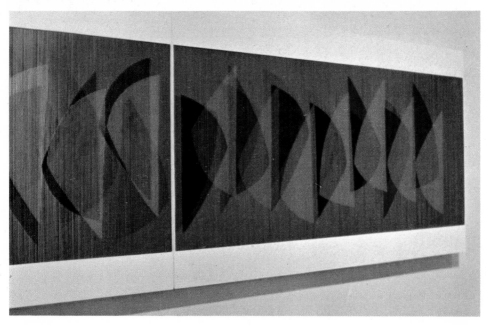

35 Carlos Cruz-Diez
Physichromie no. 196
1965 $115\frac{3}{8} \times 31\frac{1}{2}$ in.
Signals, London

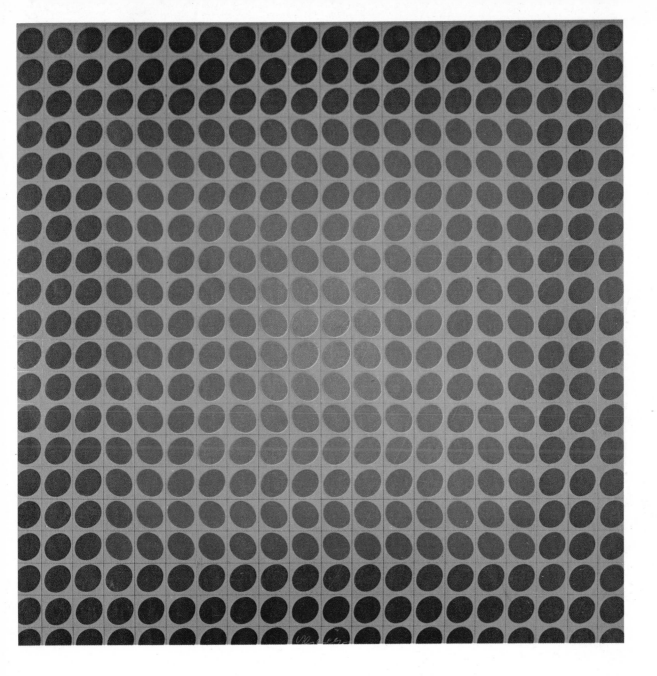

36 Victor Vasarely *CTA 102 no. 4* 1966 28 × 28 in.
 Editions Alecto, London

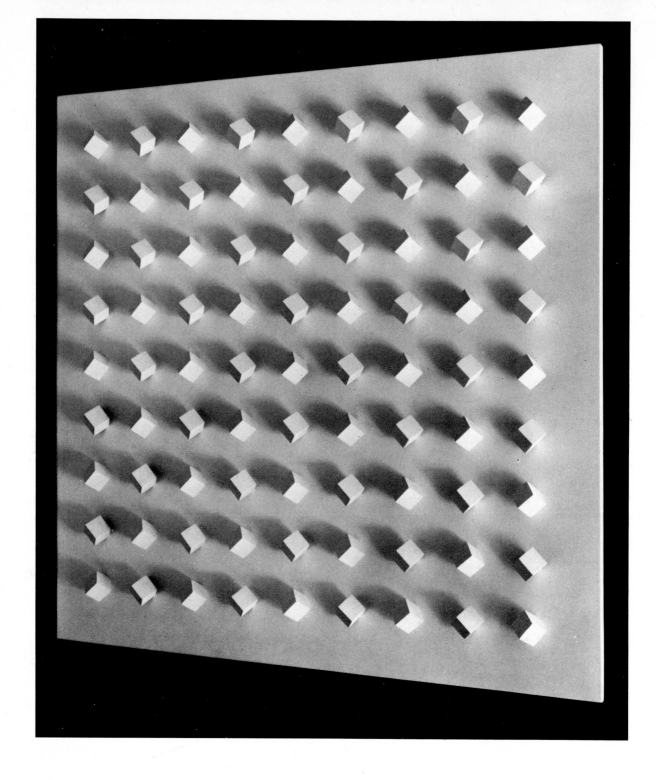

37 Luis Tomasello *Reflection no. 47* 1960 $47\frac{5}{8} \times 47\frac{5}{8}$ in.
Denise René Gallery, Paris

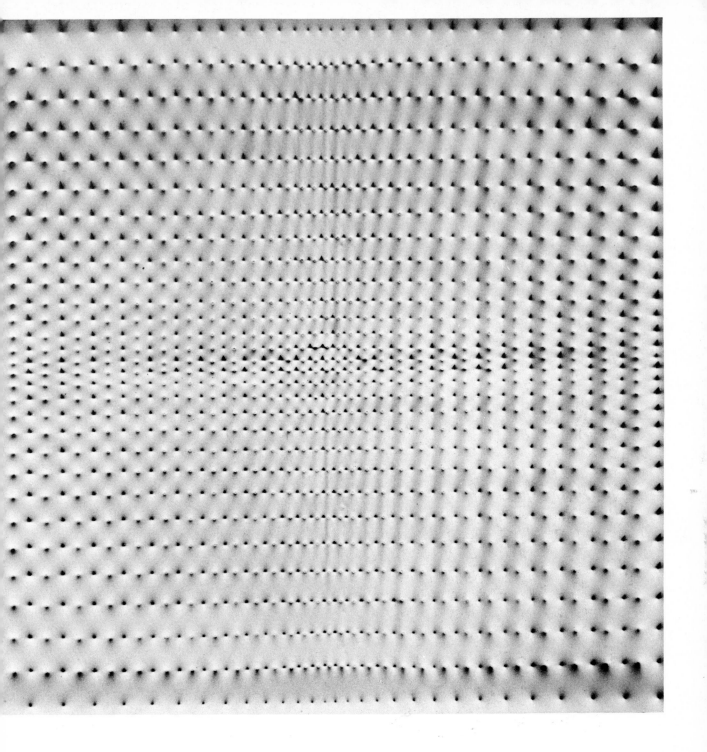

38 Enrico Castellani *Divergent Structure no. 4* 1966 31 × 31 in.
Betty Parsons Gallery, New York

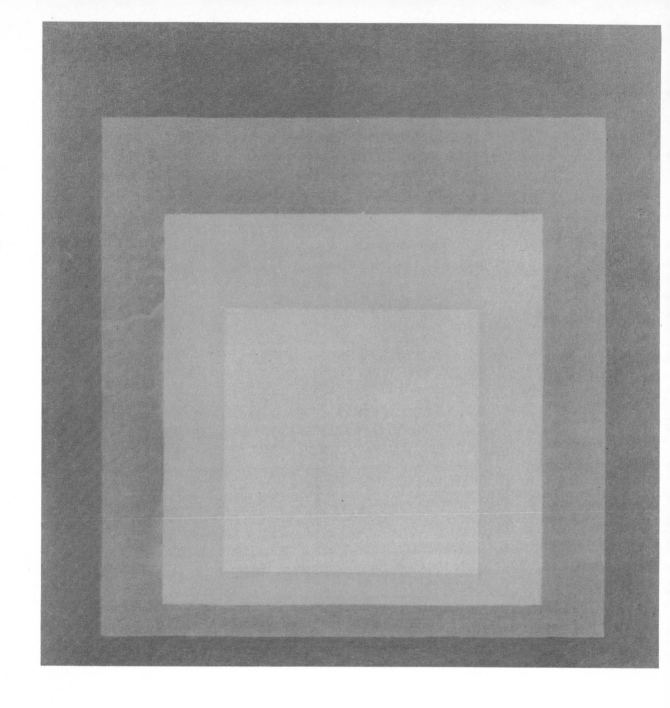

39 Josef Albers *Departing in Yellow* 1964 30 × 30 in.
Tate Gallery, London

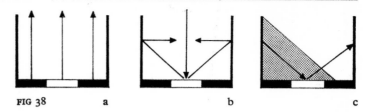

FIG 38 a b c

possible to see distinct colours: each colour imperceptibly shades into the next. A work by Cruz-Diez has one important characteristic of optical art: it is impossible to locate the elements physically in space. These works are in fact periodic structures in depth and have the optical effects of such, but the addition of depth increases the complexity of the work. Instead of a pattern of colours on a plain surface, we have three interrupted colour patterns, one on each side of the strips and one on the background space between them. The movement of the spectator accelerates the process of breaking up the forms and adds to the optical effect. One other feature of Cruz-Diez's 'Physichromies' which deserves notice is the effect of light on the painted surfaces. Light is reflected from the strips on to the background and from the background on to the strips, and it is this which brings about the optical colour mixture. (It is probably reflected light which is responsible for the 'spread' of colour in Bridget Riley's pictures.)

Cruz-Diez speaks of additive, subtractive and reflected colours. (He uses 'additive' and 'subtractive' in a slightly different way from the usual one explained on page 96.) The 'additive' colours are those which are reflected from the background and mix optically some distance from the work (fig. 38a). The 'reflected' colours are those which are caused by the light striking the walls of the protruding strips (fig. 38b). The 'subtractive' colours are those which result from the light passing diagonally through transparent strips of colour. This becomes effective when the spectator views the work from an oblique angle (fig. 38c). More will be said about this last kind of colour when discussing Cruz-Diez's artistic development in a later part of the book. Cruz-Diez uses colour spatially, that is to say, he makes colour operate in space, noticeably so. As he says, 'Colour placed on an object is dead. Projected into space, it is alive, rich, varied and vibrant.' Cruz-Diez achieves by means of his 'Physichromies'

G

precisely what the Impressionists and Neo-Impressionists were striving for: vibrant colour.

The play of lights on the surface and the diffusion of very subtle tinges of colour is an important feature in the work of a number of artists. Debourg was one of the earliest to use it. He made regular grids of projecting cylindrical wooden pegs mitred at the ends, thus exposing an oval face as in *Perception* (plate 32). These faces were orientated in various directions so as to catch and deflect the light and create a tonal pattern (bright when the face caught the light, dark when it was turned from it).

Tomasello's *Reflection no. 47* (plate 37), consisting of differently orientated cubes also arranged in a grid-formation, is a more rigid periodic structure than Debourg's, and as such acts more optically in the narrow sense in which I am using the word. As he says himself:

The repetition of the same element following a serial order . . . produces an optical sensation of movement, and in some cases this sensation is enriched by the introduction of ruptures (changes of rhythm) produced by the simple displacement about their axes of some of the elements.

Secondary structures are formed by the shadows of the cubes. The cubes also reflect coloured or white light according to the direction from which the illumination falls. Tomasello has said of his work:

the main event has been that of fixing colour upon a real plane . . . The forms I use are spatial, but they are subordinated to the plane on which they are located and from which they operate in the direction of the spectator . . . The colour on the internal face of the cube, attached to the plane, creates reflections on its surface and radiates an atmosphere of chromatic luminosity. *Colour is projected by form and vision becomes sensation.*

Tomasello creates what he calls a 'spatial surface'. Op painters dissolve the surface of their pictures; he dissolves the three-dimensionality of his reliefs. Op painters use optical effects to achieve their end; he

uses light. The result is very similar. It might be added that, although working in relief, the visual effect is like that of a painting.

The same may be said about the work of Camargo, who like Tomasello uses painted blocks, usually white and cylindrical, on a monochrome white surface and of Uecker who uses nails painted white, and Castellani who stretches monochrome canvases over grids of nails. (*Divergent Structure no. 4*, plate 38.) An additional impression of movement is given to Uecker's work by the arrangement of the nails in whorls and eddies. (In some cases the base is made to rotate.) *Spiral* (plate 40) is similar in feeling to those circular paintings which were considered in an earlier chapter. The use of nails and consequently of long shadows gives to this work a cross and counter movement that becomes more complex as the work or the light-source is moved. But one must not over-emphasize the optical effects of these works. The end result may be similar to that of Op painting but the means are different: in the one case it is an impression of luminosity caused by the action of the painting on our optical mechanism, in the other it is light. What is perhaps correct is to say that these reliefs should be regarded as optical paintings are, and not as three-dimensional objects.

The effect of light reflected off surfaces is carried a stage further by reliefs made of highly polished metal. Here again we encounter a dissolution of the surface, but this time it is more startling and more complete. As one walks in front of these reliefs when a strong light is directed on to them, it is not merely difficult to identify the surface elements but impossible. The work appears to have no solidity or any definable position in space but to be wholly composed of light. And it gathers up into itself the colours and forms of its environment and transforms them too. Further defraction of the surface is produced if, as in Mack's *Light Dynamo* (plate 41) engraved glass or electrically charged air is placed in front of it and it is made to rotate.

These effects are optical in the broader sense, but they can also be combined with and help to create the sort of optical effects found in Op painting. For instance, Alviani arranges flat strips of aluminium with semi-circular traces on a flat surface. As the light strikes them at different angles some of these strips appear concave, some convex (*Surface of Vibrant Texture*, plate 42). As in Op painting the location and nature of the surface is called in question, and in an attempt to come to terms with what it sees before it, the eye creates an optical space.

The combination of polished metal or some other reflecting surface, or lenses with periodic structures of parallel lines or concentric circles brings these light-reliefs even closer to Op painting. This is very obvious in Le Parc's *Double Movement by Displacement by the Spectator* (plate 43) where hidden lines appear in a distorted form on curved reflecting surfaces. In Levyeka Dadamaino's *Optical-Dynamic Indeterminate Object* the lines are visible but they nevertheless merge with their reflections. Martha Boto's *Luminous Polyvision* (plate 44) is a more subtle version of this principle. Here the lines are incised in metal so that they become visible only as shadows. As such they are indistinguishable from their reflections and the whole surface is thus destroyed optically. The dissolution of surface structures can also be effected by the use of lenses as in Gerstner's *Lens Picture* (plate 45) or *Optical-Dynamic Structure* by Gruppo N. By placing a system of lines behind a distorting lens the most startling, and indeed startlingly beautiful, effects can be obtained by the slightest movement of the spectator. Megert achieves similar results by using fragmented mirrors and 'zoom' mirrors, which not only distort the reflected image but also magnify or reduce it as they swoop on the spectator or suddenly retreat.

Mention must also be made of certain three-dimensional structures in plexiglass by Sobrino,

Lamis, Levinson and Stevenson, even though their effects are not optical in the restricted sense in which I have been using the term. They have this much in common with optical works that they so capture the light as to make it dissolve their own structure and radiate light from within. The use of polaroid substances by Olson and Salvadori also deserves mention for much the same reason. Though the effects of polarization are due to the refraction of light rather than to the effect on the eye or brain of certain structures, they resemble the effects of optical works in the way their own colour or the colour of objects placed behind them dramatically changes at the least movement of the object or the spectator. Structures spun out of plastic threads, such as constructions by Gabo, Pevsner or Sue Fuller also resemble optical works in the restricted sense. Though they have more to do with space and interior volume than the works hitherto considered, they have a way of dissolving and vibrating in light. One might say that in their case the solidity of volume is destroyed in a way similar to that in which the surface is destroyed in optical paintings and reliefs.

Moving objects

If these last constructions which we have been considering may be said to destroy volume optically, certain moving objects can be said to create it optically. But the end result is much the same since optically created volume is even more ephemeral than optically dissolved volume. Here again I am using 'optical' in a broad sense.

An optically created volume in the restricted sense would be one produced by spinning, say Duchamp's *Rotating Glass Plates* or his *Rotary Demi-Sphere* or 'Rotoreliefs'. Here glass strips, like propeller blades, or flat discs covered with eccentric circles, take on a solid, conical appearance when rapidly rotated. The actual rotation is two-dimensional, that is, it remains within the same plane and at a constant distance from the spectator. The impression of solidity is created illusionistically. But there are other moving objects which give an impression of solidity without creating an illusion. A good example is Gabo's *Kinetic Construction*. Here an impression of solidity, of a translucent solid object, is produced by the action of light plus the inability of the eye to follow the rapid movement of a vibrating steel spring. But this is not strictly an illusion since the spring actually traverses the area of space which appears solid, and, moreover, its solidity is not such as to deceive us into thinking we are looking at a solid object such as a wine-glass of a somewhat unusual shape.

But if Gabo's construction does not rely entirely on optical effects in the restricted sense—it uses real light and real movement, not an impression of luminosity and movement—the difference between works of this kind and static Op is not so very great. In both cases what Soto calls 'dematerialization' occurs and in both cases this is due to a failure of the eye and brain to cope with stimuli. Two more recent examples of this kind of art which deserve mention are the moving, interlocking polished metal rings and rods of Len Lye and Le Parc's rapidly moving, undulating strings and loops (*Contorted Circle*, plate 46), discussed later.

Light-objects

So far the works considered have been objects which reflect light or are illuminated by it. In them our attention is directed more towards the illuminated object than towards the light itself. In recent years a large number of works have been produced in which light itself, from various sources, is the prominent feature. The effects of these are optical in the broad sense, and, though as has already been said, they often closely resemble Op paintings, they seldom display optical effects in my more restricted sense. There are some, however, that do.

Mention has been made of Garcia Rossi's *Unstable Light Structure* consisting of plexiglass rods which are illuminated in a random fashion and function like a periodic structure of tiny dots. Morellet also has made a number of periodic light structures, which he calls 'Successive Illuminations' and 'Neons'. They operate in a similar way. The 'Successive Illuminations' (plate 47) are made up of a number of light bulbs placed along a regular grid. The 'Neons' consist of neon strips laid out in a grid. The bulbs and neon strips are lit at random and produce an unstable light structure with very powerful after-images. Stein produces moiré patterns by passing light through rotating perforated metal screens (*Web in Movement*, plate 48). The perforations do not exactly coincide, though they are identical in structure. Their superimposition, therefore, produces a typical moiré pattern, but it is less dramatic than the patterns discussed in an earlier chapter. This may be due to the radiation of the light.

Both Lily Greenham and Sedgley have used light to reinforce the optical effects of colour. By illuminating a colour pattern with different coloured lights in rotation, the pattern and its colours can be made to change in a quite dramatic way: colours change in hue and tone, fade, disappear and produce afterimages, advance, recede, pulsate, expand and contract (*Green Cubes in Movement*, plate 51). Lily Greenham writes:

The elements change in themselves and in relation to each other. As a result of the projection of different colours, patterns appear which are now two-dimensional, now three-dimensional, which dissolve, intensify and induce the eye not only to see real colours and patterns, but also to operate with the 'after-images' which it retains beyond the instantaneous changes in the object; what the eye has already seen combines with what follows.

What is happening here is that the optical effects of coloured light as reflected from a surface—the way we see it on a painted surface—are being combined with the optical effects of projected light.

These two behave differently. For instance, green and red projected light will combine to give yellow, whereas green and red pigments will produce grey. These are known as additive and subtractive colour mixtures (and do not exactly coincide with Cruz-Diez's use of these terms). Pigment colours absorb some of the white light spectrum and transmit only the light of the wavelength of the colour we see. Thus green pigment absorbs all but green light, red all but red light. Combine the two, and all light is more or less absorbed or subtracted, and we get grey. Pigments reduce tone when mixed. That they do not always produce grey is due to the fact that most pigments transmit more than one spectral colour—purple transmits red and blue, yellow transmits red and green, etc. Coloured lights, on the other hand, combine with or supplement one another to form white, each supplying what the other lacks. By adding coloured lights, there is no loss of tone. If red is added to blue a light magenta is obtained: add green to this and the light becomes white.

Now consider what happens when coloured light is combined with pigment colours. If the light is of a colour which is absorbed by the pigment, then nothing will be transmitted and the result will be black. This happens when red light is projected on to green pigment, blue light on to yellow pigment, etc. If light is projected on to a pigment of the same colour, the pigment colour may seem to disappear, at least if it is weak. If the pigment colour is a mixed colour and contains some of the colour of the light, then, the pigment colour will change in the direction of the light colour. Thus magenta in red light will appear brilliant red and in blue light it will appear bright purple-blue. Further complexities are introduced by projecting more than one light on to a colour pattern. It should by now be clear what possibilities are opened up by the combination of pigment and light colours.

Sedgley has been exploiting this in some of his recent works. He began by playing coloured lights (red, yellow and blue) either singly or in combination on to some of his target pictures. By programming the lights and varying their rates of attack and decay, by means of a rotostat switch system in three separate units, he was able to make the colours change, grow in intensity, fade, disappear, reappear suddenly, turn black and, above all, pulsate, expand and contract in a way far exceeding such activity in daylight or artificial white light. He then went on to make rotating colour wheels of fluorescent paint in which the natural colour mixing was interrupted and interfered with by ultra violet and scroboscopic light. ('Videorotors', plate 52.) The effects produced by these means are impressive. Not only do the colours change, disappear and reappear: they begin to rotate at different rates, stop or change direction. One band of colour may be rotating noticeably faster than its neighbour, or it may be rotating clockwise while others are rotating anti-clockwise and others again are stationary. Here the transformation of the elements is almost total, and op, kinetic and light art meet.

Conclusion

It should be clear by now that many works which are called 'optical' are not optical in the sense in which this term is used of Op paintings. The word 'optical' in the broad sense has a special meaning when applied to solid objects or to light-objects. It refers to that quality of the works which belongs to the play of light on their surfaces as opposed to their solid or spatial qualities. By calling them 'optical' one is merely emphasizing the fact that their appeal is to the eye rather than to the sense of touch or the kinesthetic sense. By a kind of inversion, however, light objects are sometimes referred to as 'optical

sculpture' on account of the way in which volume or space is created or suggested by the use of light. For the sake of clarity it is well to keep these various uses of 'optical' distinct. In practice, it may be impossible to keep the lines of these distinctions clear-cut, partly because, as we have seen, optical effects in the restricted sense are often combined with optical effects in the other senses; partly because in the last analysis there are physiological factors in all optics.

There is still another reason for not wanting to make too precise a division between these various kinds of art, and that is that they have many important features in common which have already been noted: the transformation of the object, the breaking down of forms or 'dematerialization', and the creation of a kind of spatial dimension which is neither purely physical nor illusory in the way pictorial space is.

It is perhaps significant that many artists move freely between these various kinds of art. It does not follow, of course, that their preoccupations are primarily with Op and that they explore these other fields because of their similarity with Op. It may be, and very often is, the other way around. They are interested in the effects of light, the disintegration of form, colour reactions, the temporal and kinetic aspects of art, etc., and this leads them to investigate, among other things, what is narrowly called Op. There are, in the last resort, very few, if any, Op artists as such—the notion of the Op artist and Op art, like many notions in art talk, is a useful abstraction to which no individual or class of objects may exclusively belong. There are certainly no artists who are interested in investigating optical effects purely for their own sakes any more than there are architects who are interested merely in discovering how much weight a given structure may carry.

5 The common features of Op

We have now considered Op art in some detail and it is time to draw together our findings, and see if we can discover any common features. It might be said that, in selecting the works which I have discussed, I have already prejudged the issue and decided what features are common and what are not. Thus the present operation is bogus. But even if it were true that the issue has been prejudged and that I have decided in advance what Op art is, it still remains for me to justify my choice and say what is the basis on which I have made my selection. This is what is being attempted here.

Superficial features

Most people are agreed about certain superficial features of Op. First, an optical work should produce a strong sensory or physiological impact or retinal experience. 'The vocabulary of painters working in this tradition,' write Jacqueline B. Thurston and Ronald G. Carraher in *Optical Illusions and the Visual Arts*, 'is derived from those image qualities which produce the strongest retinal experience.' This is a bit sweeping, perhaps, since it would rule out the gentler optical effects. Seitz's description would probably be more generally accepted:

Carefully controlled static images have a power to elicit subjective responses that range from a quiet demand made on the eyes to distinguish almost invisible colour and shape differences to arresting combinations that cause vision to react with spasmodic after-images.

He puts it more succinctly when he says: 'These works exist less as objects than as generators of perceptual responses.'

Certain other features follow from this. Op art must be (1) abstract, (2) devoid of surface interest, (3) geometrical and hard-edged, (4) of a certain optimum scale.

It must be abstract, otherwise the required optical or perceptual response cannot be obtained. 'These works,' Thurston and Carraher say, 'confront the viewer with a pattern or image that immediately evokes a prescribed visual sensation without the distracting connotations of recognizable subject matter.' Seitz says much the same: 'associations, habits and reference, muffle and distort the purely perceptual effect of lines, areas and colours'. This is repeated in various ways by almost all writers: it is implicit, for instance, in the quotation from the Groupe de Recherche in the section on direct appeal below. Why recognizable subject matter and associations should inhibit optical effects will be discussed in the following sections.

Surface interest, that is, complex and varied design, organic or informal patterns, brushstrokes and impasto, must be eliminated for the same reason: they prevent the optical effects from taking place. Where paint is used, it is applied flat and even. Most artists favour paints like acrylic which leaves an even finish. This requirement for Op art accounts for the superficial banality of most of the designs. Why it is necessary will become clear in what follows.

The need to use geometrical and hard-edged structures follows naturally from the exclusion of organic and informal patterns. But there is an additional reason for using a hard edge. Optical effects are produced by strong contrasts and the maximum contrast is obtained by keeping the boundaries between different areas clear-cut. Besides, it is usually at the edge, the point of contact, that the optical effect is generated. But this requirement is not absolute. Both Vasarely and Bridget Riley obtain optical effects with tonal modulations, and Fangor and Sedgley with soft edges.

Scale is important because, as we have seen, certain effects such as colour mixture require the spectator to be at a certain distance from the picture if they are to work. This, incidentally, makes the reproduction of optical works very difficult.

These features of Op may help to distinguish Op from other kinds of art in a rough and ready sort of way, but they are not the basic features. They are merely concerned with the artistic means, the tools of the artist's trade, so to speak. The basic features have to do with movement, time, space, light and the relationship between the work and the spectator.

Movement: the time factor

There are at least three ways in which movement can enter into painting. First, there is the representation of movement, whether of a moving object—a galloping horse, trees waving in the breeze, rain falling, or alternatively the representation of objects as seen by a moving spectator. The former has engaged the artist from the earliest times (perhaps from the days of cave painting) and it presents particular problems of its own which do not concern us here. Interest in the latter is of comparatively recent origin, being tackled in systematic fashion by the Cubists and Futurists. But apart from the representation of movement there is also a kind of movement which is common to all painting, whether the object represented is moving or static, or whether there is any object in the strict sense or not. This might be called 'formal' movement. It has to do with the composition of the painting and its elements. This is sometimes referred to as the 'rhythm' of the composition. We speak of 'flowing' lines, 'receding' space, etc. Thirdly, there is what has been called 'virtual' or 'apparent' movement. Here, the picture surface or parts of it appears to move, to heave and thrust, advance and recede and alter position. No doubt something of this sort happens in all painting though to a degree that passes unnoticed. It is more than a suggestion of movement, as in the case of a flowing line; it is more an 'illusion' of movement. This kind of movement is peculiar to Op art to the extent that it might almost be called its defining characteristic. It has already been noted that this

kind of movement is not always apparent at once. It usually requires a certain amount of concentration on the picture before it takes place, and the degree of concentration will vary from picture to picture.

Bridget Riley's *Intake* affords a good example of two of these kinds of movement. There is not only the over-all rhythm of the composition but also the movement of the flowing wavy lines (suggested movement). And, after one has concentrated on the picture for some time, the third type, virtual movement, begins to take place. The surface begins to heave and billow, and great troughs appear and become more and more cavernous.

Virtual movement introduces the *time factor* into painting. There is a time factor in all painting, just as there is movement in all painting. The picture may not itself alter—to that extent it is static—but time is required to apprehend its contents. No picture of any value reveals itself all at once. (I am not here concerned with alterations which take place over a long period of time, such as mellowing or fading of colours, darkening of varnish, etc.)

There is also, corresponding to formal movement, a kind of formal tempo. This may be due to speed of the eye movement or to visual equivalent or suggestion of slow, fast, endless or arrested movement.

In Op art a third temporal factor enters in. This might be called the optical development. As has been said, a certain amount of concentration is required before optical effects occur, and when they do occur we experience visually something which is not on the canvas or happening to the canvas. In *Intake* the surface does not actually heave and buckle, yet it appears to do so. It is not just that we observe something we had not noticed before— this can happen in the presence of any painting, but rather we observe something which we could not have observed before, since a period of concentrated looking is required for this phenomenon

to happen. And once it has begun, it continues to happen, that is, the appearance of the picture continues to change; the direction, depth and speed of the movement continually varies. Even qualitatively different changes may occur. In *Intake* as with other pictures we have considered, colour may appear, in this case a blue band at one point of contact between the black and white wavy lines, and an orange band at another. Thus the work, the object of our attention, is changing, developing, evolving all the time, rather like a film or a piece of music. An Op painting, is, as Seitz says, less an object than a generator of responses, successive, controlled, programmed responses.

Optical space

Another characteristic of Op painting which follows directly from the preceeding one and, like it, is almost a defining characteristic, is the kind of space it creates.

There is a great variety of ways in which a painting may convey an impression of depth. We have a natural tendency to see areas of different colour or tone as figure and ground, that is, as lying on top of one another. Where one form overlaps another we see it as being in front of whatever it overlaps. Or again, where perspective is employed, we have a strong impression of depth and distance, and we may even see certain parts of the picture as stretching away to infinity. The space created in these ways is a receding space. The objects in it lie behind the picture plane, as though seen through a window. It should be noted that the picture plane and the picture surface are not necessarily identical. The picture surface is merely the painted surface; the picture plane is that part of the picture behind which everything else *appears* to lie. The space created by perspective is usually homogeneous, that is, the objects seen in it are in a coherent relationship to one another as if viewed from a single viewpoint.

Towards the end of the last century painters tended, for reasons too complex to go into here, to concentrate their attention more and more on the picture plane and hence reduce the pictorial space of their pictures. This tendency is said to be expressed by Maurice Denis's well-known remark: 'a picture, before it is a war horse, a naked woman or some anecdote, is essentially a flat surface covered with colours arranged in a certain order.' One device for flattening pictorial space, used extensively by the Cubists, was ambiguous perspective. A typical Cubist picture is so constructed that it is impossible to view all the objects in it from a single viewpoint. A table will be shown as it would appear if viewed both from above and from the side, the legs and the top are shown in full, etc. Thus the tendency to see these objects as receding from the spectator in an orderly fashion is thwarted. We are forced continually to alter our assessment of their spatial relationships. What, from one point of view appeared to be further back, from another appears to be nearer the front of the picture. This continual shift of viewpoint makes us conscious of the picture plane, or, to put it another way, of the process of projecting the objects into pictorial space which passes unnoticed where single viewpoint perspective is employed.

There are, then, two features of pictorial space as it has been considered so far: (1) it recedes from the picture plane, even if this recession is limited and the eye is continually being recalled to the picture plane and even to the picture surface; (2) it is a matter of *interpretation*, of *seeing* the objects *as* receding from the picture plane, falling in behind one another.

In abstract painting the first of these two features sometimes disappears. An abstract painting is very rarely like a scene viewed through a window. Nor,

FIG 39
Bridget Riley *Intake* 1964, 70¼ × 70¼ in.
Collection John Powers, USA

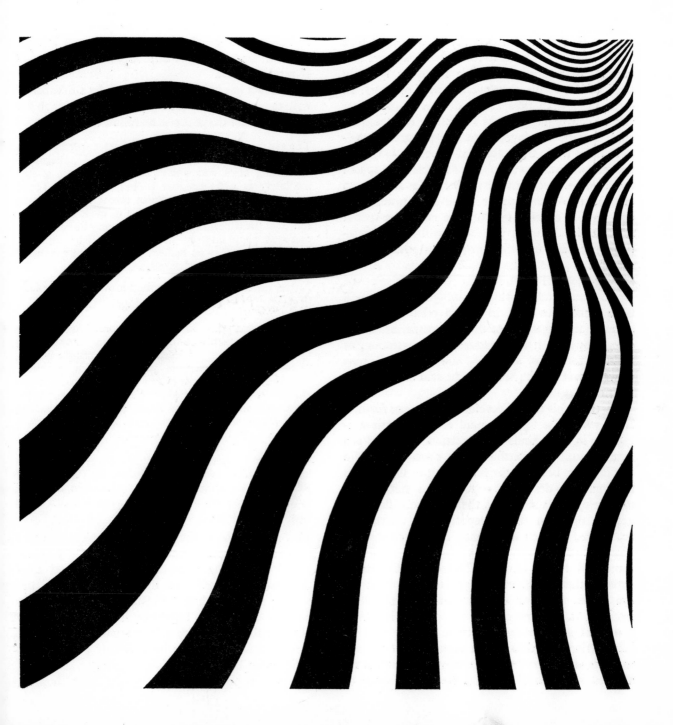

though, do the forms necessarily lie on the picture plane. But the tendency to relate them as figure and ground, to regard overlapping forms as lying in front of the forms they overlap, still operates. In some cases even perspective devices (diminishing size or converging lines as suggestive of recession, etc.) may be employed. But the picture plane—in so far as it can be established—need no longer be the forward limit, so to speak, of the pictorial space: the forms—indeed, the whole picture, as in the case of a Rothko—may appear to advance towards us and even to envelop us. In some cases the spatial relationships between the forms will remain relatively fixed and unambiguous, but in others, as for example in some of the organic abstracts by Arp or the geometrical abstracts of Stella, where the figure-ground relationship is ambiguous, there will be a continuous shift in spatial relationship and advance and recession of the various forms. In all cases, however, it is a matter of interpretation, of seeing a form now as figure, now as ground, now forward, now back. (More will be said about this in the next chapter.)

Op takes this line of development a stage further. Even where the figure-ground relationship is ambiguous in other kinds of abstraction, there still is a figure-ground relationship and a relationship, if a varying one, between the forms. But in Op art this relationship is destroyed, or rather, it is not allowed to develop. In some cases the shift from figure to ground or from one perspective to another is accelerated to such an extent that it becomes impossible to distinguish one from the other even for an instant. But it is also possible that a distinction between them never even begins to take place: the eye cannot focus on any element long enough to interpret it. The perception of space is largely a matter of interpretation. Because we are so busy interpreting the data which come to us, we are unaware of the way in which the eyes themselves are affected by the visual stimulus. We become aware of

it, however, when the stimulus is of such a kind, as it is in Op art, that we cannot proceed to the stage of interpretation.

This fact has been commented on by a number of writers on Op art. George Rickey in his book *Constructivism* describes it as follows:

The eye responds in a direct and selective way to certain colour situations, line arrangements, and patterns of alternating black and white patches or stripes, as immediately as a finger does to heat and cold. These sensations are in the mechanism of the optical system itself and are not an interpretation or evaluation of the source of the stimulus. In fact, the eye may be so shocked that attempts to interpret the stimulus may be futile . . . Again, the eye may be baffled, confused and frustrated by ambiguous visual situations.

Anton Ehrenzweig has described how this takes place in the early Op paintings of Bridget Riley:

We sometimes speak of 'devouring' something with our eyes. In these paintings the reverse thing happens, the eye is attacked and 'devoured' by the paintings. We are faced with an inexorable yet almost imperceptible variation of linear elements and units. So smooth is the change that it does not allow the eye to organize the series of units into stable larger entities on which it could comfortably linger and rest . . . But at a certain point this relentless attack on our lazy viewing habits will peel our eyes into new crystal-clear sensibility. We have to submit to the attack in the way in which we have to learn to enjoy a cold shower bath . . . Bridget Riley minutely weighs the tension between her geometrical or near-geometrical units, so as to make them destroy each other.

This is only one of the ways, the simplest perhaps, in which the optical devices used by Op painters work. Where the elements are simple and continuously repeated over the surface, where the surface pattern is homogeneous and no element is dominant, the eye is baffled by its vain attempts to organize the data before it. The result is the heaving and twitching which we have already observed.

Stephen Bann makes an interesting historical observation about this. One might have thought,

he says, that the long process of bringing the pictorial structure closer to the picture surface, as practised by Malevich, would come to a dead-end when the two coincide, 'since, if the two are indistinguishable, there is no balance of elements, simply monotony'.

In this respect, Malevich seems to have drawn the final conclusions and reached the ultimate impasse . . . But in fact . . . the scrupulous repetition of abstract elements does not result in indistinguishability of structure and surface. For the laws of vision decree that repetition of this kind creates a dazzle, or a virtual movement perceptible to the retina. In the terms which I have been using, the homogeneity of surface created by repetition of geometrical elements is relieved by a recurring 'illusion' of movement, by the presence of an unstable structure.

In this situation a different kind of pictorial space comes into being. For want of a better word I shall call it 'optical space', that is a pictorial space in which the whole picture and/or its elements appear to move about, advance and recede, undulate, change position, etc. It differs from other kinds of pictorial space in being the result, not of an interpretation of the elements, but of certain transformations occurring in the optical system; in fact, in a failure or an inability to interpret the elements. It carries forward a development begun by other abstract painters, namely, the forward or outward advance of pictorial space from the picture plane or surface. But in other kinds of abstraction the picture still keeps its distance so to speak. It is always possible to measure with the eye one's physical distance from the picture, to see it as a flat surface covered with pigment a certain number of feet away. But this is not always the case with an Op painting. Once the optical effects have begun to work, the precise location of the picture in physical space may become difficult to determine. You have a sensation similar to that which is sometimes experienced while driving along a road in fading light when the road before you seems to rise up like a wall or a distant object momentarily appears to be only a few yards away. Steele has said very aptly of some works of Soto: 'You can bump your nose on a Soto while trying to locate it physically in space.'

The equivalence of light and energy

Op artists carry forward the Impressionists' researches into the optical equivalents of light. This is particularly true of those who work with colour contrasts but it is also true of many who work with black and white effects. Op paintings not only appear to move, they also appear to glow, to radiate light, often dazzling and vibrant. Optical space is thus a luminous space.

For many painters as we have seen Op art is also the visual equivalent of other forms of energy, of heat, for example, or electro-magnetic force. Soto explains this very clearly when he says:

What has always interested me has been the *transformation* of elements, the *dematerialization* of solid matter. To some extent this has always interested artists, but I wanted to incorporate the *process of transformation* in the work itself. Thus, *as you watch*, the pure *line* is transformed by optical illusion into pure *vibration*, the *material* into *energy*.

Other painters have presented light, heat and energy indirectly by its visible effects: the reflection of light off objects, the shimmer of a heat haze. Op artists make you experience a sensation similar to that which you experience in the presence of light and heat; they make you respond as you would if directly in contact with these kinds of energy. Vasarely's *Supernovae* may not *look* like the sky at night, but if you submit to it and allow its optical effects to work on you, it *affects* you as the night sky would affect you if you swept it with a telescope.

Direct appeal

Robert Melville, in an article in the *New Statesman* in 1966, otherwise rather critical of Op art, said:

Op painting has one advantage over every other kind. It gives everyone the same sensation, regardless of eye and experience. To the Op artist we are all equal.

This fact has not only been noted by Op artists but is part of the programme of what is called the 'New Tendency'. 'We are now concerned with allowing the spectator to react with a common shared means of perception', wrote a group which formed part of 'New Tendency', the Groupe de Recherche d'Art Visuel, in 'Stop Art'; and in their manifesto, 'Enough of Mystification', issued in 1961 on the occasion of the second Paris Biennale, they put it more forcefully:

There must be no more productions exclusively for:
the cultivated eye,
the sensitive eye,
the intellectual eye,
the aesthetic eye,
the dilettante eye.
THE HUMAN EYE is our point of departure.

This may be a little over optimistic, but it is clear that, in so far as Op art cuts out association and reference, minimizes interpretation and acts on the spectator who is willing to submit to it, it is direct in its appeal and requires very little background knowledge. Indeed, what is needed for a superficial appreciation of Op art, is the removal of prejudices and preconceptions about what art should be. The popular success of Op art is to some extent a confirmation of these artists' optimism.

Spectator participation

'Our aim', writes Karl Gerstner in the catalogue to the Nouvelle Tendence exhibition in Paris in 1964, 'is to make you a partner. Our art is based on reciprocity . . . More precisely: our art depends on your active participation.' This notion of spectator participation is a recurrent theme in the writings of the Groupe de Recherche. They wish to get away from the concept of art in which the spectator merely admires and appreciates what the artist has done. 'We wish to put him in a situation which he initiates and transforms . . . We wish to develop in the spectator an increased capacity for perception and action.' Joël Stein, in answer to a question put to him in a questionnaire drawn up by Ohio University, states this aim more fully. The spectator, he says, is put in a situation which would not exist without him.

Thus it is essentially provocation that interests us . . . In every case it will concern a spectator capable of reacting and he will not be able to continue accepting preplanned situations in a purely passive way.

In 'Stop Art', the Groupe say that they wish to stir the spectator out of his 'submissive drowsiness', a drowsiness induced by specialists on art, which allows him to accept any form of art thrust upon him.

The degree of participation will vary from merely initiating a situation to controlling it at every stage. The amount of active participation involved in Op painting (leaving aside reliefs and superimpositions) would probably be regarded as fairly minimal. But the spectator is in a situation which is partly created by his own physiological reaction to the painting: a situation which would not exist without him. It is a situation, moreover, which he initiates and transforms, to the extent that it depends on his continued concentration, and may even, as in the case of Hacker's *Cubes*, 'manipulate' perceptually. It increases his capacity for perception by making him more aware of his own perceptual apparatus. The Op artist, therefore, 'provokes' the spectator. But the initial situation which he presents is 'preplanned' and confines the spectator's activity to more or less involuntary optical response. Nevertheless it is impossible for the spectator to remain inactive: he must react.

Two consequences, it is claimed, follow from this.

One is that the distance between the spectator and the work is lessened. The work is not 'over against' him, so to speak, as something simply to be contemplated. He is intimately involved in it since he is active in producing it. The other consequence is that the personality of the artist is minimized. One of the main objections which these artists bring against certain kinds of painting such as action or gestural painting is that the personality of the artist obtruded itself too much. To such an extent did these artists wish to efface themselves that at first they formed themselves into anonymous groups and did not exhibit under their own names. The Groupe de Recherche echoed Vasarely's statement of 1960:

The 'star' artist or the 'solitary genius' is out of date; groups of experimental workers collaborating with the aid of scientific and technical disciplines, will be the only true creators of the future.

They repudiated the idea of the 'uniquely inspired painter of undying masterpieces': They considered it an anachronism. The two consequences of spectator participation are summed up in the Groupe's Paris manifesto of 1963. Speaking about their Labyrinth they said:

Our Labyrinth is only a first experiment directed towards eliminating the distance which exists between the spectator and the work of art. As this distance disappears, the greater becomes the interest of the work itself, and the lesser the importance of the personality of its maker. At the same time, the importance of all theories of 'creation' which are the rule in art today will disappear too.

If spectator participation, as it is here envisaged, involves a change in the role of the artist, it involves a different conception of the spectator also. In answer to the question: 'Is it more important to activate the spectator in a physiological manner (pure perception) than to awaken and activate his mind? Do you think that your optical researches bring a spiritual enrichment, and if so of what order?' Joël Stein replied:

The classical themes of the work of art address themselves to the 'mind' of the spectator. This implies a classical conception of man, which wants him to have noble regions and base regions . . . One still talks of the 'mind' as if it were an entity quite independent of the individual who possesses it. In order to excite and activate a spectator physiologically it is necessary to work simultaneously on his psychology. So that the provocation of new situations will provoke different activities and behaviour. Now it is clear that notions of enrichment and thence progress are similarly out of place.

Serialism and the element of chance

With a change in the conception of the role of the artist and the spectator, goes a change in the conception of the work of art. As the unique genius who is to be admired in his handiwork yields to the artist who is prepared to take the spectator into partnership, so the unique masterpiece yields to the artistic situation which awaits the spectator in order to be actuated and can be realized in a large variety of ways. 'The spectator's momentary emotion aroused by the stable, unique, definitive, irreplacable work goes against the evolution of our age', wrote the Groupe de Recherche in 'Enough of Mystification'. For them the work of art is not something done and finished with, given for all time; it is more a set of possibilities, a situation to be explored, an event rather than a thing.

The very conception of the object can be regarded either in terms of an ineluctable deployment of a given situation or as a proposition in different arrangements giving rise to an infinite number of conceivable visual situations.

This introduces the element of chance, randomness and instability. In Op art instability is attained by the random eye movements and physiological reactions induced by the painted surface. There is something paradoxical in this. Instability is achieved by what at first sight might seem the most stable of

all structures, periodic structures or systematic repetition of identical elements. The artists whom I have been quoting claim that in introducing the element of chance they are in keeping with contemporary sensibility:

The New Tendency attaches a great importance to the principle of instability, which justifies a space-time that is always modifiable, more in conformity with contemporary sensibility. Mathematical series suggest new (inédites) organizations of space. Numbers in automatic progression are put to work to extend the perceptual field to infinity . . . Grids, luminous projections, mechanic and mobile reliefs, manipulation by spectators and borrowings from optical systems already make possible the simultaneous perception of forms in continual evolution.

Morellet constructed his *Aleatoric Distribution*, which is made up of a grid of red and blue squares, by assigning to each colour an odd or even number and distributing them by picking numbers at random from a telephone book. He writes of this composition:

The principle of the picture in blue and red squares is probability: 50% red squares and 50% blue squares of the same intensity are distributed over the surface by a combination based on chance.

But Gerhard von Graevenitz, speaking of his *Regularité-Irregularité* which involves the physical, and not just the apparent movement of the elements, says that because the human memory is not capable of remembering a certain arrangement, the movement seems to the spectator to be unpredictable. The randomness is therefore more apparent than real. And Soto speaks of the 'laws of chance', which he explains as those laws which are too subtle to be discovered so that events governed by them appear to happen by chance.

It should be noted that chance enters into Op in two ways. One is the way we have just been considering, where the artist adopts some random method of construction. The other concerns the spectator. Here randomness appears in the apparent movement of the elements and the sequence of reactions, since both depend on where the eye happens to alight at a particular moment and how long it rests there. It must be added that the element of chance is by no means restricted to Op or even to kinetic art, and it is found in the non-visual arts as well—in aleatory music, for example. This gives some weight to the claim that it reflects contemporary sensibility.

Multiplicability

One final feature of Op art, though one which is not confined to Op, is the fact that Op works can be multiplied or mass-produced by mechanical processes. A number of artists—Vasarely, Bridget Riley and Sedgely, for example—entrust the painting of their works to other hands. Once they have completed the detailed planning of their work, the actual execution is very often a more or less mechanical matter. This may seem to contradict the claim made by many Op artists that their work is a kind of research. They do not know, when they embark on a project, how it is going to turn out. The contradiction is merely apparent, however. For those artists who leave the execution to someone else, the research has been done at the experimental stage. If, then, the work can be executed by someone other than the artist, it is possible, at least in principle, to entrust its execution to a machine and hence to multiply works by mass-production.

But there is more to it than that. Many of the great masters of the past entrusted the execution of their works to apprentices or studio hands, and yet no one would suggest that these works could be mass-produced, unless producing a number of copies or versions should be regarded as

FIG 40
François Morellet *Aleatoric Distribution* 1961, seriograph
31½ × 31½ in.

mass-production. But Op art is a special case. It is not simply because the work can be carried out by someone other than the artist that Op art can be mechanically produced: it is on account of certain features of Op art that this is so. First, the elements are generally extremely simple. Secondly, they have precise, clear-cut contours. Thirdly, the colours, if colours are used, are very often of uniform tone and intensity. Fourthly, the work is not designed to convey something of the artist's personality, hence his personal touch is not required. His personality is not excluded, but it is conveyed in the conception of the work rather than its execution. Finally, and following from this, gesture, brush stroke, impasto, etc., are avoided. Areas of flat, uniform colour are comparatively easy to reproduce. (This last requirement is not just in the interests of self-effacement, but is also necessary in order to obtain optical effects; see page 98.)

The multiplicability of Op works is not, in the eyes of some artists, just an accidental feature: it is the feature by which they set the greatest store. It is what makes this kind of art socially relevant. Vasarely is tireless in driving home this point. 'My aim,' he writes, 'is to introduce plastic awareness into everyday life. What I offer is social welfare *par excellence*.' He remarked to the critic Jean Clay:

Use other hands, use machinery—that's the modern idea. Look at that picture there above your head. Is it an original or a copy? You can't tell . . . Literature and music have spread through books and gramophone records. Why not do the same for painting? An artist who today sticks to the hallowed craft techniques of easel painting cannot claim to be in the *avant garde*.

Karl Gerstner wrote in the catalogue to the Nouvelle Tendence exhibition:

Our conviction is that our art is realizable according to social conditions in great numbers, and—why not?—on an industrial basis.

And the Groupe de Recherche, as might be expected of those staunch opponents of the unique artist with his unique, unrepeatable masterpieces, write in the same vein:

Almost all our works are available in four or five copies. What gives a work its uniqueness is the relationship between the artist and the work; the relationship Mona Lisa–Da Vinci is unique. Our works can just as well be made by others without losing their effect.

6 Op and other forms of art

Op art is closely related to, and often confused with, certain forms of art which (*a*) employ optical effects and illusions, (*b*) are concerned with colour contrasts, (*c*) use serial techniques of composition, (*d*) involve movement. It may further clarify the notion of Op to consider each of these in turn.

The 'Cubist tradition' and Op

One can distinguish three kinds of art, naturalistic representation, Cubism and optical art, on the basis of their treatment of optical effects and illusions. Naturalistic representation eliminates or at any rate strictly controls illusions and optical effects. Cubism employs certain illusions but controls optical effects. Op may employ illusions in order to generate optical effects; the control it exercises over them is no more than is required to prevent the total disintegration of the work.

For naturalistic representation to succeed, two things are required: (1) The spectator must be induced to see shapes on a plane surface as objects in space. As has already been said, we have a natural tendency to see forms on a flat surface in the relationship of figure and ground. So to this extent the work of the naturalistic painter is made easy. But he must ensure (2) that this relationship remains stable. Nothing in the picture must allow the spectator to alter this relationship and take as figure what is meant to be ground or vice versa. There must be no ambiguity. The size, contour, texture and context of the various forms will usually determine which is which. An enclosed, convex, highly textured area, especially if it is in the proximity of an unenclosed concave and untextured area will normally be regarded as figure. Thus, we would normally see fig. 41a as a series of convex banisters. But another reading is possible; we can, with a little effort, see this as a series of concave banisters of unusual shape. This is where the trouble for the naturalistic painter lies. Even the most apparently stable figure

FIG 41a
Reversible figure: banisters

is always threatened. The figure–ground relationship is a delicately balanced one.

Fig. 41a is an example of what is known as a 'reversible figure' illusion. Whether it makes sense to speak of it as an illusion will be discussed in a later section, but whatever one cares to call it, it is something which a naturalistic painter must as a rule eliminate at all costs, otherwise he runs the risk of having his picture disrupted. There are times, however, when a painter can afford to admit a little ambiguity of this kind. Professor Gombrich in his book *Art and Illusion* gives an example of how Klee uses the 'open book' illusion in his painting, *The Old Steamer*. The 'open book' illusion consists of two rhomboids placed side by side so as to appear as a book with open pages either face upwards or face

FIG 41b
'Open book' illusion

downwards (fig. 41b). Klee adds more rhomboids, and, as the eye shifts from one to another, we get the impression of a dilapidated old craft chugging its way along. Not everyone, perhaps, would agree

H

FIG 42
Victor Vasarely *Harlequin* 1935, 22½ × 15¾ in.
Denise René Gallery,
Paris

that this is a naturalistic painting; it might even be regarded as having something in common with Op.

This brings us to the borderland of naturalism and Op. In the book just referred to, Gombrich makes an interesting comparison (suggested by Whistler) between Frith's *Derby Day* and Manet's *At the Races*. In spite of the meticulous detail in Frith's painting, the crowd is represented, as in the Manet, by tiny indeterminate dots. The Manet is more interesting pictorially, says Gombrich, because

Into the Manet we can project the sparkle and excitement of an excited mass of people. He uses the very ambiguity of his flickering forms to suggest a variety of readings and to compensate thereby for the lack of movement in the painting.

I do not think it is the sparkle that we project into the Manet. That is surely a physiological or optical effect produced by the repetition of indeterminate dots and by colour contrast. But there is projection, or rather interpretation; for we see the sparkling dots as a moving, jostling, waving crowd. Optical effects are being used in the service of naturalistic representation.

In many of Seurat's paintings—*La Tour Eiffel* and *La Poseuse de Profil* (plate 1), for example—dots and flakes of colour are more loosely related to the subject depicted. They have a sort of autonomous existence: they float on the picture surface or in a shallow space around it; they seem to dance and swirl like a million brightly coloured snowflakes. Isolate a small area of one of these paintings and you have something very close to an Op painting. But in the end these tiny particles of colour settle back into the scene, for a time at least. Such pictures momentarily, but only momentarily, hover on the edge of Op.

There is another interesting meeting-ground between Op and naturalism in the 'proto-optical' paintings of Vasarely. Here an interrupted system is

FIG 43
Victor Vasarely *Zebras* 1932–42, 51 × 45 in.
Denise René Gallery, Paris

employed. A pattern of black and white squares is distorted in such a way as to give an impression of swelling. *Harlequin* and *Zebras* are good examples of this. *Harlequin* is made up of a series of black and white squares at an angle to the picture edge. At certain points the squares move out of alignment (become lozenge-shaped) and increase in size. Where this occurs they take on the solid form of a dancing harlequin. Because of the instability of the composition due to the distortion of the squares the impression of movement is greatly accentuated. *Zebras* is composed of black and white stripes varying in width and formed into a loose spiral containing the interlocking heads and necks of two zebras. Again the distortion of the stripes gives the impression that the zebras are moving their necks and rubbing their heads against one another.

To call this naturalistic is probably stretching things a bit. These pictures have more in common, perhaps, with Cubist pictures. But unlike Cubist pictures, the two Vasarelys can be fitted into a more or less coherent spatial setting, and, though there is a strong emphasis on the picture plane, they have more bulk than one usually finds in Cubist pictures. But again they differ from Op proper in so far as the optical effect is limited and restrained, particularly in the case of *Zebras*, by the presence of figuration. Op depends for its effect on the absence of a point of reference or focus within the picture.

These uses of illusion and optical effects are rare in naturalistic painting. Indeed, except for the Manet and the Seurat, the paintings we have just been considering have a tenuous enough claim to be called naturalistic. In general, naturalistic painters avoid perceptual ambiguities and other effects as disruptive forces tending to destroy the pictorial effect they wish to produce. Things are quite otherwise with Cubist painters. As we have already seen, it is the Cubist painter's intention to restore interest in the picture plane. From his point of view, the tendency to see a painted surface as objects in space, although he does not wish to eliminate it altogether, distracts attention from the surface pattern. Therefore, those very things which the naturalistic painter finds disruptive—ambiguous or reversible figures, etc.—the Cubist painter finds most useful technical devices for recalling attention to the picture plane. By preventing the spectator from interpreting the surface shapes unequivocally, they force his eye back continually to the surface. They thus set up a tension between the tendency to see objects in depth and a contrary tendency to see patterns on a plane surface. Braque's *Still Life with Marble Table* (plate 50) is a very good example of this. The table and the objects on it seem to float backwards and forwards in space. At one moment the table-top seems to lie flat on the picture plane; the next moment it is drifting backwards towards the

napkin and fruit. Much of this, however, is ambiguous perspective rather than reversible figure-ground relationship. The area in the bottom right, for instance, may be either floor or wall. The presence of recognizable objects and overlapping of forms makes a thoroughgoing reversibility impossible. This is attained only in non-figurative painting.

It might be thought that non-figurative or abstract art does not require such devices in order to ensure that the pattern remains on the picture plane. But this is not so. Any shape or patch of colour on a plane surface may be seen as figure or ground, and hence as related in depth to the other shapes and patches around it. This is true whether the painting is geometrical or amorphous. If the abstract painter is to keep attention on the picture plane, he must, like the Cubist figurative painter, thwart this natural tendency. Most abstract art has this much in common with Cubism. Some abstract painters even employ what are undisguised reversible figures. These are of particular interest and importance for the present study, since these artists are frequently classed as Op artists. The assumption is that, if they use optical illusions, they must be Op artists. This leads to confusion. If they are considered to be Op artists, then it must be recognized that their use of optical illusions and optical effects is very different from that found in, what I shall call, 'hard-core' Op. In fact, one might almost say that the two are diametrically opposed. They are certainly incompatible. Albers is a case in point. He is usually classed among the Op artists, yet many, if not most, of his paintings are not Op at all—certainly not 'hard core' Op. His 'Structural Constellations' (*Engraving no. 30*) and 'Graphic Tectonics' illustrate this very well.

The 'Structural Constellations' are reversible figures—actually they are 'impossible' figures, that is, no completely coherent reading of them is possible; and whatever reading is given, its reverse is always possible. In the illustration here, what is at one

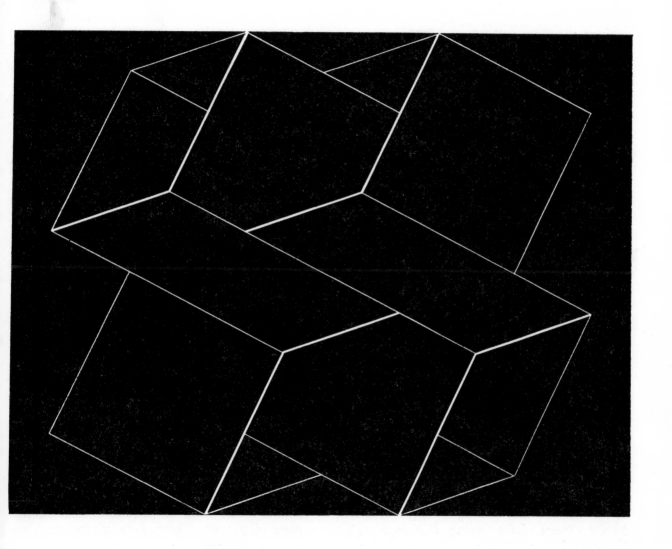

FIG 44
Joseph Albers *Structural Constellation: Engraving no. 30* 1955
25⅛ × 19 in. Denise René Gallery, Paris

moment the outer wall of one boxlike structure, becomes at the next moment the side or interior of another. This continual shift of viewpoint, incidentally, hides the remarkable symmetry of these constructions, a symmetry which would hardly pass undetected in a Cubist painting. But the principle of both is the same: every attempt to locate these structures in a coherent pictorial space is frustrated.

The 'Graphic Tectonics' operate on the same principle. In *To Monte Alban*, the white rectangles can be seen as either the flat tops of pyramid-like structures or openings at the ends of corridors. But the repetition of lines and the rapid changes of perspective may bring about an effect typical of Op. Hence the 'Graphic Tectonics' may be regarded as either straddling the borderline of hard-core Op or marginally within it.

The Albers pictures are by no means the only ones which lie along the boundaries of Op. Quite a number of the so-called 'hard-edge' painters employ ambiguous figures. Frank Stella is an obvious example. In *Hyena Stomp* (plate 49) a series of concentric squares can be seen either as solid pyramids viewed from above or as hollow pyramids viewed from below. It is possible to see these pyramids diminishing in size as one approaches the centre of the picture or growing in size and number as one approaches the outer edge; or one can see them as continually changing, alternately solid and hollow. This continuous alteration from concave to convex creates a surface tension along the diagonals formed by the corners of the squares. It is as though a brightly coloured awning was slung on wires which allowed a certain amount of play. There is a further ambiguity about this picture: the diagonals do not meet at the centre, and what appear to be a series of concentric squares in fact form a spiral, as one can easily discover by running a pencil along the bands. It will be found that, while the outer figures are nearly square, the inner ones become progressively more rectangular. In the famous ambiguous figure known as the Fraser Spiral a series of concentric circles appear to be a spiral. *Hyena Stomp* is the reverse of the Fraser Spiral: here a spiral appears to be a series of concentric squares.

Once more the Cubist principle is at work: illusion is set to destroy illusion. As Miss Lucy Lippard writes, the aim is

to utilize illusion as a foil to (such) modernist flatness (anti-illusionist) so that its falseness and trickery is apparent but necessary; persistent reversals of visual fact force the eye back to the plane . . . By offering two conflicting groups of visual data, the artist demands that the painting be seen as a painting first, and an illusion of illusion secondarily or not at all.

In the paintings of Stella optical illusions are used for purposes quite different from those of the Op painter: namely, to force the eye to see the painting as colour on a flat surface or in shallow depth.

In Benjamin Cunningham's *Equivocation* (plate 53) a number of devices with which we are now familiar—the equivocal or reversible figure and interrupted systems—as well as shading, are employed. But the result, in contrast with Stella's *Hyena Stomp*, is remarkably static. This is almost naturalistic illusionism, what I shall call 'abstract illusionism'. Close examination reveals that the figure is not quite so stable as it appears at first sight. It is, in fact, an 'impossible' figure. Moreover, at certain points, particularly in the lower left and upper right of the picture, the regular pattern of squares breaks down the contour of the bowl-like shape in which the figure rests. Nevertheless, the clues favouring a three-dimensional reading are so strong (especially where shading is used) that an easy transition from depth to surface cannot be made. At most this sort of picture achieves Cubist ambiguity and even then only to a limited extent.

Mortensen's *Opus Rouen* (plate 54) employs the multiple 'open book' illusion already referred to (fig. 41b). This is particularly obvious in the left-hand side of the picture: the change of viewpoint

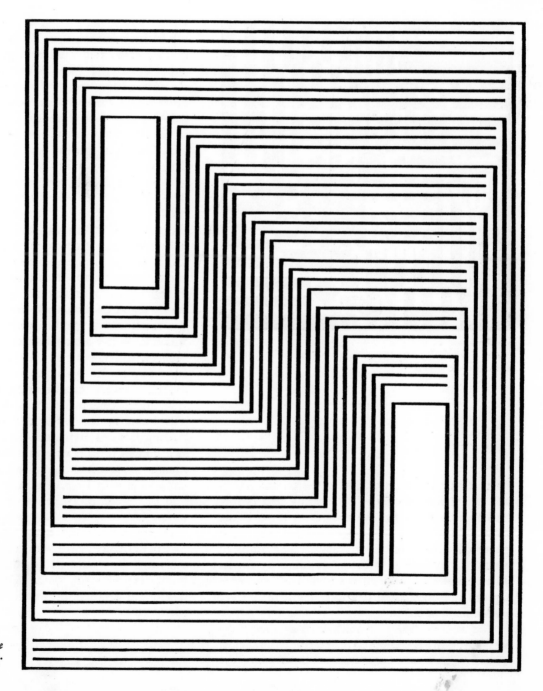

FIG 45
Joseph Albers *To Monte
Alban* 1942, 13¼ × 10½ in.
from 'Graphic Tectonics'

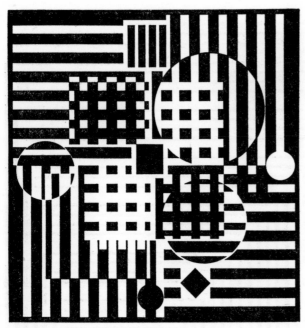

FIG 46
Victor Vasarely *Pleione* 1961–3, 82¾ × 78¾ in.
Pace Gallery, New York

on that side produces a kind of concertina effect, and the rhomboid shapes cut sharply and deeply into space. But as the eye progresses towards the right and back along the upper left-hand side of the picture, it is brought back to the picture surface, in much the same way as in the painting by Stella. The optical effects which are typical of hard-core Op are not allowed to develop. The principle of Cubism still operates.

The same is true of a work such as *Pleione* by Vasarely. This is composed of interrupted systems. The circular areas appear as magnifications of the stripes and grids, though on closer examination it can be seen that this is an illusion: only certain parts of the circular area could be magnification, the rest is either exactly the same as or totally different from the surrounding area it is supposed to magnify. In other words, the eye is invited to read the picture in one way and then prevented from doing so, just as in Cubism. There is a retreat from and return to the picture surface, but this process is never allowed to develop to such a point that the surface is destroyed.

Vega, like *Pleione*, employs interrupted systems. The distortion of the black and white squares results in a bulging or hollowing of certain areas of the picture. But, although this effect is concentrated in certain areas, it affects the whole picture. After a short time the distorting effect spreads to other areas and the whole picture is in turmoil. It soon becomes impossible to fix on any definite point of reference which might be considered the picture plane. Even the small circle in the upper left-hand corner, which looks like a magnification of the surrounding squares, will not act as such a point of reference. It is too small; the squares in its vicinity swirl around it rather than lie under it to be magnified. It is interesting to compare this with *Harlequin*. The bulge in the lower half of *Vega* is like the bulging form of Harlequin. By identifying the one as a human form it was possible to relate it to the squares around it as figure and ground, but this is impossible with *Vega*. The bulge in *Vega* can sink into as well as protrude out from its surrounding squares.

Having considered the role which optical illusions play in Op as compared with other forms of painting, this might be a good place at which to break off and briefly consider the wider issue of the notion of illusion in relation to art in general and Op in particular.

FIG 47
Victor Vasarely *Vega* 1956, 76¾ × 51 in.
Denise René Gallery, Paris

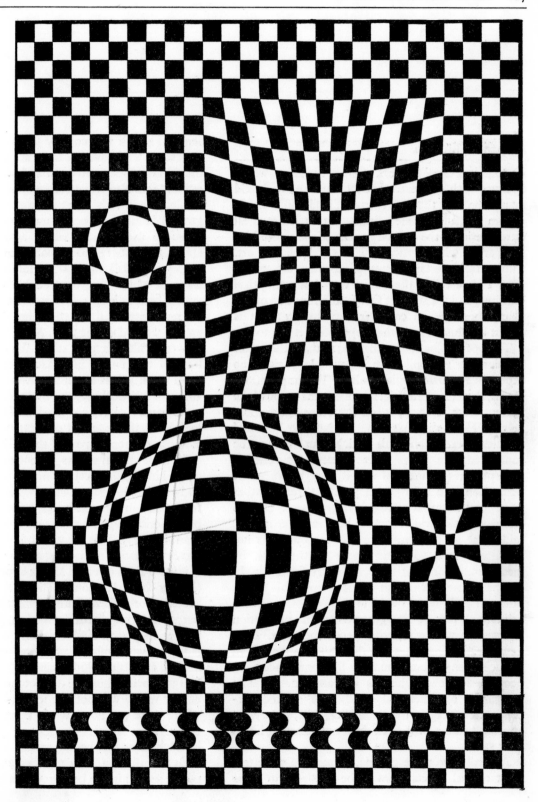

A note on illusion

Though it is usual to speak of Op art as an art which operates with or creates optical illusions, it should by now be clear that this is true, if at all, only within certain carefully defined limits. Op art is not at all illusionistic, in the ordinary sense of the word. Nor is all art in which optical illusions are used Op art. Cubism and certain forms of abstract art within what I have called the cubist tradition use optical illusions, and are still not Op. It might not be out of place, therefore, to consider very briefly what is meant by illusion and what application it has to art.

The psychologist Boring says that the term 'illusion' has no application in psychology, since 'no experience actually copies reality'. The implications of this, though interesting, lie outside the scope of the present work. Illitson, is, on the other hand, more helpful. He admits that there is what may be called veridical perception with which illusion may be contrasted. He offers three criteria for veridical perception; (1) 'internal consistency between the perception and information gained through other perceptual channels or cognitive processes.' On this criterion a stick which appears bent in water may be said to be an illusion, since this perception is not consistent with what we know of the stick by measurement or what we perceive by feeling it. In another sense it is not an illusion, since this is just how a stick in water ought to look. (2) 'Consensual validation', that is, the agreement of the perception in question with what other people perceive. This, however, distinguishes veridical perceptions from hallucinations rather than from illusions, since most people experience illusions in common. (3) The 'pragmatic or functional significance' of the perception. Here again the 'bent stick' fails, since what appears to be a bent stick does not function like a bent stick.

According to these criteria, it must be admitted, most optical effects seem to be illusions, in some sense. Though we see grey spots (after-images) on the canvas we know that there are none there. When the surface appears to bend and sway, we can reach out and feel it to reassure ourselves that it is flat and stable. When rods hung in front of a moiré background disintegrate before our eyes, we have only to move to make them whole again. Thus optical effects fail test (1) and probably test (3) for veridical perception. Still, they do not fail the tests in all the ways in which the 'bent stick' fails. A stick will appear bent as long as it is in water, but after-images do not appear all the time nor does the surface appear warped all the time. Moiré effect is different. It is more like the 'bent stick'. We cannot dispel it as long as we remain in a fixed position (if it is in relief) and, if it is a painting, we cannot dispel it at all. Most optical effects, however, are easily and perceptually corrigible illusions (and this goes for moiré too, if movement corrects the illusion). This, as we have seen, is part of their fascination.

In this, optical effects do not differ from certain other kinds of optical illusions such as ambiguous and reversible figures, and the like. They do differ from them in other respects, however. Ehrenszweig has described optical effects as 'hallucinatory' rather than illusory. This is worth investigating. In an illusory situation something appears to be other than it is: two lines of equal length appear to be unequal (Müller-Lyer Illusion). This is a matter of interpretation or rather of misinterpretation; an error of perceptual judgement (assuming that things must look as they are). Hallucination, on the other hand, is not a matter of misinterpretation (though it may involve an error of judgement). When Macbeth saw a dagger before him, he did not take something for a dagger which was not one in fact. He saw a dagger where there was none, where there was nothing but thin air. Seeing after-images and buckling canvases is much more like having an hallucination than like seeing an illusion. It is not a case of mis-seeing, of taking something to be a grey spot or moving canvas

which is another kind of spot or another kind of moving object. Of course, you might say that the canvas is seen as spotted with grey, or buckling, when in fact it is unspotted and stable, and in that sense these effects are illusions. But this is stretching things a bit since both the spots and the heaving forms are not seen as part of the canvas but as phenomena in some way detached (visually) from it.

Both optical effects and illusions of the Müller-Lyer type differ from those other visual phenomena which are usually called illusions, namely, ambiguous and reversible figures. It is hard to see why these latter are called illusions. They do not involve mis-seeing: there is no correct way of seeing a reversible staircase. Nor do they involve seeing what is not there before us. But perhaps they fail Illitson's test (3): we cannot tell which way the staircase is going nor whether we are looking at it from above or from below. If they happen to be impossible or irrational figures, then they may be said to be illusions in so far as they appear to be possible but are not.

It is in order to differentiate the effects found in Op art from these other illusions properly or broadly so called that I have referred to them as 'optical effects'. But even if they should be regarded as illusions, it is not as illusions that they are used in art. It is extremely difficult, as we have seen, to give any satisfactory account of illusion even in psychology, for the simple reason that what counts as correctly seeing, seeing what is really there, the veridical, is often in the last analysis arbitrary. In art it is even more difficult to give sense to the notion of illusion. It may sometimes be useful to talk about illusion or to use the term 'illusory', but these terms have no strict or precise meaning. 'Illusionistic' art or *trompe l'œil* in the strict sense (i.e., where deception is complete) has as such nothing to do with aesthetic appreciation. It has to do with appreciation only in so far as we appreciate the skill of an artist. As a piece of illusionism, if it is successful, if we are

completely taken in by it, it has as much or as little to do with aesthetic appreciation as the real thing we take it for. We may appreciate a painted *trompe l'œil* cornice or niche or 'marble' pillar, but it is not as a *painting* that we appreciate it, since, if it is successful, we do not see that it is painted. (The situation is slightly complicated where we know that it is or must be a painting but still cannot see it as one. But here it is at most the skill we admire.) Apart from strict illusionism, which as such has nothing to do with aesthetic appreciation, no precise meaning can be given to 'illusion', since the distinction between the veridical and illusory, or the real and the illusory, do not apply to art. It is as irrelevant to speak of illusion in art as it is to speak of truth or falsehood in fiction. Of course, we *can* compare pictures of objects with real objects. We can say that the apples in a picture are not real. But what is the point of saying that? No one takes them for real. As Harold Osborne says in his article, 'On Artistic Illusion': 'There is no illusion between image and actuality inherent in the characteristic outlook of naturalism.' (It may not be true to say that a Mr Pickwick visited Bath, but this does not mean that *The Pickwick Papers* is full of false statements.)

John F. A. Taylor in his book *Design and Expression in the Visual Arts* has spelt this out in some detail, and, lest the point has not been sufficiently made, here is what he says;

It is a confusion of understanding to suppose that in these matters one deals with an illusion. An illusion can occur only where a firm distinction can be drawn between appearance and actuality. But in these cases the appearance *is* the actuality, the sole actuality which the master artist permits himself to consider. With respect to such immediate appearances no error is possible except the kind of error that stems from obtuseness, from failure to attend to the actual differences that are to be found among appearances. An authentic illusion is never a failure to see appearances; it is simply a failure to interpret them rightly . . . In his (the master artist's)

visual field there is no room for illusion, for no inference is ever invited to an actuality beyond its precincts. Its appearances are, for purposes of the master artist, the things meant by actuality and to seek actuality elsewhere is to part company with him.

Taylor is speaking here about simultaneous contrast, but what he says is applicable to every aspect of the visual pictorial field. One might be tempted to think that at least the colours of the pigments are more real than the apples in the picture or the after-images which seem to flit across its surface. But, as we have seen, the colours in the picture are not the same as the colours on the palette; their value and even their hue is determined by their size, by the other colours around them, by the light and by the distance of the spectator from them. The only reality they have, from the point of view of an appreciation of the picture, is the way they appear in the picture. Here, however, they are on an equal footing with the apple or the after-image, as real or unreal as they. We can, of course, make the after-images disappear and in a favourable position the apples may become areas of juxtaposed colour, whereas it might seem that we cannot alter the colours of the pigments, whatever position or attitude we adopt. This, however, as we have seen, is not so. If we come close enough and isolate the colours, their appearance will change however subtly. So there is nothing aesthetically relevant to the picture which is more real than anything else, and hence nothing illusory about it either.

Art is only an illusion to someone who treats it as a continuation of the rest of its surroundings, who regards, say, the recession in pictorial space as a continuation of the space in which he stands. But to regard art in this way is to misunderstand it completely, to take it for something which it is not. Art can only be seen for what it is when it is treated as a separate reality. And this goes for Op just as much as for naturalistic painting. Anyone who does not see optical effects for what they are, who believes he sees 'real' grey spots or a bulging canvas, is not seeing the painting as an Op painting. He has missed the point. He may or may not appreciate what he sees but he is not appreciating it as Op. If Op artists employ what are commonly called illusions, it is not in order to create illusions. If they produce illusions, in the strict sense of deceiving, as opposed to stimulating, the eye, they have failed to produce Op art, whatever else they may have succeeded in.

Colour imagists and Op

So far we have been considering abstract painting in which illusions and other such devices are used in order to maintain the dominance of the picture plane while allowing some projection in depth. These, of course, are not the only means by which this result can be achieved. Abstract Expressionist, Action and Tachist painting achieves the same result by means of texture. The marks of the brush, the thickness of the paint, random spatter and dribbles, the grain of the canvas itself are all reminders that what we have before us is a flat surface covered with pigment. We may see a Pollock as a tangled forest, a Soulage or Kline as monolithic, girderlike shapes, a Rothko as a dense, opaque cloud of colour of indefinite depth and extent. But whatever way we regard them, we are inevitably brought back to the surface qualities. This concern with the picture plane which they have in common with the other abstract painters we have been considering—the geometrical abstractionists—marks them off from hard-core Op.

There are, however, a group or class of abstract painters who do not rely either on texture or on illusion to maintain the predominance of the surface. These deserve mention here because they have either had an influence on Op painting or because they are sometimes considered, not without reason, to be indistinguishable from certain acknowledged Op painters.

Among these one could name the Delaunays, and Herbin, on the one hand; and Davis, Kelly, Louis and Molinari, on the other. All of them are concerned with the relationships of colour or colour and form on a plane surface. They do not exclude pictorial space nor do they use special devices to ensure the dominance of the pictorial surface, since both are taken care of by the judicious juxtaposition of colour and form. Take, for example, *Nude* by Herbin (plate 55). Here you have an almost symmetrical composition. This gives equal weight to the forms as forms. Contrast is provided by the colour, not only colour contrast, but a limited spatial contrast too—the white circle and paler blues and reds tend to come forward, the dark blues to recede (though this varies according to the direction from which the eye approaches them and also according to their shape—circles tend to expand outwards). Any imbalance caused by the colour contrast is restored with the help of the asymmetrical white lines.

This painting has much in common with Op: the flat, textureless paint, the simple, sharply contoured figures, the bold contrast of colour. But it differs from Op particularly in the prominence which is given to the forms as forms. This is ensured by the way each form is insulated from the others by an area of black; the colours are not allowed to interact and blur the contours. The asymmetry, too, plays a part: the eye is encouraged to move about and inspect each form from different points of view.

A painting like *Black-Gray Beat* by Davis is a very different matter. It is composed entirely of vertical bands of colour. These forms are so simple as to be almost anonymous; one is hardly conscious of them as forms. The colours are juxtaposed and react on one another. But these reactions are carefully controlled. The passages of intense colour are balanced by greys and blacks, and though each colour appears slightly differently in each environment—the pink gets progressively paler from left to right, and so on—its value remains fixed. Although as Jacob Keinen says, the colours 'create splendid and pulsating fields' a chain reaction is not allowed to occur. However much a colour may be affected by its neighbours it retains its identity. That this is not so in Op painting, where the colours react to such an extent that their hue, tone and intensity is continually changing, should be obvious from the brief study of pictures such as Bridget Riley's *Chant II* and the others discussed in Chapter 3.

Norbert Lynton has made this distinction very clearly in an introduction to an exhibition of Michael Kidner's paintings.

The exploitation of the visual dynamics of colour is one of the characteristic pursuits of modern art. There are two methods by which colour may be made dynamic: both of them depend on the optical effects of adjacent contrasting colours. A: the painter can juxtapose two areas of sufficient size and contrasting colours. The colours will seem mutually to enhance their vividness . . . (This will be the case particularly if the areas have a succinct form and if they are surrounded by a comparatively neutral field.) B: The dynamic interaction of colours can be achieved by the eye's tendency to see in generalities (optical mixture). This can be done . . . by a gradual mutual transfixing of colour areas . . . and stripes of one colour, in invading the other colour's field, transform it while they are themselves transformed.

But though there is a distinction between these 'colour imagists' as Seitz calls them and hard-core Op it is largely a matter of degree; a question of how far the painter will allow the colours to react and to what extent he wishes to preserve the picture plane. Sidney Tillim has given the name 'American-type' Op to the work of Kelly, Louis, Noland, Stella, Feitelson, Feeley, Liberman and Poons, but he remarks that: 'To the extent that it is optical at all, the American style is far more colour oriented than percept oriented—which implies structural differences as well.' The distinction between colour and percept orientation is obscure, but there is no doubt about structural differences.

Poons is an interesting case. He speaks contemptuously of Op: 'Now it's easy to forget about painting and just make one of these optical things.' American critics disassociate him from hard-core Op on the grounds that for him optical effects are secondary and incidental. But this begs the question. Optical effects are not the be-all and end-all for Op artists either, though these critics try to make it appear that they are. Poons is certainly the nearest to Op of the artists listed above, with the possible exceptions of Feeley and Liberman. A painting like *Northeast Grave* (plate 56) has many of the characteristics of Op—a homogeneous field of simple and identical shapes repeating themselves, a limited number of contrasting colours, etc., and it operates like an Op painting: the shapes seem to hop about, after-images appear, the surface becomes unstable. The presence of what might be called artificial after-images which seem to mirror their stronger neighbours—give the painting an illusory depth which has something in common with the ambiguities referred to earlier, and thus preserves a balance between surface and depth. This possibility prevents a thoroughgoing optical effect from taking place, and therefore gives support to those who wish to disassociate Poons from Op proper. But this is a fragile support. These works of Poons show that no clear-cut boundary can be drawn between what is Op and what is not.

A similar conclusion may be drawn from Albers's paintings in the series 'Homage to the Square'. Whereas Poons is more often placed outside the frontiers of Op, Albers is usually placed within them. Yet it is not at all clear why this should be so. Albers, it is true, is interested in the optical effects of colour, but in the series referred to he is very careful to control them. As Seitz says:

Albers, indeed, has always avoided . . . a hostile attack on the senses. His famous nests of squares are assembled from softer contrasts and analogies in which the median tones interact subtly with the central and outer areas.

The addition of the third, mediating colour, its appearance delicately modulated by its neighbours in gaseous transparency, produces a more tranquil mode of interaction.

Departing in Yellow (plate 39) illustrates this very well—too well perhaps. The gradation from the central lemon yellow to the outer olive yellow could hardly be gentler: the colours are so close to each other as to be hardly even analogous, much less complementary. And yet if the outer and the central squares were brought into contact a stronger contrast would take place. The transition is so beautifully modulated—the third square from the centre mediating between the outer olive yellow and the citron—that one would never suspect that any departure from yellow had taken place. If this is Op, then it is Op at its gentlest.

Constructivist, programmed and Op art

The 'colour imagists' have one other feature in common with Op artists, namely, the simplicity of their structures. This feature is shared by certain other groups who are not so exclusively interested in colour relationships. These, the heirs of Mondrian and Malevich, may be loosely called Constructivists (more accurately, Concrete artists) and include Gorin, Peire and Seuphor. They work with hard-edged, geometrical units which adhere closer to the surface than any other form of abstraction. These are usually assembled into well-balanced compositions of form and colour. Most of these compositions are not in the least threatened by optical displacement. But there are others in which the units are small and uniform, as in the compositions by Bill and Lohse, which very closely resemble certain Op works.

As we have seen, the repetition of a large number of identical geometrical units will produce an optical flicker. Thus, only a hair's breadth comes between some of these compositions and a work like

Müller's *SD 65* or Hacker's *Cubes*. It requires a very delicate balance between the size, number, colour distribution and placing of the units to prevent optical effects from taking place. Indeed, Hacker's *Cubes*, because of their size, only barely work optically, though they do not adhere to the surface either. Yet, precisely because these artists whom I am calling Constructivist or Concrete artists, are at such pains to preserve the surface, their aims are essentially different from those of Op artists, in spite of some striking superficial resemblances.

Indeed, as we shall see in the following chapter, certain Op artists arrived at Op in direct opposition to and rejection of Constructivist principles. As the Groupe de Recherche stated in a manifesto in 1962: we are 'against the fruitless promulgation of a manner which has remained attached to geometric forms and which now merely repeats for the most part the propositions of Malevich and Mondrian,' and Stein adds:

The surface ought not to be considered as an end in itself, but as a pole of contact in the relationship eye–picture . . . It has evolved, passing from the sensory data of the normalized situation—*art concret*—constructivism. It seems to me necessary to discover a new surface organization by mathematical series not using them like the constructivists to guarantee the mathematical equilibrium of their compositions or to exemplify certain mathematical laws, but to use them as motive forces.

This reaction did not lead uniquely in the direction of Op or Kinetic art. Some artists carried the principles of Bill and Lohse a stage further in the direction of greater indeterminacy or randomness of construction. Instead of determining once and for all the distribution of the units, they set up a programme with a wide range of possibilities which could be realized successively and in which each realization was determined by chance. Because of the instability of these structures, the result is very often optical. Hence, programmed art based on

indeterminacy, though not identical with, is certainly compatible with, optical results. Many of the works considered in Chapter 2 were both programmed and optical. Morellet's *Aleatoric Distribution*, as we have seen, though optical in its effects, was arrived at by picking random numbers from the telephone book.

Op and Kinetic art

In the last chapter we saw how prominent a part movement plays in Op painting. In this chapter we have seen how this comes about, namely, by the use of optical effects. All the paintings considered in the previous sections, whether by Braque, Albers, Stella, Davis or Poons, have an element of movement, a continuous departure from and return to the picture plane. But in each case this movement is controlled so as not to allow it to destroy the picture plane. In Op these controls are removed and the whole surface appears to be in motion. (This does not mean that there is no control over the movement in an Op painting, but only that the control is exercised at a later stage.) In practice it may be difficult to determine in a particular case whether or not the degree of movement is sufficient to bring a painting within the category of Op. There are no clear-cut boundaries, as has already been noted.

Because of the intensity of the movement (or apparent movement) in Op painting, it is common to classify Op with Kinetic art. As Seitz says, 'the art of mechanical movement' (a slightly inaccurate or at least tendentious way of describing it) and optical art 'have an intertwined development that cannot be totally disentangled'. He believes, however, that our experience of Op is of a different order from our experience of works which involve actual movement. Op, as he puts it, 'always exists in a tension with factual immobility'. Those who wish to classify Op along with Kinetic art disregard this feature of Op. They hold that, because

of the strong impression of movement in Op paint-
ing and in spite of its physical immobility, it should
be regarded as a form of Kinetic art.

The case for including Op painting along with
other forms of Kinetic art is forcefully argued by
Stephen Bann in *Four Essays on Kinetic Art*. There
are three kinds of Kinetic art, he says: (1) that
which involves actual movement on the part of the
object, whether this is mechanically induced (like a
work by Schoeffer) or by some other means (like a
Calder *mobile*). (2) that which requires to be moved
by the spectator or alters noticeably as the spectator
moves in front of it—'induced' movement; (3) that
in which neither the object nor the spectator move,
but an impression of movement is conveyed—
'virtual' or apparent movement, which 'only be-
comes appreciable after an effort of concentration'.
Op is said to belong to this last class.

One reason for including Op, says Bann, 'lies in
the fact that it is the artist's avowed intention to
create a sensation of movement through trans-
parency and arrangements of line and colour'. The
artists themselves reject the separation of actual and
virtual movement. They believe that they are intro-
ducing a movement no less real and actual even if
there is no displacement of mass in the works
themselves. Vasarely has referred to his works as
'cinétique' ever since 1955, even though they are
entirely of this virtual type. Bann goes on to say:
'Does not optics, even in the form of illusion,
belong to Kinetic? Does not agressing the retina
in fact make it vibrate? . . . A change of nomen-
clature would obscure the fact that Vasarely is
avowedly concerned with presenting movement in
his chosen media.' To separate Op from Kinetic art
would introduce an unnatural division within the
work of such artists as the Groupe de Recherche,
Martha Boto and Vandanegra who include both
virtual and actual movement in their work. 'It is
clear that identical preoccupations with form govern
both their virtual and their actual works.' All

Kinetic Art has some optical effect and both kinds of
movement have in common 'the minimizing of the
work itself'.

In spite of what Stephen Bann says, there are
artists who make within their own work the very
division which he considers confusing. Soto, for
instance, says that he made 'a definite transition from
optical art—in which the picture would be embraced
at one glance without the intervention of move-
ment—to kinetic art in which movement and time-
duration are directly experienced.' Soto is here
separating virtual and induced movement.

Seitz agrees with Soto that there is an important
difference between these two kinds of movement.
For instance, moiré effect, he says, requires move-
ment on the part of the spectator and reliefs 'would
not come alive for an immobile spectator'. Yet he
admits that it is the impact on perception which
counts. He prefers to draw the line between the
immobile and the mobile, or rather between the
mobile and the static which produces a dynamic
perceptual response:

Perceptual viability, not physical movement, is at
issue whether it results from internal variation or change
of viewpoint . . . The intent of *The Responsive Eye* . . . is
to dramatize the power of *static* forms and colours to
stimulate dynamic psychological responses.

Even Stephen Bann is prepared to admit some
distinction between our experience of the various
kinds of Kinetic art: in a sense, he says, virtual
movement occupies a half-way ground between the
mobile and the static. Elsewhere he says:

The fact that the term 'kinetic art' can be applied to a
wide range of works must not be taken to imply that the
aesthetic experience of movement is identical in all cases.
In fact, this experience seems to vary in direct relation-
ship to the existence of the three basic groups.

He even offers a criterion for distinguishing be-
tween them (which does not seem universally valid),
namely, that, whereas virtual movement is elusive,

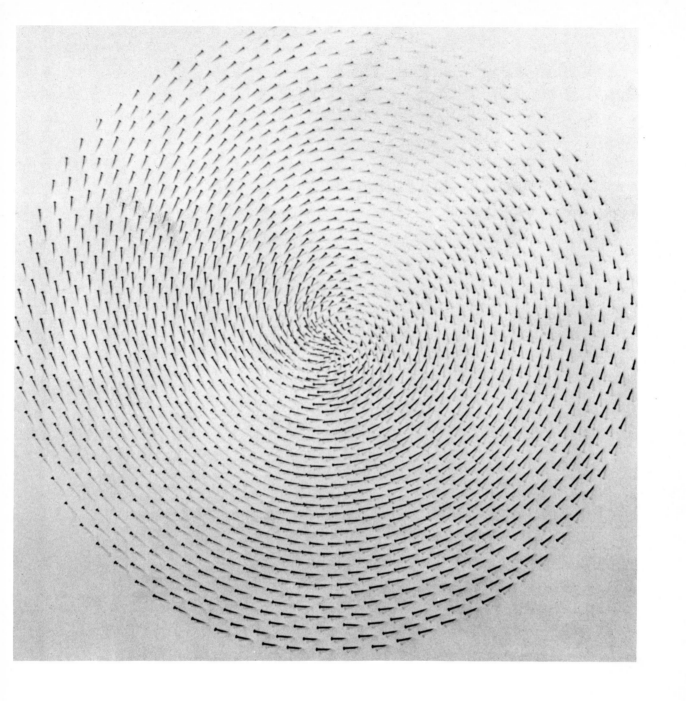

40 Gunther Uecker *Spiral* 1965 39½ × 39½ in.
Collection Hon. Mrs Miriam Lane, Oxfordshire

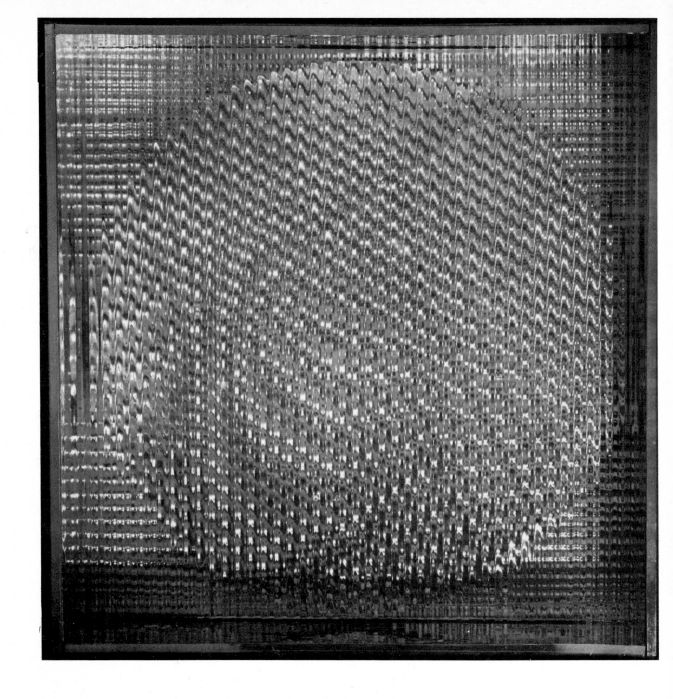

41 Heinz Mack *Light Dynamo* 1963 22½ × 22½ × 22½ in.
Tate Gallery, London

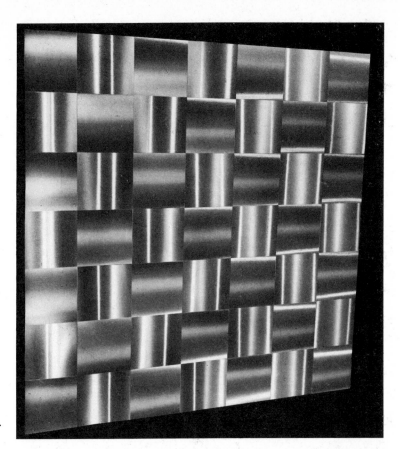

42 Getulio Alviani *Surface of Vibrant
 Texture* 1963 aluminium $38\frac{1}{2} \times 38\frac{1}{2}$ in.
 Denise René Gallery, Paris

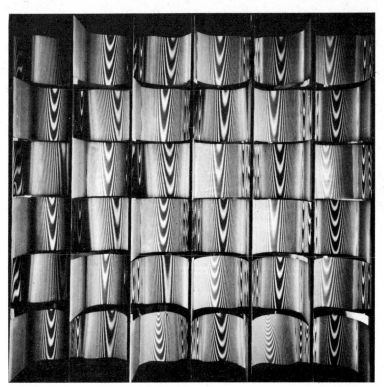

43 Julio Le Parc *Double Movement by
 Displacement by the Spectator* 1965
 $48 \times 48 \times 9\frac{1}{2}$ in. Detail
 Denise René Gallery, Paris

44 Martha Boto *Luminous Polyvision* 1965 $23\frac{1}{2} \times 23\frac{1}{2} \times 23\frac{1}{2}$ in.
Denise René Gallery, Paris

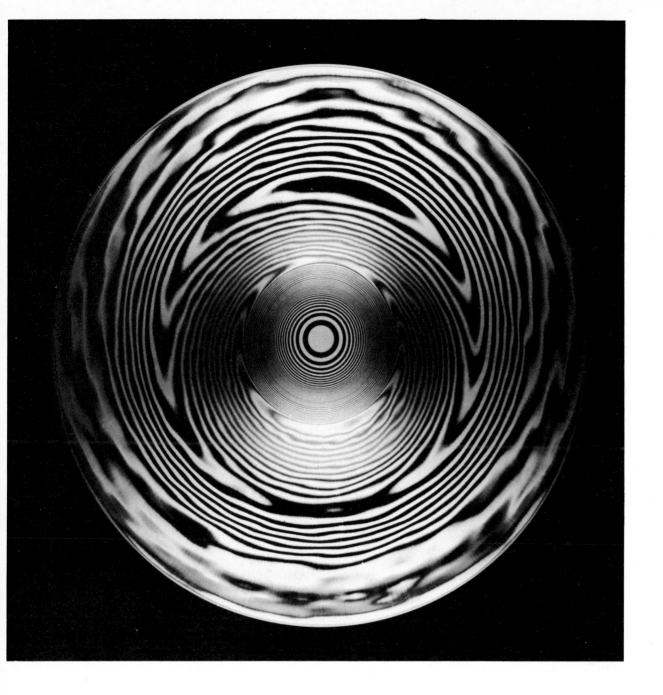

45 Karl Gerstner *Lens Picture no. 15* 1964 concentric circles behind plexiglass
lens $28\frac{3}{8} \times 28\frac{13}{16} \times 7\frac{1}{4}$ in.
Albright-Knox Gallery, Buffalo. Gift of Seymour H. Knox

◀46 Julio Le Parc *Contorted Circle*
 1966
 Denise René Gallery, Paris

47 François Morellet *Successive
 Illumination* 1963
 Denise René Gallery, Paris

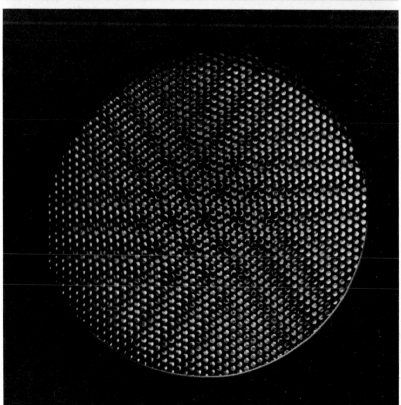

48 Joël Stein *Web in Movement*
 Denise René Gallery, Paris

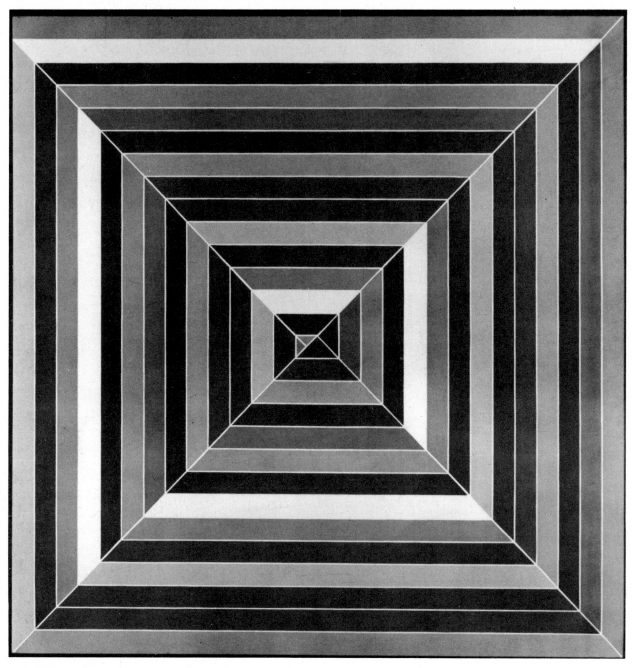

49 Frank Stella *Hyena Stomp* 1962 77 × 77 in.
Tate Gallery, London

50 Georges Braque *Still Life with Marble Table* 1925 $51\frac{1}{2}$ × 29 in.
Museum of Modern Art, Paris

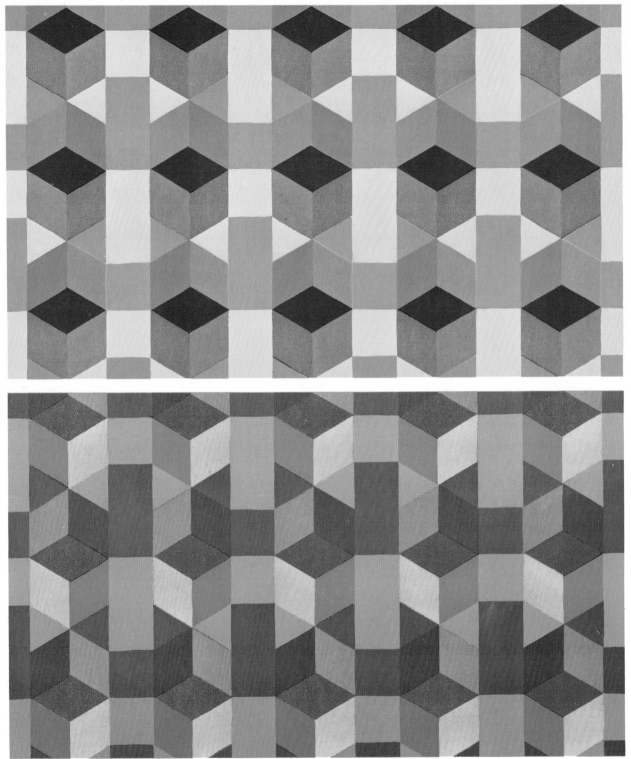

51 After Lily Greenham's *Green Cubes in Movement* 1967

52 Peter Sedgley *Videorotor* 1968 72 in. diameter
Collection Richard Feigen, New York

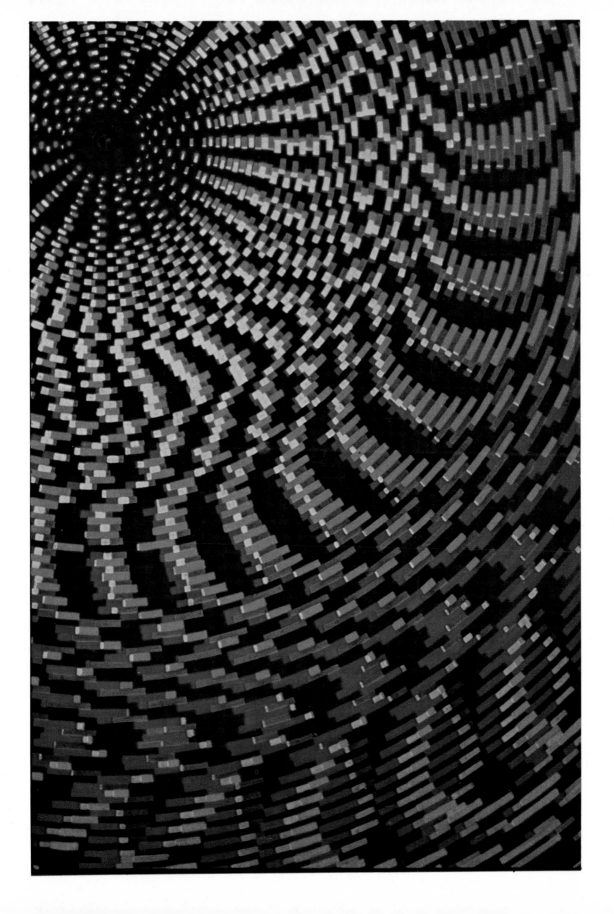

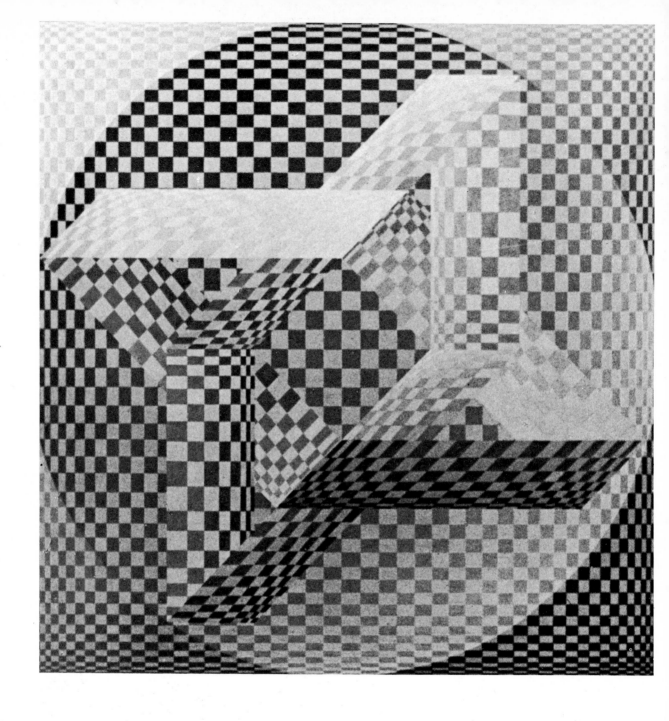

53 Benjamin Cunningham *Equivocation* 1964 26 × 25½ in.
East Hampton Gallery, New York

54 Richard Mortensen
Opus Rouen 1956
$63\frac{3}{4} \times 20\frac{1}{2}$ in.
Denise René Gallery,
Paris

55 Auguste Herbin *Nude*
1960 $18\frac{7}{8} \times 15$ in.
Tate Gallery, London

56 Larry Poons *Northeast Grave* 1964
90 × 80 in.
Collection Joseph H. Hirshhorn, New
York

57 J.–R. Soto *Repetition Yellow and
White* 1951 75 × 51¼ in.
Denise René Gallery, Paris

58 J.–R. Soto *Cube of Ambiguous Space* 1969 98½ × 98½ × 98½ in.
Denise René Gallery, Paris

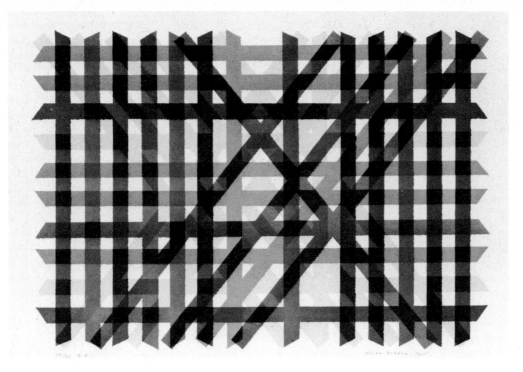

59 Piero Dorazio *Untitled* 1965 lithograph $22\frac{1}{4} \times 30$ in.
Marlborough Fine Art Ltd., London

60 Antonio Asis *Spiral* 1966 metal on metal $39\frac{3}{8} \times 39\frac{3}{8}$ in. Detail
Denise René Gallery, Paris

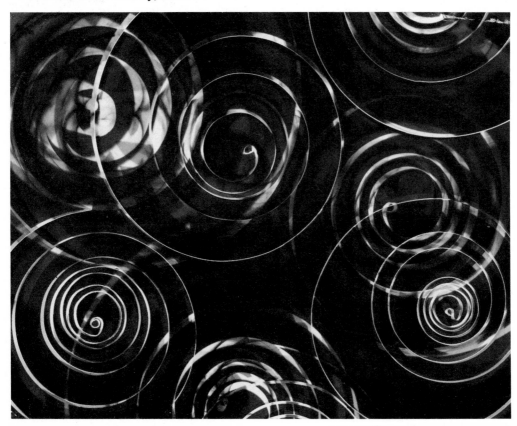

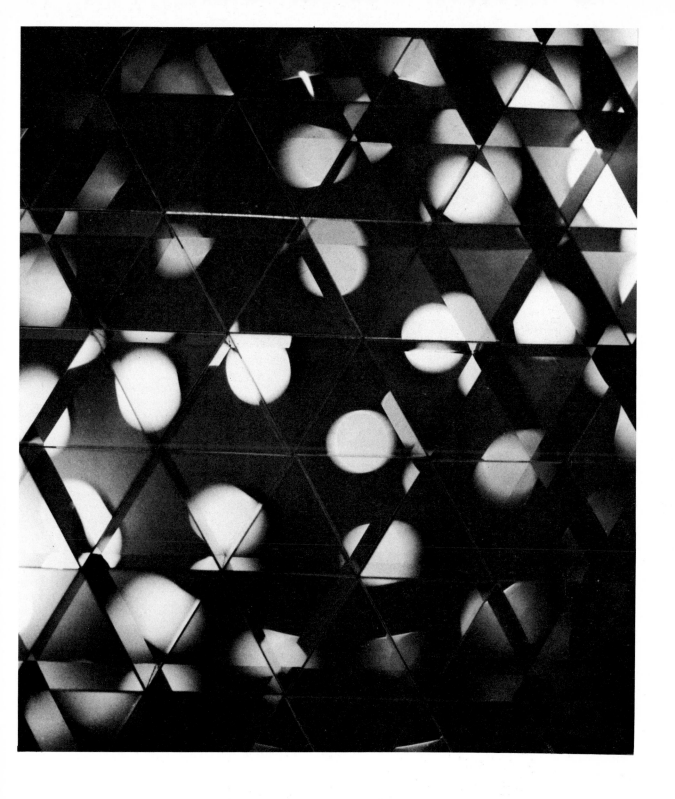

61 Hugo-Rodolfo Demarco *Animated Table* 1966 35½ in. diameter
Denise René Gallery, Paris

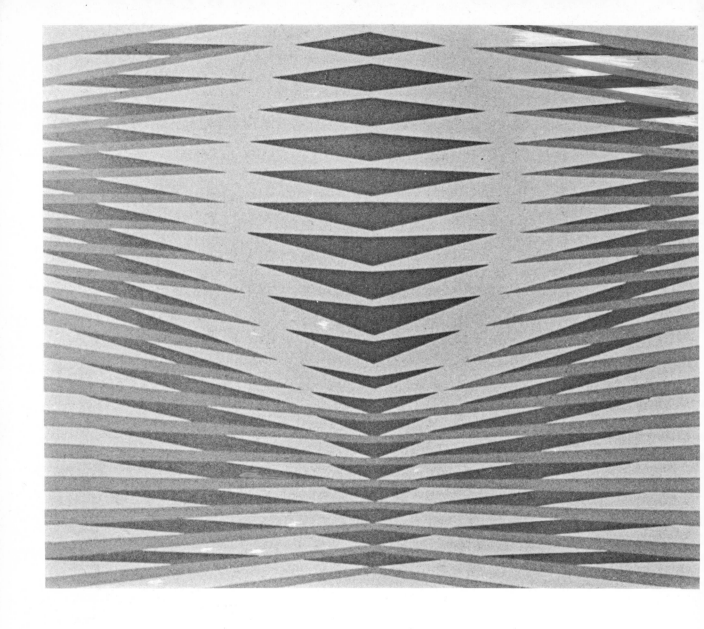

62 Michael Kidner *Orange, Blue and Green* 1964 49 × 60 in.
British Council, London. Calouste Gulbenkian Foundation Collection

63 Bridget Riley *Pink Landscape* 1958-9 40 × 40 in.
Artist's collection

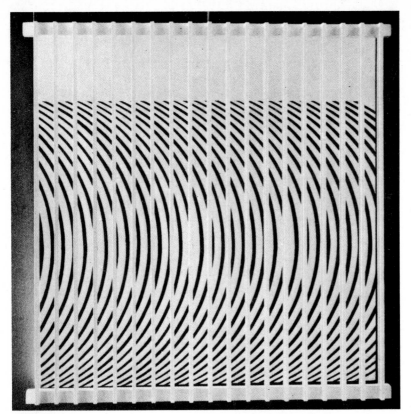

64 John Goodyear *Black and White
 Waves* 1964 24 × 24 × 9 in.
 Private collection

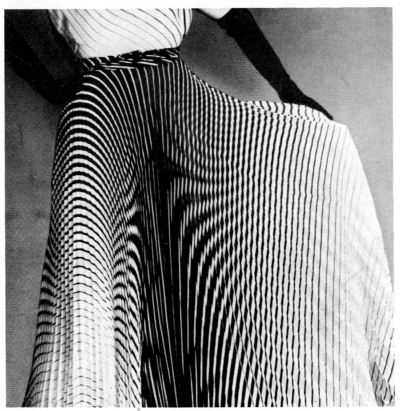

65 Getulio Alviani. Dress
 Galleria del Deposito, Genoa

mechanical movement is predictable—'the machine subjects this elusive movement to a periodic cycle'.

There is, therefore, considerable divergence, not only in the use of terminology, but also in what is meant by the terms used. It is, however, certain that optical effects are to be found in each kind of Kinetic art. Gabo's *Kinetic Construction* undoubtedly moves—it does not merely give the impression of movement—but it does give an impression of solidity, and this is an optical effect of light on a moving object. But not all works which actually move are Op, as, for example, works by Bury or Tinguely. Nor, if it comes to that, are all works which actually move 'kinetic' in the accepted sense— the *Mona Lisa* on wheels would not be 'kinetic' (though if it were spun fast enough, it might be— but that is another matter).

The first thing therefore to be clear about is that 'op' and 'kinetic' are not two exclusive categories. Some artists describe their works quite correctly as 'optical–kinetic' or 'optical–dynamic'. But it should be further observed that 'apparent movement' covers not only works which require no movement on the part of spectator but also those which do. The movement in a Soto relief is just as much apparent, just as optical (for all that the spectator moves) as the movement in a Bridget Riley. In both cases the work itself is static. But of course, the spectator, as Soto says, has a greater experience of movement when he himself moves than when he remains stationary or when his movement does not noticeably alter the picture; and for that reason these works may rightly be considered kinetic. If, however, this is what is meant by kinetic, then it should be noted that in this respect static works which do not change when the spectator moves are no different from works which actually move. For, where the work moves, the spectator does not; so he does not have that direct experience of movement about which Soto speaks.

What conclusion is to be drawn from all this? Since the term 'kinetic' shifts in meaning as it passes from moving objects to works involving spectator displacement and still further when applied to purely static works, it would seem less confusing to use it without qualification of moving objects only. It would be still possible to speak of works involving spectator displacement as 'optical–dynamic (or optical–kinetic) reliefs' and even to speak of 'optical–dynamic or optical–kinetic paintings'. But whether the term 'kinetic' is extended or not, the term 'optical', which can be applied *without change of meaning* to all kinds of works should not be restricted to static works. For, if reliefs and paintings can be called 'kinetic' it is because they *move optically*; but if moving works are called 'optical', it is not because they move, but because the movement produces optical effects (and these are *actual*, not virtual or apparent, optical effects).

7 Principal figures in the European movement

At the beginning of this book the question was raised: why did Op not develop directly from the investigations into the properties of simultaneous contrast of colour carried out by Seurat and the Neo-Impressionists? The answer given was that European art was not yet ready for the transition to geometrical abstraction that this would involve. At the beginning of this chapter two further questions present themselves. First, why was an Op art movement so long delayed after the transition to geometrical abstraction had been accomplished and after a number of optical works had already been made? The beginnings of geometric abstraction go back at least to the First World War; the Op art movement cannot be said to have properly begun before the early 'fifties—a lapse of forty years. Secondly, and conversely, why after such a lapse of time did it begin when it did, or indeed, why did it begin at all?

As regards the first question, a number of factors must be taken into consideration. For one thing, optical effects were regarded by most artists (and still are by some, e.g. Max Bill) as an amusing sort of visual trickery. This may be partly why they appealed to Duchamp. Or they were merely an extension of the science of perception. Or again, they were useful artistic exercises and experiments—as they were for Balla and the teachers at the Bauhaus—but too restrictive in themselves. All of which amounts to saying that they were not taken seriously. As Soto put it: 'Most optical paintings seem to me to have a great deal of surface drama, but no real density.' There is yet another reason to which Seitz has drawn attention, namely, that until recently the kinds of pigments and other materials necessary to produce optical effects satisfactorily were not available. The range of colours now at the artist's disposal, which come direct from the manufacturer and do not have to be mixed on the palette with consequent loss of intensity, is vastly greater than it was even thirty years ago. Acrylic and emulsion paints enable the painter to achieve the homogeneous surface essential to optical effects, even when working with a brush, which is often difficult with oil-bound paints.

As for the second question, a partial answer, at least, is supplied by considering the artistic situation in the period immediately following the war, that is, between 1945 and 1950. At that time there were in Paris two forms of abstraction: the geometrical form practised by the artists discussed at the end of the first chapter, and a more expressionistic form of abstraction such as was practised by Kandinsky in his early period and outlined in *On the Spiritual in Art*. It was this which most attracted the younger painters—Wols, Hartung, Soulages, Mathieu, Manessier, Bazaine. Estève, Riopelle—and was given the name *tachisme* or *art informel*. By the early 'fifties Tachism was in the ascendant. By the end of the 'fifties a reaction against the informality set in, and a new generation of artists found in optical and kinetic art a more precise and disciplined form of abstraction which was in turn different from pre-war Neo-Plastic, Suprematist and Constructivist abstraction. In other words, Op art came into its own as an alternative form of geometrical abstraction. But, as we saw in the first chapter, it also grew out of the sort of abstraction practised by artists like Herbin, Mortensen, Baertling and Dewasne. This is evident from the development of Vasarely round whom many of the new generation rallied.

Vasarely

George Rickey is probably right when he says that 'the primary source for the artistic use of optical phenomena is not the teaching of Albers on colour but the painting and influence of Vasarely'. Victor Vasarely was born in Pecs in Hungary in 1908. As a child he was highly inventive. Speaking of his 'Transparencies' he writes:

In my native Hungary the windows are double because of the extremes of the continental climate. One winter

when I drew a sun-face on the outer pane, then, shutting the inside window-frame, I tried to reproduce exactly the same drawing on the second transparent surface, separated from the first by some six or eight inches . . . These two sun-faces that were superimposed when looked at from directly in front, doubled their grimaces when I moved my head to the right or to the left. This crude little cinema has left deep traces in my subconscious.

At the same time he developed a passion for grids:

In about 1913, as a child, I injured my forearm while playing . . . The wound was dressed with gauze, a light white fabric that changed its shape at the slightest touch. I never tired gazing at this micro-universe, ever the same and yet other. I would play with it, pulling the crowded threads one by one.

Seven years later, in 1920, when he was twelve and at the *lycée*, he was fascinated by isobar maps of the earth—'those equal lines energized the well-known contours of the continents'—and the iso-clinical, isochronous and isochromatic lines of physics completed his vision. 'I passionately loved those networks. I filled whole notebooks with them.'

On leaving school he began a course in medicine, but abandoned it two years later and took a job as an assistant book-keeper in a ball-bearing factory. One day the boss asked him to do some posters. He entered one for a competition in *La Vie Publicitaire*. He did not win, but the magazine introduced him to modern art.

It was fantastic. I was 21 at the time. There were masses of posters inspired by the Bauhaus as well as reproductions of Gropius, Kandinsky, Klee, Breuer, Albers, Moholy-Nagy—and so on.

It was there he came across Bortnyik's offer to pass on what he had learnt at the Dessau Bauhaus. Vasarely attended Bortnyik's 'Bauhaus' from 1928–9 and there, he tells us,

I swallowed the lot pell-mell—Cubism, Leger, Malevich, Mondrian, Tatlin, Lissitzky, Chagall, Le Corbusier, Matisse.

His views on these artists have been described elsewhere, but it might not be out of place to add one more quotation here:

Malevich ended up with zero, a white square on a white ground. Mondrian too led into a *cul-de-sac*. I didn't want to follow him. I did not want to add to the number of navel-contemplating works. This concoction of poetical, rarified, perfect specimens seemed out of touch with the problems of modern man.

In the following year, 1930, feeling suffocated in Hungary, he left for Paris. While with Bortnyik he had made a thorough study of lines and criss-cross networks. 'For ten years applied and experimental graphism was to be my principal occupation in Paris.' For a living he worked at the Havas, Draeger and Devambez print works doing pharmaceutical advertising. Then in 1935 he bought a book on modern art with reproductions of Klee, Ernst and all the artists he had studied in Budapest and forgotten. As a graphic and commercial artist he had felt superior to painters whose work seemed useless. Reading that book he realized that the painters were the real innovators and that all the best ideas in publicity work came from them.

During the early years in Paris, 1931–2, he made his first optical works. They were geometrical drawings for fabric prints. 'Many of these 10 × 10 cm drawings, pretentiously enlarged, might have constituted an anticipatory collection of "Op Art" . . . In any case in 1954–6, I developed major works from them: *Tlinko*, *Eridan*, [etc.]' These were followed in 1933–8 by the figurative Op works already discussed. He says:

Curiously enough, it was in my '*Two-dimensional Graphic Studies*' executed between 1933 and 1938 that the optical kineticism finally appeared in a vigorous and decisive way. *Checkerboards*, *Harlequins*, *Zebras*, *Tigers*, *Prisoners* and *Martians* moved, not by mimeticism, but by the aggressiveness with which their structures struck the retina. Although figurative, these studies, rich in invention, constituted the basic repetory of my abstract kinetic period in the plane, undertaken in 1954.

The reference to mimeticism has to do with the work produced after 1938, at the time when he discovered Futurism. These were only imitations of movement, mere optical deceptions, *trompe l'œil*. 'Like Futurism itself,' he says, 'these studies of movement were on the wrong track.' Between 1938 and 1951 Vasarely did no more optical works.

During this period he worked as a commercial artist. He had plans for opening a school, and to gain support for his project he held an exhibition of over a hundred display cards in 1944 in apartments owned by Denise René. Though the exhibition was a success, he got no encouragement to open the school.

In 1946 he went through a brief Tachist and Symbolist phase.

This was where I started to follow a lot of false scents. There was the gestatory period in 1946: pictures made entirely of paste, of which I sold dozens. I could have become an Estève or Bazaine. The same year I went through a symbolist period full of angels, prisoners, the devil, rather like Prévert. I could have gone on, but what I had learnt from the Bauhaus made me rebel.

In the summer of 1947, while on holiday on the beach at Belle-Ile, he returned to geometrical abstraction.

The abstract was only revealed to me in 1947 when I was able to recognize that pure form and pure colour could represent the world.

There followed, from 1947 to 1951, a period of 'pure composition', though not quite as pure as he would have liked. Though he recognized in pebbles and pieces of glass polished by the rise and fall of the waves the inner geometry of nature, he still suffered from traces of gestural painting. He also discovered that it was not easy to rid oneself of figurative elements—he called them phantoms of his past—a line that becomes a horizon, an angel with outspread wings, etc. Although the climate was not favourable to abstract painting—Tachism only became popular in 1950—Vasarely received support

from other artists: Deyrolle, Dewasne and Arp in 1946; Mortensen and Poliakoff in the following year. They met on Saturday nights and discussed their work.

His return to optical art in 1951 came about through a return to the grills and networks of lines. He first made some small linear drawings which were photographically enlarged to room size and exhibited under the title 'Photographisms'. (They were also used as a setting for a ballet.) The transposition of these drawings, with their character intact, to a super-human scale, demonstrated for Vasarely the power of the machine as an aid in artistic production. These were followed in 1952 by 'Grills' which consisted of two superimposed similar networks. These 'Photographisms', as we have seen, are only partially optical in their effect, and the 'Grills', though they give a much stronger impression of movement owing to the displacement of periodic structures, are often too structured to be fully Op. The 'Transparencies' and 'Deep Kinetic Works' (described above), which he made in 1953 and the 'Kinetic Works in the Plane', begun in 1954, are quite definitely optical in their effect. (All of these have been discussed elsewhere in the book.) It should be noted that the 'Deep Kinetic Works' are 'kinetic' only in the sense that they involve actual movement on the part of the spectator, and the 'Kinetic Works in the Plane' because they give an impression of movement.

In 'Planetary Folklore' Vasarely sings the praises of optical kineticism:

The stake is no longer the heart but the retina, the refined mind becomes the subject of experimental psychology. Sharp black–white contrasts, the unendurable vibration of complementary colours, the flickering of rhythmed networks and permuted structures, the optical kineticism of plastic components, all physical phenomena present in our works, the role of which is no longer to create wonder or to plunge us in sweet melancholy, but to stimulate us and provide us with wild joys.

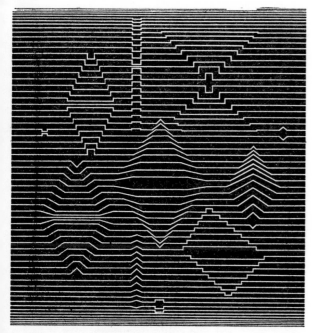

FIG 48
Victor Vasarely *Photographism Ibadan* 1952–62, 64½ × 59 in.
Private collection

And in his 'Notes for a Manifesto', in what has come to be called the 'Yellow Manifesto', published on the occasion of the Movement exhibition at the Denise René gallery in 1955 (at which Agam, Soto, Calder, Duchamp, Tinguely, Bury and Jacobsen also exhibited), he refers to his work as 'kinetic' (*cinétique*) in passages of some obscurity.

THE SCREEN IS FLAT, BUT, BY PERMITTING MOVEMENT, IT IS ALSO SPACE . . . *We possess the instruments and the technique and finally the science to attempt a plastic-kinetic* . . . The animation of the plastic develops to-day . . . *by the methodical employment of the* CINE-MATOGRAPHIC DOMAIN *by the discipline of abstraction. We are at the dawn of a great epoch.* THE ERA OF PLASTIC PROJECTIONS ON SCREENS, FLAT OR IN DEPTH, IN DAY-LIGHT OR DARKNESS, IS BEGINNING.

With these optical-kinetic works, he believes that

he has brought painting into line with the outlook of our day:

At a time when mankind has extended his knowledge to cover both macro- and micro-cosmos, how can an artist get excited about the same things that made up the day-to-day world of the painter of the past, restricted as it was to what came within his immediate sense-range —his home, the people he knew, his garden . . . Henceforth art will adequately express the cosmic age of atoms and stars.

The 1955 Exhibition caused something of a sensation. It brought together for the first time artists with a common purpose and interest in the artistic use of kinetic and optical effects. From now on Op art can be considered as a movement, and no longer as an isolated phenomenon or the pursuit of a few artists ploughing lone furrows. (The name 'Op', of course, was not given to it till ten years later.)

Since 1955 Vasarely has been building on the foundations laid in the early 'fifties. Not all his work has been Op in the strict sense. The most significant developments in his art have been: the transition from black and white to colour in the early 'sixties, though without any of the optical movement of other optical colourists; the introduction of tonal values about 1965; three-dimensional solid objects—pyramids and columns—in blocks or 'units' of coloured geometrical forms; and the design of manufactured multiples. Other minor developments include the use of deforming glass in his 'Deep Kinetic Works' of 1958. In some of his most recent work, *Tri-Dim* (1969), he seems to have projected the columns and pyramids back on to the canvas as ambiguous forms of great solidity. This marks his furthest departure from strict Op so far. But he has not abandoned it entirely, since he is also doing works on the *Vega* theme.

Vasarely has also done a number of environmental works, op murals and screens, such as those for the Cité Universitaire in Caracas in 1954. He believes that his art has a sociological value. For this

reason he attaches much importance to the mechanical multiplication of his works. And he usually entrusts the execution of the work to his assistants, once he has worked out the idea. This is possible because he works with expansible plastic units and the hand of the artist has no significance for him.

Henceforth the initial creative object will be of 'small-format' made up of constants . . . an expandible medium, doubling as a sort of 'partition scenario' which will enable the artist to recreate on canvas, a tapestry, a fresco, an *album* of prints, or a plastic kinetic synthesis, or even a filmed abstract symphony.

One consequence of this, in his opinion, is the end of the individual artist and the unique picture.

It would seem that there is no difference between me and any vulgar careerist. A difference exists, however. *His* ideas date from the Renaissance; *I* fight for the debunking of the artist and an end to individual pictures.

In conclusion, one could say of Vasarely that, in spite of the influence he has had on the evolution of the Op movement, in a way, optical effects are only incidental to his work. His primary interest is the 'plastic unity of form-colour' on a plane surface or pure composition. If Vasarely has inspired Op artists and produced some outstanding works of this kind, he is not primarily, much less exclusively, an Op artist himself. His respect for the plane surface and the clearly defined, if ambiguous, form keeps him within what I have called the cubist tradition, even though, in departing from direct reference to natural objects and the spatial orientations of figurative painting, he has broken with Cubism proper.

Soto

The development of Soto as an optical and kinetic artist closely parallels that of Vasarely in time. He came to Paris in 1950. By 1951 he was 'groping his way towards *vibrations* and *optical art*'. In 1954 he made his first 'Superimpositions'. The two artists share certain common influences, notably Mondrian, Malevich and Kandinsky. They both pursue a pure form of abstraction and both want to carry abstraction beyond the stage reached by Mondrian and Malevich to something more dynamic. There is a possible discrepancy in their attitude to Mondrian, however. Vasarely sees him as the painter who reduced the visible world to its simplest elements while Malevich began the process of building up a vocabulary of abstract forms. Soto, on the other hand, saw Mondrian as truly abstract. 'He was the only artist I knew who was completely abstract.' He does not regard Vasarely as a completely abstract painter: 'In Dewasne's work, and in Vasarely's, the forms are clearly derived from the world of objects.' Even Vasarely would admit that this is true of his work up to 1951 and he would probably agree with Soto's own claim: 'My work is totally abstract. It was born out of a study of painting, not of life.' Fifteen years junior to Vasarely, Soto came on the scene at a time when geometrical abstraction was already accepted and established. He could, therefore, take it as his point of departure.

Jésus-Raphaël Soto was born in Ciudad Bolivar in the Orinoco Province of Venezuela in 1923. At the age of fifteen he became a sign painter. A Lebanese member of a Surrealist group taught him to draw. His technique was so good that the local people and their bishop signed a petition to have him sent to art school in Caracas. There he was absorbed by Cézanne and Van Gogh. 'I was asked at the school to copy nature,' he says, 'I was shocked and disillusioned.' He had the good fortune, however, to work under Monsanto who was enlightened enough to tell him: 'You want to go further than my ideas . . . well, go ahead, then.' Even in those days Soto had achieved that clarity of expression which is one of the outstanding characteristics of his work. Cruz-Diez, a fellow student, remarked: 'For you, Soto, painting is something very uncomplicated.' 'My own sense of clarity,' says Soto, 'astonished me.'

After a period as professor and director at the School of Fine Art, Maracaibo, from 1947, he left for Paris in 1950. Paris for Soto meant Impressionism. He was struck immediately on landing at Cannes by the 'Impressionist light'. Impressionism, whether that of the French or of Turner, meant an enormous amount to him.

While the other Venezuelans in Paris studied abstract art under Dewasne and Pillet, Soto worked on his own. He painted huge canvases of simple geometrical elements. He had very quickly put impressionist techniques behind him and had fallen under the spell of Mondrian. Since 1950, when he first saw Mondrian's paintings of 1917 composed of plus and minus signs, he has never given a thought to pointillism. At first he made irregular forms 'in order to dynamize the impeccable composition of the Dutch master'. But this did not work. He then realized two things: first, that *forms must be left behind*:

Even the word 'plastic' I reject. I was against 'neo-plastic art', and I know Mondrian was too. Plastic evokes form. But I am against form. I have never believed in the plastic relationships between forms.

secondly, that to make the image move he must use optical means:

I really started out with the desire to make Mondrian move. Mondrian's last three works, the boogie-woogie paintings . . . affected me deeply . . . It seemed to me that he was about to make the image move optically, and it was this process that filled my mind when I started making works in 1951.

And he discovered that the means by which forms could be made to disappear and the picture made to move optically were the same: repetition.

In 1951 he made a number of reliefs which he called 'Répétitions Optiques' or simply 'Repetitions'. One splendid example, *Repetition Yellow and White* (plate 57), consisting of yellow, white and black rectangles or lozenges, already displays many of the essential features of Soto's work:

clarity, precision and the use of simple elements and pure colours.

I began with repetition—identical forms repeated across the canvas—and always the simplest possible forms such as rectangles and squares. I have always worked with the smallest number of elements, to get away as far as possible from *description*. French painters have tended always to use 'beautiful' forms, forms with a decorative function. I decided to use more anonymous and impersonal forms—the line, the square, the circle . . . By means of endless repetition of the square, the square itself disappears and produces pure movement.

But, though there is some optical movement in these pictures, Soto had not yet achieved the pure movement he was striving for: he still was groping his way towards *vibration* and *optical art*.

In these pictures Soto was carrying the impersonal, systematized and programmatic method of Bill and Lohse a stage further. During the next two years, 1952–3, he continued along these lines, not only with optical reliefs, but also with serial studies of superimposed dots. He had already been impressed by the notion of serialism in music, in which, as he put it, the twelve notes are organized in advance independently of their sound. He saw this as a means of escaping from artistic preconceptions, unconscious influences, associations and 'good taste'.

I sacrificed my taste for colour and my pleasure in organizing. I isolated the three primary and secondary colours, as well as black and white. To each I gave a fixed place in numerical order along a line determined at random. Then I applied the colours systematically along the grill, repeating the operation over the whole surface.

The result was not only an annihilation of the individual forms, the dots, but the sort of optical vibration he was looking for.

At first these systems or grills of dots were superimposed directly on one another at a slight angle—as with Vasarely's grills of the same period—but in 1954 the transparent grills were placed in front of

one another separated by some distance. The vibration was increased by the movement of the spectator, and not only were the forms annihilated, but the distance between them as well. The first of these, *White Dots on Black Dots*, which Soto describes as 'my first kinetic work' (*structure cinétique*), which he exhibited that year at the Salon des Réalites Nouvelles, and the impressive *Metamorphosis* of the same year have already been mentioned. But, though he refers to them as 'kinetic' because they call for actual movement on the part of the spectator, a definitive transition to Kinetic art did not take place till the following year.

The real revolution occurred in 1955, my definitive transition from optical art—in which the picture could be embraced in one glance without the intervention of movement—to kinetic art, in which movement and time-duration are directly experienced, becoming a fundamental constitutive dimension in my work.

Soto's distinction between optical and kinetic art has already been discussed. Though some distinction such as Soto makes is valid, I shall continue to treat his 'kinetic' works as strictly optical, since, whatever they may do besides, they function optically. Soto implicitly admits this when he describes the genesis of these works. The idea came to him when, in April 1955, he saw for the first time what he calls (quite rightly, even though the title is incorrect) Marcel Duchamp's 'optical machine' (the *Rotary Demi-Sphere*). 'I said to myself that I would make the image *move without a motor*.' Apart from the use of plexiglass, the introduction of lines instead of dots, the breaking up of the regular grids and the greater distance between foreground and background, the main difference between the 'kinetic' works and the earlier superimpositions lies chiefly in the use of moiré effect. It was this which finally brought about the complete destruction of form and distance, the dematerialization of the elements.

Incidentally, Soto tells us he arrived at the idea of super-imposition by taking the *juxtaposition* of profile and full-face in a Cubist picture of a woman for *superimposition* of viewpoints. 'That is the reason why later on my research went in the direction of superimposition!'

Sufficient has been said about Soto's use of moiré elsewhere. It remains only to say that between 1955 and 1957 Soto produced some stunning plexiglass superimpositions, one of the most spectacular being that entitled *Spiral*. In 1955 he took part in the Movement Exhibition and held a one-man exhibition in the following year.

In 1957 the plexiglass superimpositions gave way to the 'Vibration Structures'—structures of wire or rods placed in front of a moiré background—and to the series of 'Relations' consisting of coloured squares and rectangles also against a moiré background. Both of these have already been discussed. It is worth mentioning, however, that the 'Relations' had their origin in certain works done from 1953 on. These—for example, *Two Squares in Space* (1953), *Metamorphosis of a Square* (1955) and *Suggested Cubes* (1955)—were concerned with the suggestion of volume by the use of a 'shadow' square on a flat surface and a relief square in front of the surface.

In the earlier 'Vibration Structures' it is possible to perceive the suspended wire structure or the rods as distinct elements, even though they dissolve on being moved or when the spectator moves. But as Soto's work progressed, the rods tended to become more ethereal and to form a sort of veil or luminous curtain. One can trace this development through the 'Ecriture' series from 1963 and the 'Immaterial Vibrations' (1965). Soto is at present interested in creating environments and free-standing works with rods or nylon threads, suspended from the ceiling or rising from the ground, instead of the traditional reliefs attached to the wall, which are isolated by clearly defined boundaries. The 'Kinetic Environments' or 'Vibrating Walls' (1966), the 'Penetrables',

Moving Saturation, Green Expansion, Yellow Progression and *Cube of Ambiguous Space* (1968–9, plate 58), all illustrate his current preoccupation. This is entirely in line with the general development of his art—the transformation of material and space into light. Now the 'immaterial', light-like effect is becoming, like light itself, all embracing.

Even at the centre of a cyclorama, whether kinetic or static, we are always face to face with the work. We remain observers. My 'Penetrables' are very different. Composed of metal rods or nylon threads hung from the ceiling, like a rain of metal, they envelop the whole space. They allow us no escape. We are no longer face to face; we are inside. Besides, today we know very well that we have not got man on one side and the world on the other, as they thought in the time of the Renaissance. We are immersed in the trinity—space-time-matter—as the fish is immersed in the water.

Soto has not enjoyed anything like the reputation nor had anything like the influence that Vasarely has had. Yet I am inclined to agree with Jack Burnham when he says: 'Perhaps the kinetic sensibility in Optical Art owes its origins more to Soto than to any other artist.' Notions such as vibration, dematerialization and immateriality, serialism, pure relations, repetition, the annihilation of forms, spectator participation, and the relationship of art to modern scientific concepts of time, space and matter, have all found embodiment in Soto's work. These, and not retinal stimulation, are what Optical art is all about. If Op art requires a justification, it can point to Soto, and I should be very surprised if, on the merits of his work alone, it does not stand the test of time.

Agam, Fontana and Klein

A third artist considered a pioneer of optical-kinetic art is the Israeli-born Yaacov Agam. Born in 1928, he studied at the Bézalel School of Art in Jerusalem. He came to Paris one year after Soto, in 1951. He had no formal art education and the chief formative influences on his work were Van Gogh, Kandinsky's *On the Spiritual in Art*, Max Bill, Giedion and Itten. Between 1951 and 1953 he arrived at his own particular kind of Kinetic art: 'Contrapuntal' and 'Transformable' pictures. He exhibited these in 1953 at the Galerie Craven. This, he claims, was the first exhibition of Kinetic art.

The 'Transformable' pictures are among the earliest works involving spectator participation. *8 + 1 in Movement* (1954) consists of eight rods on pivots and twelve holes. The possible arrangements amount to over three hundred million. *Motion and Transformation* (1956) is made up of movable geometrical figures mounted on ball-bearings. One by one they lose their identity as forms as they are sent whirling about: it is as though they were literally dissolved in light. Agam, no less than Soto, is obsessed by the notion of light and the power of light to dissolve form. The source of Agam's inspiration, however, is to be found in his Jewish faith:

'Let there be light', said God, and there was light. The power of the word, the light-creating word: what ambition is aroused by this exploit of God who by a word made light to shine!

Other preoccupations which he shares with Soto such as the spiritualization (dematerialization) of matter also come from his religious beliefs. Agam describes himself as 'the son of a rabbi who has tried all his life to dissociate the spirit from physical matter'. His work also reflects the Hebrew attitude to form and to time. The two ideas are interconnected. The notion of form as complete and enduring, which has its origins in classical Greece, is alien to Judaism. For the Jews, neither God nor reality can be limited by form; reality is a continuous flux, a coming into being, possibility.

My intention was to create works of art which would transcend the visible, which cannot be perceived except in stages, with the understanding that it is a partial revelation and not the perpetuation of the existing.

In the Light and Movement exhibition in Paris in 1967 Agam exhibited a 'room' containing a single bulb which was lit and increased in luminosity with the sound of the voice. He called it *Space Rhythm 'Let there be Light'*. Agam's inventiveness in creating 'transformable' works is considerable. These include 'Tactile works' consisting of circular coloured discs on springs which vibrate rapidly on being touched and appear to dissolve, and 'Sound Tactile works' which emit sounds corresponding to the vibrations of the works.

The other category of works which Agam inaugurated about 1952 are the 'Contrapuntal works' discussed at length elsewhere.

Although a Kinetic artist in the sense that his works require displacement by the spectator, Agam, as I have tried to show elsewhere, has much less claim to be called an Op artist. Except for the rapidly moving 'Transformable' works, the amount of optical vibration is rather slight.

Vasarely, Soto and Agam may all be considered, in varying degrees, to be Op artists. There are others however, who, though not themselves Op artists, had considerable influence on the development of the movement between 1955 and 1960. The chief of these were Fontana and Klein, but Manzoni and Dorazio also played a part.

In 1946 Fontana issued a manifesto entitled 'Spazialismo', known as the 'White Manifesto'. In it he declared:

a new aesthetic is taking shape: luminous forms through space. Movement, colour, time and space are the concepts of the new art. In the subconscious of the man in the street there is a new conception of life; the originators have begun the conquest of the man in the street.

It also contains words reminiscent of Malevich:

Sensation was everything with the primitive man; sensation in the face of misunderstood nature, musical sensations, rhythmic sensations. It is our intention to develop this original condition of man.

He offered his canvases—monochrome, gouged, slashed and encrusted—simply as objects of perception. He also experimented with the use of neon light in 1950. It was his misfortune that for nearly a decade his ideas were overshadowed by the predominance of Tachism and he himself was mistaken for a Tachist or gestural painter. But by the middle 'fifties the younger artists, especially in Germany and Holland as well as in Italy, realized what he was trying to do and came to visit him in Milan. The principal ideas which they took from him were the emphasis on sensation and optical stimulation, and the relationship of light and space. 'Fontana,' writes the Dutch group NUL, 'lays down that the new synthesis is the sum of the elements, of colour and of movement, all three of which are perceptible to the senses. A new art results from this synthesis, based upon time and space.'

The influence of Yves Klein was even greater, and his untimely death in 1962, at the age of 34, did nothing to diminish it. Klein's chief contribution was his monochrome paintings, particularly the monochrome blue paintings. He first exhibited monochrome (pink and orange) paintings privately in London in 1950. But it was his 'International Klein Blue' monochromes shown in Milan, Paris, and Düsseldorf in 1957 that brought his work to the attention of younger artists, especially those who later formed themselves into the Groups Zero and NUL. (In the same year he held an exhibition at Gallery One, London.) The significance of these monochromes for other artists was twofold: first, they represented a renunciation of the associative and emotional use of colour and of the use of the canvas as an arena in which the painter wrestled with his unconscious, leaving elegant gestural brushstrokes as a testimony to his psyche. These monochrome pictures marked a new start—hence the 'void', zero and nul—in which, as it were, the slate was wiped clean and a new, pure sensibility came into being. Secondly, the canvas is here used as a

physical thing, a reflector of light, which in turn destroys the importance of the canvas as a physical thing. Interest shifts to what happens on it and to the surface: the diffusion of light. As Soto remarks in a passage quoted earlier: 'He took hold of reality and put it on the canvas. It is the sign of reality which he gives us; not the naturalist rendering of it.'

Klein referred to himself ironically as a representational and realistic painter—'I am a painter of space . . . in order to paint space, I must be there in person, in space itself.' The person of Klein was in the end more important than his works. In this especially he differs from those whom he inspired. With him the important thing was the event, the act of painting, rather than the end-product. In 1958, at the Iris Clert Gallery he 'created' (and sold) fictitious works in an empty white gallery. Two years later, at the Galerie Internationale d'Art Contemporaine, he presided in evening dress over the creation of 'Anthropometrics of the Blue Epoch' made by paint-covered models ('living brushes') dancing over white canvases to the accompaniment of a 'Symphonie Monotone'. That same year, 1960, he made his 'Cosmogonies', paintings exposed while still wet to the wind and rain. In the following year he did a series of 'Fire-paintings', playing a blowtorch on to the canvas; and in the garden of the Museum Haus Lange, Krefeld, he exhibited by means of gas jets a wall of fire.

What Klein was doing was interpreted in various ways. He was extending the possibilities of art, calling in question the work of art as 'object', drawing into the sphere of art the age-old 'elements' fire, air and water. He was striving to break down the barriers of art and open it to something limitless —'Wouldn't the future artist be he who expressed through silence, though eternally, an immense painting lacking all dimensions?' He was rather like a romantic Duchamp. Above all, he was trying to assert the 'immateriality' of art, to free art from the tyranny of its material basis in the art-object. He

left behind artistic ideas rather than works of art; but they were seminal ideas soon to fructify.

Like Klein, Piero Manzoni died young, in the same year, in fact. In 1957 he began painting monochrome pictures which he called 'Achromatics'; in 1959 he made 'Pneumatic Sculpture', and, in the same year his most Kleinian works, 'Lines', consisting of lines drawn on paper many metres long and inserted in cardboard tubes with a different measurement as title. Levyeka Dadamaino said of him: 'He is the first of our new generation to have found a new spirit.' And Castellani: 'It is a great pity that Piero Manzoni is no longer alive to defend and perpetuate that impulse towards innovation which he gave to young Italian painting.'

Piero Dorazio, who lived in Paris from 1947, though perhaps less spectacular than either of the others, shared their dislike of Tachism and in his own painting comes nearer to the conventional kind of Op painting, even though he may not be regarded as an Op artist himself (plate 59). He began painting abstracts in the tradition of Mondrian, Moholy-Nagy, Bill, Albers, Magnelli and the later Kandinsky in 1942. What he learnt from them was the systematic organization of form and colour as opposed to informal composition and 'discovery'. But he went beyond them in creating open space and interpenetrating colour. 'They are experiments into the constructive possibilities of light,' writes Nello Ponente, whether it be external light functioning to modulate the elements in relief, or an illumination transmitted through the transparency of superimposed planes.

In the superimposition of planes or lines forming a grid or lattice of criss-crossed brushstrokes, 'colour weaving', he comes closest to producing a periodic structure and creating an optical effect. These were begun in 1958. In spite of their resemblance to certain works by Louis and Noland, they differ from them in one important respect, namely, that they create a luminous space and do not adhere to the surface of the picture.

By 1957, however, optical-kinetic art had begun to attract the younger artists. In that year Equipo 57 was founded in Paris and the first Night exhibitions were being held in Dusseldorf. The movement which may loosely be termed New Tendency was coming into being.

New Tendency

The name was first used for an exhibition held at Zagreb (Nove Tendenije I) in 1961. This exhibition represented the crystallization of ideas already in solution. Two sets of events preceded it: the formation of various groups and a number of exhibitions—Vision in Motion—Motion in Vision at Antwerp in 1959, Kinetische Kunst at Zürich, Monochrome Malerei at Leverkusen and Bewogen Beweging at Amsterdam in 1960. The groups included: Equipo 57 founded in 1957, Group Zero founded in 1958, the two Italian groups, Gruppo N and Gruppo T, both founded in 1959; then in 1960 three groups: Groupe de Recherche d'Art Visual, and the German groups, Effekt and Nota, and finally, the Dutch group, NUL, founded in 1961. At a meeting in Paris in 1963 these groups and a number of other artists declared that they belonged to the recent generation coming immediately after Max Bill, Vasarely, Fontana, Lippold, Soto, Tinguely and Bury.

New Tendency, as Karl Gerstner points out in a 1964 Paris exhibition catalogue, is not strictly a movement or a programme but a set of common opinions and aims. Negatively, it was a rejection of both Tachist and Constructivist abstraction, as well, of course, as any form of naturalism. This was also clearly stated in the catalogue introductions to many of the exhibitions. Udo Kulterman writes in the introduction to Monochrome Malerie:

Tachist art, which has become dangerously official, is opposed by an artistic activity which is working almost entirely underground . . . This new artless art . . . will find its fulfilment in a creative self-restraint.

And Michel Fauré in the 1964 Paris catalogue,

The group wishes to evolve continuously without a definite character. It attempts to escape from non-figurative naturalism, no less than from Neo-Dadaism . . . Members of the 'New Tendency' claim to go beyond the ideas of informal as well as constructive art. They violently rebel against the abuse of geometric forms inherited from Malevich and Mondrian. They realize that lyrical abstraction and geometrical abstraction cancel each other out, because, beyond the principles which restrict them, other, newer values intervene: movement, light and monumental space.

This echoes and summarizes statements made by Vasarely, the Groupe de Recherche and others associated with the New Tendency in the preceding years.

The positive aspects of the New Tendency—direct appeal, spectator participation, multiplicability of works (by no means exclusively optical)—have been considered at length in a previous chapter. For the sake of convenience I shall first consider the groups, in more or less chronological order, and then some of the more outstanding and better known individuals.

Equipo 57

The first group to be formed was Equipo 57, founded, as its name implies, in 1957. It was entirely made up of Spanish artists working in Paris: Juan Cuenca, Angel Duarte, José Duarte, Agustin Ibarrola and Juan Serrano. They held their first exhibition at the Café de Rond-Point de Montparnasse and the Denise René Gallery that year and then returned to Spain and settled at Cordova. Here they worked out their theory of 'the interactivity of plastic space'. Duarte, the spokesman of the Group, explains it thus:

These researches have to do with: the formation of free

and expansible surfaces and structures and the formation of regular and irregular structures composed of hyperbolic paraboloids . . . As it is used in these works [light] has two principal roles to play: to isolate the structures from their environment and thus give them their own illumination which creates a unity between the light-source and the object. Movement combined with light produces a series of projections both on their base and eventually on the surrounding walls, ceilings and screens.

Duarte is here talking about his own work, but the principle is the same whether the works are metal, engraved glass or, with certain modifications, flat surfaces.

In 1958 the group spent five months in Denmark at the invitation of Mortensen and Hansen. They became associated with the New Tendency in 1962 and took part in their meeting in 1963. In 1966 the group was formally dissolved after a final exhibition in Bern. They wished to work individually, though Duarte maintains that this did not detract from their collective experience: 'this form of work and investigation remains, in my opinion, the most valid for our time.' However, their example was quickly followed by the other groups.

Group Zero

Zero, we are told in one of the catalogues of the group's exhibitions, indicates the 'zone of silence and pure possibility, a new beginning as at the countdown of a rocket launching'. The group came into existence almost by accident—it has never been an anonymous team like the other groups. In the late 'fifties, as we have seen, Tachism and abstract expressionism dominated the art world, and galleries were reluctant to accept anything else. So, in Düsseldorf in 1957 Heinz Mack and Otto Piene, whose studios adjoined one another, took to holding Night exhibitions in their studios. For the seventh of these, on the theme 'The Red Painting', in April 1958, Piene brought out a catalogue magazine entitled *Zero*. The articles included ones by Yves Klein on monochrome painting, Mack on vibration and Piene on light articulation. In this exhibition they were joined by Günther Uecker. The common theme of all their work was the purification of colour and the serenity which results from it (in contrast to the turbulence of Abstract Expressionism), and the articulation of light. Light was the theme of the eighth and last exhibition, 'Vibration' in October 1958. Mavignier, Holweck and Zillman also took part in it.

The principal influences on the group were Klein, of course, and Max Bill, under whom Mavignier had worked at Ulm. (He included their work in his Konkrete Kunst exhibition in Zürich, in 1960.) But there was a resistance to Bill's intellectual approach. For Fontana the group had the greatest respect, and, though he had no direct influence, the work of Piene was said to resemble his. And finally Tinguely, who gave them the impulse to motorize their light works in 1959.

By 1958 they were internationally acknowledged. Mack exhibited 'light reliefs' at the Iris Clert Gallery, Paris, that year, and in the following year they took part in the Antwerp Vision in Motion exhibition. As the other New Tendency groups began to emerge they were invited to join them and took part in the Bewogen Beweging, Nove Tendenije 1 and 2, and NUL exhibitions. Only Uecker was represented at the Nouvelle Tendence exhibition in 1964. By then it was felt that they (and NUL) did not share the same outlook as other members of the movement, and to a certain extent this is true.

By the early 'sixties it became apparent that there were two almost contrary tendencies within the New Tendency movement. One put the stress on collective group activity, anonymity, perception and a close alliance with science and technology. The other valued the independence of the individual artist, harmony between nature and technology, poetry and idealism. Group Zero belongs professedly

to the latter. Around 1960 they gave their work the title 'New Idealism'. By this they wished to distinguish themselves from 'New Realism' on the one hand, and certain kinds of kineticism on the other. 'New Realism'—represented by Klein, Tinguely, Arman and Spoerri (with whom they are often associated because of their connection with Klein and Tinguely)—being Neo-Dadaist and in some ways parallel to American Pop art, in their opinion touched only the surface of our culture. They also believed that certain kinds of kineticism, with its self-conscious use of scientific means and emphasis on perception was in danger of reducing Kinetic art to research into the psychology of vision or industrial design and fashionable modern decoration.

What the group meant by 'New Idealism' is clearly stated by Piene when he says:

We try to remain faithful to our idea of giving more beauty to the world . . . One of the most important aims proved to be the attempt to reharmonize relations between man and nature—nature offering enormous impulse from the elements . . . the sky, the sea, the Arctic and the desert, air, light, fire, water as means of expression—and not put the artist in the position of a fugitive from the 'modern world'. No, the artist is to use the means of technical invention as well as those of nature.

Of the three principal members of the group, Uecker as we have seen is the most optical. He is more concerned with the direct action of light but his structures also produce an optically induced movement. His works have naturalistic and associative overtones: they resemble a corn-field swept by the wind or tall buildings of a city—though they may also resemble an energized field of force which has closer affinities with Op. Again, while they give an impression of movement, the surface and the elements (the nails) rarely lose their identity as they do in Op. With Mack the surface and the elements do dissolve, but again it is by the direct play of light rather than by optical means. Like Uecker's work,

Mack's has associations with nature; most obviously with the rippling of sunlight over waves. Piene's work is even further removed from Op in the strict sense, though it is, of course, optical in the broader sense since it is concerned with the effects of light. If Group Zero must be considered as standing on the fringe of Op, this is not surprising, since by their own admission these artists are not primarily concerned with perceptual effects and are, indeed, suspicious of them. (The group dissolved itself in 1967.)

The group NUL which has been frequently mentioned was founded in 1961 by Henk Peeters, Jan Schoonhoven, Herman de Vries and Armando. It had much in common with Group Zero, though with surrealist or Neo-Dadaist tendencies alien to that group. It was even further removed from Op than Zero was, though some of the random programmed structures by de Vries and some periodic structures by Peeters have an element of optical movement.

Italian groups and artists

In 1959 two groups were founded in Italy: Gruppo N at Padua—Alberto Biasi, Ennio Chiggio, Toni Costa, Eduardo Landi and Manfredo Massironi—and Gruppo T at Milan—Giovanni Anceschi, Davide Boriani, Gianni Colombo, Gabriele Devecchi and Grazia Varisco (who joined in 1960). Both these groups belonged to the opposite wing of the New Tendency from Zero and NUL. It has been said of Gruppo N that it represented the nearest to a scientific approach of any of the groups. In their 1962 manifesto they stated as their field of investigation: 'psychological perception in all its aspects; perception capacity of the retina, peripheral vision, eye movement, perception at the level of the retina and cortex, focus, visual acuity, colour perception.' They were also interested in variation in the object–spectator relationship. Of the Group

Costa is the most Op (we have already considered his *Optical-Dynamic Structure*, 1961, plate 10). Biasi was concerned with the refraction of light through prisms, but in collaboration with Landi he produced a remarkable optical work, also called *Optical-Dynamic Structure*, made of polystyrol, metal threads and light bulbs, which alters radically as the spectator moves in front of it, and produces effects rather similar to those of Gerstner's *Lens Picture*. All of these works depend for their effect on the movement of the spectator and they are all reliefs rather than paintings. Nevertheless the effects are for the most part optical.

Gruppo T, the Milan group, were also interested in variability in the object and the effect of active spectator participation. But on the whole their interests were far less confined to optical phenomena and their projects extended to such things as the effects of atmosphere on variable objects (1959), multiple kinetic objects reproduced in series (1960), programmed images (1961), the application of industrial techniques, and industrial design. Although the interests of Gruppo T were not particularly directed towards optical effects, some of the members, Colombo and Boriani in particular, have made works, some in moiré and others of rapidly moving plastic tape, which have a decided optical effect.

Gruppo N, in spite of its most fanatical adherence to the principle of collective activity, was the first to break up, in 1964. Gruppo T survived for two more years. This breaking up of the groups was inevitable. Leaving aside any desire for individual recognition, it is not possible to produce mature works by committee. Collaboration may be valuable at the initial or experimental stages of a movement, and certain projects may call for collaboration, but there is no reason to believe that all artistic ideas can be worked out collectively or that two heads are more creative than one. Besides, an artist cannot entirely suppress his individuality. The idea of an anonymous, collective art arose from three sources: reaction against the over-individualistic gestural painting, an attempt to emulate scientific corporate endeavour and socio-political beliefs. In short, it was an attempt to impose an extra-artistic ideal on artistic activity. But the realities of the artistic situation asserted themselves and most of these artists were sufficiently concerned for their art to accept them.

This may be a convenient place to say a word about some Italian Op artists who are not members of any group, in particular Getulio Alviani and Enrico Castellani. Alviani, like the Gruppo T members, has been interested in programmed art and in collaboration with industry. But unlike them he has concentrated on the vibration of light off polished surfaces. As we have seen, he usually incises almost indiscernible lines in the elements which go to make up these structures and it is the light caught in these incisions rather than the structures themselves which cause the vibrations and destroy the surface. Alviani describes the effect of his work in an interesting equation:

Some of the moments of dynamic appreciation are: specularity + reflection + light source + angle of vision + movement = vibratility (on the part of the object) + reaction (on the part of the spectator) = interrelation + perception = situation.

The unity of his structures lies not in the relationship between the parts themselves but in the total perceptual effect, and the total perceptual effect takes place only when the parts have been actively united by the viewer. In Alviani's work, as in that of so many Op artists, spectator participation takes place on the level of perception and not of manipulation.

Castellani was a friend of both Fontana and Manzoni, and directed *Azimuth* with Manzoni in 1960. It is not surprising, therefore, that he works entirely in monochrome. But he sets traps for the light by punctuating his canvases with bulges and

hollows in regular or irregular grids, thus increasing the optical vibration. Castellani says challengingly of his work:

line, indefinitely repeatable rhythm and monochrome surface are necessary in order to give to the work the concreteness of the infinite which alone will survive the fusion of time, the sole dimension, measure and justification of our spiritual needs.

Other Italian artists working with optical effects include: Levyeka Dadamaino and, to a limited extent, Enzo Mari.

Groupe de Recherche d'Art Visuel

This Group was founded in Paris in 1960. The founder members were: Demarco, Garcia-Miranda, Garcia Rossi, Le Parc, Molnar, Morellet, Moyano, Servanes, Sobrino, Stein and Yvaral. Of these, six survived, three Frenchmen: François Morellet, Joël Stein and Jean-Pierre Yvaral; two Argentinians: Julio Le Parc and Horacio Garcia Rossi; and a Spaniard, Francisco Sobrino.

Yvaral is the son of Vasarely, and Le Parc came into contact with Vasarely soon after he arrived in Paris in 1958. The influence of Vasarely was strong. But there were other influences. Le Parc had been interested in the Art-Concrete-Invention movement and in the Spatialist movement inspired by Fontana before he came to Paris. Morellet had been a geometrical abstract painter from 1950 and from 1952 had been interested in systematic repetition and superimposed grids. Like the Italian groups, the Groupe de Recherche belonged to the scientifically orientated, collectivist wing of the New Tendency. If this wing came eventually to dominate the movement, it was due largely to the Groupe de Recherche. They have also been the most cogent and voluble spokesmen for the movement.

In 1963 the Group showed its first collective exhibition work, 'Labyrinth' (fig. 49), at the Paris

FIG 49
Groupe de Recherche d'Art Visuel: Plan of 'Labyrinth 3' at the Contemporaries Gallery, New York, 1965. From *Image* 1966

Biennale. Before considering the artists individually, a word should be said about this group venture 'Labyrinth'. This was not a collective effort in the sense that various members worked on a single communal theme, as the Italian groups did. Each member of the Groupe de Recherche made an individual, if anonymous, contribution to the communal event which had certain basic common aims already described in an earlier chapter. The spectator was led progressively past (and in some cases over) a series of objects calculated to stimulate him in various ways. In some cases he participated involuntarily by setting polished metal plaques in motion as he passed by them and thus producing reflections and metallic sounds. More often he was invited to participate voluntarily by pressing buttons which set objects in motion, or by activating discs or rubber balls by hand, or advancing and receding from distorting mirrors. Many of these objects are hardly more than sophisticated toys, and indeed some of the rooms are described as 'games-rooms'. But the general aim was to make the spectator perceptually more aware and get him actively involved. For instance, by activating a rubber ball suspended on a spring in front of a striped board, he becomes aware of the distorted appearance of a moving object. There was no attempt to mystify the spectator by tricks. The only mystery involved was the mystery of perception of which most of us are only dimly aware most of the time.

Optical effects were, of course, only one of the means by which the group attempted to arouse the attention of the spectator and provoke him into participation. In reply to the questionnaire by Ohio University already referred to they stated their views on Op. First, they regard Op as a kind of research into visual phenomena, whereas their aim is not that or not only that. Secondly, they consider Op as an attempt to provide 'visual satisfaction'. Whether this view of Op is correct or not, it is certain that the main purpose of the Groupe de

Recherche was neither pure visual research nor the stimulation of pleasurable visual sensations, but the provocation of the spectator to active participation and thereby to the development of all his faculties.

By 1966 the artists had begun to exhibit individually (Le Parc won the prize at the Venice Biennale in that year) and their individual traits which by then were discernible could now be fitted with a name. They formally disbanded at the end of 1968. A number of factors led to their dissolution: first, what might be called the cult of personality—Stein says somewhat bitterly: 'Having been the Groupe de Vasarely we have become the Groupe de Le Parc'; secondly, a 'closed shop' mentality—they had admitted no new members; thirdly, disagreement on what spectator participation should consist of: was it to be a spectacle involving the public or a provocation of the public? But above all it was the loss of anonymity that caused the break-up of the Group.

Though they might not admit it, their collaboration was closest and individuality less discernible in the period when they were most optical in the narrow sense, that is, when they were making periodic structures of lines, bands of colour or small geometrical units. They all produced structures of this kind up to 1961. Morellet, who is the most strictly Op of the group, began making them in 1952. They were perhaps the simplest ever made, sometimes consisting of endless repetitions of tiny vertical lines, and were called 'Tirets' (hyphens), 1956–8. It was at this time that Morellet made his *Aleatoric Distribution*, using numbers from the telephone directory to determine the position of the units. These were followed by the 'Trames' (webs) of superimposed lines or wires. Morellet says of them:

If you superimpose very simple forms (good forms, according to the Gestalt theory) and vary the angle of superimposition, a whole series of structures appear. These perfectly controlled structures are . . . far more

L

appropriate [for an aesthetic experience] than some intuitive, unique work or even the tests contrived by psychologists.

From 1960 the group began to make moving objects, reliefs and light objects. From now on their individuality became more and more apparent. Morellet continued to make his grids but now they were either three-dimensional (the *Sphere Trame* of 1962) or light structures (with light bulbs in 1963 and in neon from 1965). In 1960 Le Parc, who was by far the most inventive of the group, was making 'screens' of free-moving polished metal squares which caught and reflected the light, deflecting it in all directions as they gently turned with the slightest movement of the air. In 1964 he began to make those distorting mirrors already described. 'I was not interested,' he says,

in creating, let us say, a sort of spectacle with endless variation as its only purpose, nor in repeating temporal sequences programmed in advance. I was trying to deepen a highly attractive aspect of reality: the condition of instability. To lay hold of it as it really is, one must work with the most dematerialized elements possible.

And so he had resort to the dematerializing effect of light.

Garcia Rossi also started to work with light, creating unstable structures of continually changing light either by passing it through plexiglass rods or through defracting glass screens. 'I aim, with the minimum of choice and a great economy of means, to conceive and realize experiences with multiple possibilities'. Sobrino, too, was interested in light, in his case natural light, and its power to dissolve and fuse transparent structures. The remaining two members of the group, Yvaral and Stein, turned to moiré effects; Yvaral achieving it by wire structures in low relief activated by the movement of the spectator; Stein, by passing light through moving, perforated discs. At the same time they were exploring other means of engaging the activity of

the spectator, but these have little or nothing to do with Op. What they say of the New Tendency in general applies very particularly to themselves: its most important characteristic was a realization of 'the need for clarity and for the desire to put the accent on the visual presence of the work'. They were *par excellence* the Groupe de Recherche d'Art Visuel.

Cruz-Diez

Of the other artists working in Paris who were not members of groups, special mention must be made of the work of Carlos Cruz-Diez. Cruz-Diez was born in Caracas in 1923 and studied with Soto and Debourg at the School of Fine Art there (1940–45). From 1944 till he arrived in Paris in 1960 he was connected in one way or another with design and publicity. During that time he visited New York (1947) and Barcelona and Paris (1955–6). While in Europe he became interested in the physical qualities of colour and this led to the 'Physichromies' (physical chromatism) in 1959. As he says, his 'Physichromies' are the fruit of experimentation. They are based on physical experiences which become important for him as soon as they are used to create an interesting visual event.

The 'Physichromies' were preceded by reliefs of coloured cylinders sometimes interconnected and perforated by rods (1954). These were followed (1955–6) by superimpositions, reliefs and free-standing objects with biomorphic forms—he called them 'forestal signs' and they do look like leaf patterns or light patterns in a forest (a Venezualan forest). Between 1957 and 1959 his interest in the optical effects of form and colour grew. His canvases, composed of trapeziums and rhomboids of striped zebra-like contrasting colours, became quite frenetic. Meanwhile he had been studying the problem of colour reproduction in photography and came upon Land's work on the additive properties of coloured

light. Land claimed to be able to produce the whole range of spectral colours by red and green filters alone. This and a work of his own, *Colour Radiation* (1959), in which coloured lines at acute angles overlap parallel lines, led him to experiment with colour radiation and reflected colour and also to investigate the phenomena of interference and moiré effects produced by frames.

Cruz-Diez started his experiments with red and green strips of card at right angles to the surface of the picture seeking the optimum interval between them which would transform these basic colours into the spectral colour by radiation and reflection. From these experiments resulted the first *Physichromie*. He had begun to paint with light instead of pigment. He says of *Physichromie no. 3*,

The solution I found with more plastic possibilities for making the most of colour reflection, was that of constructing a surface made of parallel blades spaced regularly. The slant of these blades controls the admission of light. The result thus obtained is that of a changing chromatic atmosphere and not that of plain colour simply painted on with a brush.

Since 1959 Cruz-Diez has been exploring the possibilities of his discovery. In 1962 he began to use what he called the 'open palette', that is, other colours besides red and green, and in the same year he introduced background shapes, mostly circles and squares, with clearly defined contours (hitherto they had been rather amorphous and ill-defined, if present at all) which appear and disappear with the movement of the spectator. The next significant developments took place in 1964 when transparent 'blades' were used. They created an entirely different chromatic atmosphere. This led, in that same year, to a new type of structure, the 'Interferences', consisting of a rigid and a mobile, or two rigid planes superimposed on one another. Both planes were transparent and contained identical structures in different colours and at slightly different angles. When the spectator moves the mobile plane,

or moves in front of the rigid planes, an extraordinary variety of subtle colours and tones appear.

Cruz-Diez says about his work:

The principle of experimentation has always guided my work. All my works are based on experiments in Physics but these experiments are valuable to me only in so far as they help to create a plastic object, a visual event. I have deliberately not referred to 'expression', because I think that no one is interested in my expression but only in the plastic object that I may create.

His most recent experiments are, like Soto's, in the direction of an environmental art. These may take the form of more than man-size transparent coloured screens which filter the light and both change in colour and transform the colour of the surroundings ('Transchromies' 1968). There is a noticeable change in his use of colour which has become harsher and more dissonant. His latest environmental works, 'Chromosaturations', create a total environment. They consist either of plastic strips in complementary colours suspended from the ceiling and arranged in a circle (like a shower-bath), just large enough to envelop a single person; or of a succession of three small rooms interconnected and flooded with blue, red and green light (in that order), through which the spectator passes ('Habitacles of Pure Colour'). In the first of these the spectator experiences a world of simultaneous contrast; in the second, a world of successive and mixed contrast. 'Art', says Cruz-Diez,

ought to satisfy the immediate needs of man. We live in a world in which each of us is in a constant state of balance between the gregarious and the intimate. It is a matter of creating works which correspond to these two situations . . . which give us a rest from collectivity when we need it (hence my individual works) or which cure us of loneliness when we no longer want it . . . At the same time art passes from the figurative to the experienced, from the imaginary to the *happening* (*l'evénément*).

Other Paris artists

One remarkable feature of the New Tendency is the number of Latin American artists connected with it. Besides Soto, Cruz-Diez, Le Parc and Garcia Rossi, one can name the Venezuelan Narciso Debourg, and the Argentinians Hugo-Rodolfo Demarco, Martha Boto, Antonio Asis and Luis Tomasello.

Debourg and Tomasello work with reliefs, using small units arranged in regular grids and designed to reflect the light across their surface. Debourg, who came to Paris in 1949, began making these reliefs in 1951. He was then inspired by Constructivism. 'At that stage of my work', he tells us,

the solid elements produced a play of light and shade which concentrated attention on the element itself as something solid, giving to the work as a whole a restrained rhythm.

From 1964 he began to cut the elements (cylindrical pegs) diagonally (mitring them). Later he hollowed out their upper face. This gave the transformation of the light more nuance.

I could thus establish in the interior of each hollow element an atmosphere which made the relations between the elements more obvious. By using hollows I diminished the solid aspect of the elements and finally detached myself from my earlier constructivist influence.

Tomasello came to Paris in 1957. Like so many Latin American artists, he had begun his career as a concrete painter much influenced by Mondrian, using the square as a basic unit. When in 1957 he started to make reliefs, the square became a cube. These works have already been described. He wants to make the spectator aware of the way in which colour is born of form. '*Movement is born*', he says,

(1) from the optical sensation produced by the serial arrangement of the elements
(2) by spectator displacement
(3) by the transformation of light
(4) and, notably, by the *intensity and duration of the reflection.*

Natural light (the sun) is the ideal source of illumination for a better appreciation of the infinite variations of these objects at different times of the day.

Demarco's earlier work (begun somewhat later than that of Debourg and Tomasello) was rather similar to theirs. He made grids of reflecting squares at different angles. But in order to increase the impact of reflected colour he covered them with sheets of plexiglass on which transparent coloured geometrical forms were painted. The movement of the spectator in front of them brought about a complete transformation of the structure. 'This work,' he says, 'led me to study movement in greater detail and especially the *time-movement* relation which creates new surfaces and new immaterial, unstable and transformable spaces.' He discovered that by rapidly moving a succession of coloured objects and by changing their speed, he could change not only their form but also their colour (*Animated Table*, 1966, plate 61). The addition of scroboscopic light so completely alters the forms that one cannot believe that, on seeing them static in normal light, they are the same objects which one was looking at a moment before. 'All my investigations', he says,

are directed to the intensification of the transformation of the image, to making the field of perception more dynamic and to the realization in plastic forms of the immaterial properties of time.

The works of Asis are almost in total contrast to those of Demarco. Whereas Demarco's are often frantic in their activity and scintillating in their rapid and brilliant changes of colour, Asis's works are quiet, slow-moving and contemplative. He works either with grids of polished metal springs or spirals (plate 60), which even when static have an optical effect due mainly to the intricacy of their reflected patterns, or with reliefs which produce large and generous moiré patterns generated by their own movement or by displacement by the spectator. These moiré patterns are mainly black and white

but they also have discreet elements of blue or red. The problem which seems to him primordial is 'the relationship between two similar colours—whether a simple monochrome—placed side by side or one on the other to obtain kineticism—or a vibrational monochrome'. In spite of his contact with other members of the New Tendency, he has never been directly associated with it: he prefers to conduct his research on his own.

Martha Boto has much in common with Asis (though it might surprise her to hear it). Unlike Debourg, Tomasello and even Demarco, they are both concerned (Asis in his spirals) as much with interior as with exterior reflection of light. She projects light on to and through metal or plexiglass, the metal highly polished and often grooved to make contrasts of light and dark. She has a particular predilection for the circle, whether in the form of a hollow tube or a hole through which light rings emerge and intermingle, as ephemeral as smoke rings, or again concentric discs. Sometimes colour is added, but more often they are achromatic. The extraordinary complexity of the effects achieved by the compounding of reflections hides the simplicity of the structure, and the effects are not confined within the ambit of the work but fill the whole room.

Finally, a word must be said about another artist working in Paris, who is not a Latin American but was born in Vienna, Lily Greenham. She began her career as an operatic singer and is as much concerned with concrete poetry as with the visual arts. Her first contact on coming to Paris was with the Lettristes. She began painting in 1959 and describes the work she did then as 'informal constructivism'. In 1961–2 she became interested in concrete painting, and in 1964 in movement. She has been concerned with the transforming effects of either changes in distance—patterns change with the fusion or separation of the elements as the spectator approaches or recedes—or changes of the colour of

the light on the coloured pattern, according to the laws of light and pigment mixture already described. She has a project, which will probably be realized in 1971, of painting a room and altering the colours by changing the colour of the light. Unlike Sedgley's work which also exploits the effect of light on pigment colour, the pattern and colour changes in Lily Greenham's work are abrupt, not gradual. There is no dissolution of the surface pattern, only periodic alteration of it.

Other continental artists

So many artists are involved with optical effects one way or another that only a brief mention of each can be made in this survey. Since many names have been included it may be useful to mention them again, placing them in their national setting. I shall begin with Germany.

Apart from Group Zero in Düsseldorf, there are two other German groups, both in Munich and both founded in 1960: Nota and Effekt. Nota got its name from a periodical edited by Von Graevenitz in 1959–60. The other members of that group are Gotthart Müller and Walter Zehringer who may be considered as Op artists proper, and Rudolf Krämmer, Klaus Staudt and Uli Pohl whose work is optical in a broader sense. Zehringer also belongs to Effekt along with Dieter Hacker, Karl Reinharz and Helge Sommerock. Other artists working in Germany who have some claim to be considered as Op artists include: Almir Mavignier, Ludwig Wilding, Harmut Böhm, Wolfgang Ludwig, Klaus Müller-Dominick and Reiner Kalhardt. Some would probably include Günther Fruhtrunk but most of his paintings seem to belong rather to the cubist tradition, as I have called it, than to Op proper.

Von Graevenitz, while still a student, edited *Nota* and was active in the formation of the New Tendency. He specializes in the random movement of

numerous identical elements such as circles and strips of metal. These produce the suggestion of displacement or hopping about, analogous to the phi phenomenon and in so doing disrupt the surface on which they lie and create a luminous space. Von Graevenitz also made some seriographs of densely packed structures of tiny overlapping squares at different angles to one another which have a more pronounced optical effect. Von Graevenitz says of his work:

My kinetic objects are visual objects. The elements are simple. The organization is not hieratic (no composition). The movement is not linear (no beginning, no end) . . . Because the organization is open—as it has been developed in the theory of games—there is playfulness involved.

Like the Groupe de Recherche, Von Graevenitz makes works which he unashamedly calls 'play objects'.

Mavignier, who was born in Brazil, completed his art studies there and came to Europe to work under Bill, Bense and Maldonado at the Hochschule in Ulm from 1953 to 1958. His interest in optical effects dates from this period. He was associated with Group Zero and was instrumental in organizing the first New Tendency exhibition at Zagreb. He specializes in the use of dots of varying sizes against a dark ground to create rhythmic, pulsating structure of intense irradiation and colour concentration. In some cases these dots grow into stalagmites, and the addition of depth and hence the intensification of luminosity through reflection increases their impact immeasurably. A luminous field of uncertain depth is created. Mavignier calls them 'Permutations'. The only control the artist exercises over them, he says, is in determining the permutation-system; the result, for better or worse, is completely unforeseen. The introduction of relief brings with it new problems about the relations of light and colour; the points or dots tend to become objects in their own right, and the structure now

has a bright and dark side. Mavignier points out that 'this colour-light relationship is different from that of flat painting, in that the light can only produce its effect according to the intensity of colour emitted'.

A third artist working in Germany who deserves more than passing mention is Wilding. He is concerned almost entirely with line structure and particularly with moiré patterns. He worked for a time with Willi Baumeister. His interest in optical effects began in 1951 when he made structures of squares which diminish and increase in size across the canvas, rather like those which Bridget Riley was to make a decade later. In 1953 he began to make grids of lines which resemble the colour-weaving of Dorazio of five years later. His interest in moiré patterns can be traced back to 1955, long before Oster's famous articles. From 1957 he made line the basis of all his undertakings and in 1960 started to work with coloured and black and white moiré reliefs. It will be obvious from these bald facts that Wilding was far in advance of most other Op artists, and yet he remains a comparatively unknown figure. The restraint with which he treats moiré, the incredibly rich effects he can produce from simple, almost classical structures as in the example on the cover of this book, should not distract attention from the no less rich and varied effects which he can obtain from simple line structures on a flat surface, such as the one illustrated here, without the use of moiré.

Besides Germany the two countries which have contributed most to continental Op outside France are Switzerland and Yugoslavia. Among the Yugoslavs the name of Miroslav Sutej has already been mentioned; to it may be added Ivan Picelj, Vlado Kristl and Yenceslav Richter. Leading Swiss artists are Karl Gerstner and Christian Megert.

FIG 50
Ludwig Wilding *Line Drawing* 1962, wood, acrylic 31½ × 31½ in.

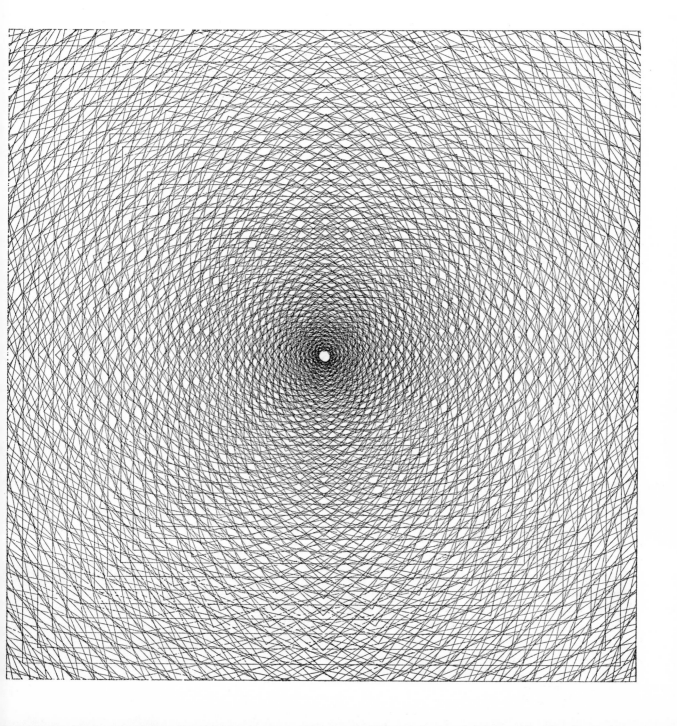

Gerstner has been one of the leading figures in the New Tendency from the beginning. He is primarily interested in programmed art and in particular in interchangeable pictures governed by a programme. In 1957 he published a book on programmed art (*Kalte Kunst*, 'Cool Art'). In 1964, together with Spoerri, he launched one of the first series of multiple editions of works of art, 'Edition MAT'. Like so many artists working with programmes, he has produced a number of works which have a definite optical effect. These consisted of either perspex lenses which distort a regular structure; or regular grids of polished, grooved metal which catch the light and are transformed by it; or again, structures of perspex prisms placed over mirrors with colour elements.

Megert also works with distorting mirrors. The earliest (circa 1962) produce fragmented images. Next come environmental works (*Object*, 1964) with fragmented mirrors and light which give an impression of infinite regression. Finally, 'Zoom' mirrors (1966), also fragmented, which move towards and away from the spectator. The disruption of form thus produced and the space created, which is not related to a picture plane, are analogous to the effects described as optical.

Other continental artists who should be mentioned are the Belgian Walter Leblanc, the Austrian Marc Adrian, the Russian group Dvizjenie (Movement) the Spaniard Eusebio Sempere, and the Pole Wojciech Fangor. Of these, at least something must be said about the work of Fangor.

It came as a surprise to Fangor to discover, in 1965, when asked to exhibit at The Responsive Eye exhibition, that he was an Op artist. His chief preoccupation is with space. He was born in Warsaw in 1922 and began work as an artist doing graphics and exhibition designs in collaboration with architects. Working with architects, he says, gave him a concern for space.

For me painting is a kind of reverse illusion of perspective. I build on the problem of the spectator in space, not outside the picture. Space is what I am primarily interested in.

And he adds: 'I want the painting to be . . . itself, with no literary connections, but with some connections with the world in which I am living'. This desire to 'avoid all literature and object-like associations' and 'to do with painting what can't be done with other means' puts him in line with the artists of the New Tendency.

But he does not believe in a programmed art. His approach is empirical. He describes his method of work as follows:

I employ certain technical principles with more or less predictable results—actually many of the physiological phenomena that I get into my work are no mystery to anyone—but there is always a kind of surprise for me. Sometimes it takes four or five coats of paint before I reach . . . not what I expected, but when the painting comes alive. If I knew exactly what would come I wouldn't have this need to do it . . . For me the physical act of painting is very important. When I start a painting I have a general feeling that such and such a combination of colours will produce something, but you can't calculate that.

He began painting large soft-edged forms in the late 'fifties and made the first of his most optical works, the circle pictures, in 1958. He produces his effects mainly by tonal contrast, usually dark against white. Optical effects are with him only one of the means of creating space and surrounding the spectator with it, but they are perhaps the most powerful means: his great target pictures positively envelop the spectator's visual field and draw him into their mysterious world.

8 British and American Op

Op art developed later in Britain than on the continent—the earliest Op paintings seem to have been done by Steele in 1960. Yet it developed independently and without awareness of what was happening elsewhere. Two events in particular had a profound effect on the evolution of British Op. One was the exhibition of American painting at the Tate in 1957. The other was the series of courses given by Harry Thubron, then at Leeds College of Art, especially those given in 1958–9. In a letter to the author, Kidner describes these two events as follows:

So far as I was concerned there were two events in the late 'fifties which mattered. First the exhibition of American painting at the Tate which put paid to cubism, and, second, in the fervid limbo that followed the American bombshell, a week's colour course under Harry Thubron. Thubron presented colour as a set of abstract relationships within the framework of the exercises he set.

It was not the directness with which the American painters applied the paint, nor their 'gestural approach', which most impressed the British artists —'I could never,' says Kidner, 'be convinced of the profound nature of my own gestural marks.' What impressed them was, first, the space in these pictures, 'a truly shallow space and a scale which extended vertically and laterally rather than in depth'. The picture was no longer a make-believe window but stayed flat on the wall. Secondly, the paintings were not first envisaged in the mind's eye and then committed to the canvas. They were the end-product of a process. Thirdly, the use of colour for its own sake. The Abstract Expressionists had carried forward the liberation of colour begun by the Impressionists. It was no longer fixed to any kind of reference or even to any form or shape.

The significance of Thubron may be judged by the many tributes paid to him by leading artists, educationalists and critics. 'The most significant thing since Marion Richardson' wrote Victor Pasmore in 1956. 'Someone who has pushed more than one generation of students in the direction of greater and more independent fulfilment' (John Russell). 'The most inventive teacher of the time.' (Anton Ehrensweig). While at Leeds, Thubron revolutionized the basic course, and from 1952, through his summer and winter courses, he brought the influence of his method to bear on a wide circle of artists and teachers. The method itself is hard to describe for the very good reason that one of Thubron's main ideas was to avoid all rigidity.

The aim is to stop people doing 'art' and to make it difficult for them to give you what has already been done in art. This tends to avoid cliché and cuts across habit.

In so far as the method had any positive characteristics (apart from Thubron's own dynamic personality) these consisted in an openness to non-artistic, chiefly scientific and technological ideas; for instance, the physics of light and colour, optics generally, or the psychology of perception—'a lot of know-how exists outside art schools which ought to be inside them.' This aspect of Thubron's course naturally had a direct bearing on Op, while the experimental approach, as we have seen repeatedly, favours the development of an optical art.

Thus, though there was no direct contact between British Op artists and the New Tendency (this came later: Bridget Riley exhibited in Paris at the Nouvelle Tendence exhibition of 1964, and, together with Sedgley, Steele and Kidner, at the Responsive Eye exhibition in 1965), both developed along similar lines through a rejection of gestural painting and a more experimental approach to form and colour. Both Kidner and Steele state this explicitly. As Kidner says:

this method of working represents a reaction against the direct assault on the unconscious practised by the American Expressionists, and it springs from a growing belief that the exploitation of optical realities offers the painter a discipline neither narrow nor closed.

To this Steele adds:

An important piece of dogma to which we all subscribed concerned the necessity to expunge from our work all traces of the individual artist's 'touch' or handwriting from the surface of the picture and allow the personality to show, if at all, only through the way in which the pictorial material was selected and presented.

The very rigour with which the qualities of *belle peinture* were eliminated, says Steele, of itself brought in a new unsolicited phenomenon calling for special attention, namely, the optical effect—'a battery of optical occurences or flickering overtones in the eye and mind of the spectator . . . a revelation of the intrinsically kinetic quality of the very act of seeing.'

The British artists did not form themselves into groups nor publish manifestos—that is not the British way—and so must be treated individually.

Bridget Riley

Bridget Riley was born in London in 1931 and studied at Goldsmiths College (1949–52) and the Royal College of Art (1952–5). But one of her most formative experiences occurred when she was teaching art at a secondary school (1957–8). She discovered that the more she limited the tasks she set her pupils, the more individual and inventive were the results. Her own art was to become a perfect example of this principle. While working for an advertising agency and at the same time searching for direction in her art, she met Harry Thubron at his exhibition at the Institute of Contemporary Arts in 1958. She found her ideas closest to his and attended his summer course in 1959. There she met Maurice de Sausmarez who encouraged her interest in Seurat (she had been practising a pointillist technique since 1957). About this time she produced *Pink Landscape* (1958–9, plate 63). This painting was of enormous importance for her subsequent development. With its pointillist technique it could, if greatly enlarged, have become an Op painting. But, more importantly, it was Bridget Riley's first attempt to convey a visual equivalence of energy—in this case, heat. The picture was based on a view of a huge plain somewhere in Italy.

The heat off the plain was quite incredible—it shattered . . . the topographical structure of it and set up violent colour vibrations, and to articulate that experience it was only possible to fire it off again in optically vibrant relationships of colour units . . . the local colour was unimportant—the important thing was to bring about an equivalent shimmering sensation on the canvas.

During the next two years she did two 'field-paintings', but it was not the field or figure-ground relationship which interested her so much as what she calls the 'bleep' between the shapes, as in *Kiss* (1961).

In 1961 she produced her first optical work, *Movement in Squares*. It consists of black and white squares progressively distorted towards the centre of the picture, thus producing a warping and buckling movement, a disequilibrium which continually readjusts itself and does not fall apart. With this picture she had found her direction.

She describes her method of work as 'additive' rather than 'reductive' (a method which is practised by most Op artists and many others besides).

I believe more and more that, after nearly fifty years of 'reductive' aesthetics we have reached a point now when the real challenge is how to work 'additively'; the old principle 'less is more' has become a completely academic rule.

She takes a basic unit (square, triangle or circle) and 'paces' it (puts it through its paces), pushing it as far as it will go without losing its identity. We have seen this happening in the case of the square (*Movement in Squares*) and a triangle (*Straight Curve*, 1963 above). In *Fission* (1962–3) black circles are 'paced' through the oval until they become straight lines (or circles viewed end-on?). She finds the circle the least flexible and most restrictive of all forms.

Experience tells her how a given shape is likely to behave but she never jumps to conclusions; there is always something different in the demands she makes. Her method is always empirical. Since she began to work with colour she has even found it necessary to make full-scale cartoons because the behaviour of the elements on the large-scale cannot always be predicted from sketches. Once she tried to develop a series of ideas purely conceptually, but though as a mathematical structure it was exhilarating, it was inapplicable to any visual situation:

I just set off mentally building up this structure. Later I tried to find the actual physical situation in which this perfect thing that I had built up intellectually would work . . . I just could not make it visible. It had been conceived and developed independently of vision. I finally concluded that it had never been visual in my terms at all.

Although her work may give the impression of a logical progress, it is exploratory in the way described by Fangor. As she says, she has no definite idea of the goal, though she knows when she is going wrong 'like a child playing with a hoop . . . Although you don't know exactly where you are going, if the hoop . . . careers wildly off at a tangent, you know perfectly well that's not right.' Edward Lucie-Smith says that Bridget Riley's preliminary sketches are more finished than many other artists' finished work, but there is still, even in her case, a world of difference between the two. Apart from scale, the finished work is not always based on any one preliminary sketch. They are experiments which may be combined with others and in any case will be transformed in the finished work. Indeed the finished work, or at least the cartoon (the actual painting may be done by assistants), is often itself experimental.

In calling them experimental there is no implication of scientific experiment. Bridget Riley is not interested in the psychological or physiological effects as such. She is even surprised when people complain that they make an almost painful assault on the eye. She has no intention of being aggressive either. She is prepared to admit, however, that the most 'aggressive' pictures done in 1961–2 may reflect some inner conflict within herself which has since been resolved. This in itself is interesting in view of the accusation of being 'depersonalized' (the 'twentieth-century bogey', as she calls it) which is often levelled against this kind of art. As she says, 'to develop as much objectivity as I can is simply counter-balancing this inevitable presence of myself in the work.' In so far as she has any particular preoccupation—apart from making a picture which is visually satisfactory, which hangs together—it is with the visual equivalence of energy and not with psychology.

A last general remark must be made on her concept of space. She considers it 'more American than English', that is, the sort of open, shallow, non-focal space which 'originated with Mondrian and was first completely articulated by Pollock'. But she also wants 'a fluctuating surface—an active space' which, as she says, 'operates like the action of a whip'.

From 1961 till 1965 she worked in black and white for greater precision, clarity and sharpness of contrast. She worked not only with the geometrical units already considered—square, triangle, circle—but also with lines, at first horizontal and straight (*Horizontal Vibration*, 1961; *Serif*, 1964), later with undulating and vertical lines (*Fall*, 1963; *Current*, 1964). Variations in tone were introduced right from the beginning (*Black to White Discs*, 1961). The movement in these early works was gentle. It became more violent in 1962 with the 'Blaze' series and the 'Disfigured Circle' series of 1963. But by 1963 a somewhat gentler note was creeping in with *Twist* and *Fall*, both vertical, the latter curvilinear—the curve was suggested in *Straight Curve* of the same year.

Colour was introduced first as a contrast of undulating horizontal bands of warm and cold greys,

that is, greys mixed with warm or cold colours, as in the 'Arrest' series in 1965. Colour plays a more important role in *Deny* of the following year, though this was mainly concerned with colour in relation to different tonal values of grey. Black and white was not immediately abandoned for in that year, 1966, she made *Static* and *One* (alternate black and white vertical, spear-like triangles). Direct colour contrasts, which began with deeply undulating bands (*Cataract*, 1967), presented new problems. At first she worked with just two contrasting colours, still with tonal variations. Gradually the tonal variations were eliminated (*Chant*, 1968) and other colours added (*Late Morning*, 1968). With the use of tonally equal colour went a return to very simple structures—vertical straight lines—but in her most recent work structural complexity is returning—the diagonal, in the hot, oriental (*Orange, Violet, Green Elongated*, 1969), and the elongated triangle (*Green and Magenta Diagonals*, 1969).

Bridget Riley's art has developed with an assurance, a relentlessness even, which is rare in the history of painting. As Edward Lucie-Smith wrote in *The Times* when she was awarded the prize at the Venice Biennale in 1968:

There can be few modern artists who have moved more logically from one phase to another without giving the impression that the work they are currently engaged upon is in some way incomplete . . . There never seems to have been a phase of her career when she felt at a loss as to where to go next.

Peter Sedgley

Peter Sedgley was born in London in 1930 and studied architecture for some years. But he found that his work as an architect did not give him the scope for invention and the exercise of the imagination which he needed, so he took to painting and is largely a self-taught artist. His earliest works were *frottage* rubbings and monotypes, but, though these gave him plenty of scope for free invention, they lacked discipline and purpose. It was in the work of Bridget Riley that he discovered, in 1961, the kind of art he was searching for, restrained without being restrictive. Unlike Bridget Riley, his interest very soon turned to colour and the reactions of form and colour, using the full chromatic scale.

Sedgley has never been interested in producing satisfying combinations of form and colour but in making them function, that is, react with one another to produce a third thing, entirely new, which he calls the 'characteristic'. This may involve an impression of movement in otherwise static elements or a moiré effect, as in the 'Trace' series (1964) discussed earlier, and it always involves colour modifications (*Blue and Green Modulation*, 1964; *Yellow Attenuation*, 1965). By varying the areas of different colours he produces tonal changes and even changes of hue. Sometimes one has to approach quite close to the canvas to assure oneself that the colours are in fact homogeneous. In his early pictures (up to 1965) he worked with precise, hard-edged forms, mostly straight lines and circles, and occasionally with small units like small circles with displaced axial lines as in *Mill* (1964). At that stage he was concerned to find a basic 'vocabulary': 'I set about clarifying for myself the basic premises for art and in so doing established a keyboard of colours and a metre capable of modulation.' He used a scale of eight colours, of which only three were used in any picture, with the yellow playing a role equivalent to the dominant. (Like so many Op painters he uses terms drawn from music, and the resemblance between his work and music—scale, tempo, counterpoint, modulation, rather than the emotional equivalent—is very striking.)

In 1965 a noticeable change took place in his work with the softening and blurring of edges and the use of 'shaped' canvases, mainly hexagonal. Within these shapes—which formed an integral part of the picture and were not, as with most rectangular

canvases, merely the place where the picture ends—
he placed soft, glowing blossoms of colour in regular
grids (*Suspense*, 1966). But the most spectacular
pictures of this period were his soft-edged targets.
These grew out of works such as *Manifestations* or
Cycle (1964) in which concentric rings of colour were
placed on a black ground. These tended to pulsate,
and the pulsation increased with the use of the soft
edge. These soft-edged targets move in depth,
expand, contract and glow against the absolute
darkness of the black ground (*Red Quantum, Phase,
Quantum*, 1966). They have often been compared
to Fangor's target pictures and it has been said
that they were inspired by them. While there is
much in common, particularly the softened edge
and the pulsating effect, there is this important
difference. Sedgley always adheres to his colour
scale, juxtaposing adjacent colours and modulating
through them—red to orange to green to blue—
whereas Fangor rarely does this and often uses black
or some dark colour to mediate between two con-
trasting colours. Fangor usually works with dark
against a light ground, Sedgley with light against
dark. As for the influence of Fangor on Sedgley, the
author is a witness that Sedgley was already painting
his targets before he saw Fangor's.

Unlike Bridget Riley, Sedgley finds the circle a
good shape to work with. It is 'anonymous', homo-
geneous, with no variation in outline, and thus allows
him to concentrate on colour and give the minimum
attention to shape. In 1967 while attempting to
find an artificial light which simulated daylight and
would be suitable for evening showings in his studio,
he began to experiment with the effects of using
colour filters to illuminate his target pictures. The
results were quite remarkable. Some colours changed
hue, others disappeared, others turned black. He
then produced the system of colour illumination
using three coloured light sources (red, yellow and
blue) already described. In these 'Chromatic
Variations' Sedgley was merely playing light on to

static target pictures. With his 'Videorotors' (1968)
he set the targets in motion. In place of the soft-
edged concentric rings he now used concentric
blocks of luminous paint, and in place of the three
light sources, ultra-violet and scroboscopic light.
The effects have been described elsewhere (page
97). Sedgley has also made a series of target
ceramics which capture the light and subtly trans-
form it—the light in the white centre of a ceramic
may appear pink. Now he has a project for a dome
covered on the inside with concentric circles of
colour on which a light programme can be pro-
jected. It is to be contemplated in complete isola-
tion. He calls it *Solo*.

Jeffrey Steele

Jeffrey Steele, a year younger than Sedgley, studied
at Cardiff and Newport Colleges of Art. Like the
other British Op painters he was impressed by the
'heroic confrontation with the universally felt *angst*
through the use of Dionysiac gesture and pigment
on a large scale' which characterized the American
Abstract Expressionism at the Tate exhibition.
But he 'mistrusted the by-passing of the thinking
part of the mind which gestural painting entails'.
Some love of the philosophical method of Descartes,
he tells us, predisposed him towards a more rational
and austere form in the tradition of Suprematism
and Neo-Plasticism. But until he went to Paris on a
scholarship in 1959, he found no satisfactory
development out of the work of these pioneers.

There he came in contact with the works of
Albers, Max Bill, Herbin, Lohse, Vasarely and Soto.
'I definitely resolved to proceed from then on by
controlled and logical experimentation.' While still
in Paris, in 1960, he made his first black and white
Op paintings. Being soon forced to return to
Cardiff he was able to work out his own ideas with-
out the harrassing awareness of other artists'
solutions to the same problem. Like so many other

Op painters, he stumbled on Op rather than consciously pursued it, and at the time was unaware that other artists, both in his own country and abroad were working towards the same conclusions. Once having discovered it, he set about exploiting it:

Realizing that the observation of any given object entails a complex range of involuntary movements in the perceptive mechanism until recognition or identification is achieved, I began to try, in paintings, to balance numerous possibilities for appraisal in order to block this final resolution, thus bringing the spectator's optical dynamism into play . . . as in ju-jitsu one's opponent's strength is used against him.

He reduces his material to a mathematically coherent relationship. He works within a system, as Lohse does, and like Lohse (unlike, say, Mortensen) he does not depart from it—'If you alter the picture you may have a nicer picture. If you modify the system you establish a principle on which you can build.' But, though the execution of the picture, once a system has been chosen, is a logical process, the choice of system is spontaneous and intuitive. Moreover, he never knows how the finished picture is going to look. There is always a sense of a leap into the void, and, in spite of his systematic approach, he also feels obliged to work by hand. He envisages a computerized art which will translate two-dimensional ideas into three-dimensional and architectural structures, and even into sound, but he does not see any immediate prospect of its realization. The computerized versions made of his *Baroque Experiment* (1964) are an impoverishment of the original idea. He is also fascinated by the idea of stretching an image a mile long without altering its height so that it can be seen by people passing in a train, but so far he has made only one large billboard painting which may be seen outside Cardiff Station.

Steele is perhaps the most 'continental' of British Op artists, and he was until recently, the only Op artist to confine himself to black and white. One of

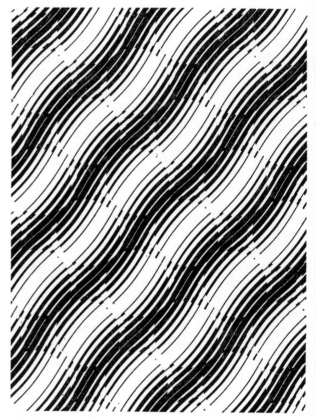

FIG 51
Jeffrey Steele *Sub Rosa* 1966, 48 × 36 in.
Collection Arne Larsson, Stockholm

the outstanding features of his work is its luminosity, and these two features seem connected:

I have worked only in black and white because the use of colour would interfere with the factors of light and movement which hold my interest.

Steele's development, like his art, has been systematic and methodical, growing in complexity as simpler problems are solved. The earliest were continuous or broken lines often with little enough optical movement (*Orlando* 1960). These were followed in 1961 by simple structures of black and white squares and circles, and those staccato lines

caused by periodically indenting slightly diagonal lines as they cross the vertical (*Gespenstliche Gestalt* and *3rd July*, 1961). Complexity increased when the enclosing staccato lines generated secondary squares (*Divertissement* and *Lavolta*, 1965) and created a luminous centre or luminous axes. In 1965 straight lines gave way to curves which became increasingly convoluted, with greater movement in depth (*Mock Valentine* and *Sub Rosa*, 1966 and *Ilmater*, 1966–7). With the increased complexity the luminous quality became more subtle: light seemed interwoven with the structure (*Eleusis*, 1966). Gradually the somewhat rigid geometrical structure was replaced by plaited strands of undulating lines. In his most recent paintings Steele has introduced colour contrasts and the undulating lines have been broken up and the units reversed. It is Steele's present aim to have things both ways: to give the spectator successively an impression of optical movement and of a pattern on a plane surface. This has always been his aim to some extent: he never really wanted to allow the optical effect to disturb the surface pattern.

Other British artists

A number of British artists who would not be regarded as Op artists have from time to time produced optical effects in their paintings. Some of Hoyland's colour contrasts, particularly the reds and greens, set up vibrations and cause after-images. In some of his most recent work he seems to be anticipating and counteracting these effects by actually painting in the after-images. Some of Tyzack's work of the early 'sixties also gave off a strong sense of movement and particularly pronounced after-images. The typewritten concrete poems of Houédard also have the vibrancy of a periodic structure. There are, however, a few British artists for whom optical effects are more than incidental occurrences in their work. Among these Michael Kidner and Peter Schmidt deserve more than a passing mention.

Kidner took up painting full-time rather late in his career. He started by painting semi-abstract landscapes, and then in the 'fifties, under the impact of the Tate exhibition and Thubron's courses, turned his attention to the optical effects of colour. At first he was concerned with the after-image, but not being sure that the spectator would divine what he was at, he painted in faint after-images, either in the form of circles (the 'original' above, its 'after-image' below) or patches of colour with their 'after-images' in attendance. About 1961 he set about liberating colour from form, first by juxtaposing bands of two colours, but this merely created an ambiguous positive–negative relationship. The addition of a third colour set up an 'unstable alliance' with the other colours and this produced some colour movement which only indirectly related to the form. The use of shallow relief in the following year carried the process a stage further because concealed colours could be reflected on to and mixed with the 'visible' colours. But still the result was not a pure sensation of colour but a stronger structure. At that stage Kidner was content to have made the spectator aware of what was happening. 'If the spectator gets beyond looking at the picture as a whole, he can see why it is as it is.'

The use of diagonal spears of overlapping colours came nearer to obtaining the effect he wanted. As Norbert Lynton wrote at the time:

Kidner's use of tapering stripes effects the interlocking of two large colour areas; stripes of one colour, in invading the other colour's field, transform it while they are themselves transformed.

But it was not colour mixture so much as the striking moiré pattern which causes it that gives these paintings their strongest claim to being considered optical. Some of them, for example, *Orange Blue and Green* (1944, plate 62), positively explode outwards, shattering the confines of the picture. (Kidner had by this time become familiar with the writings of Oster on moiré.)

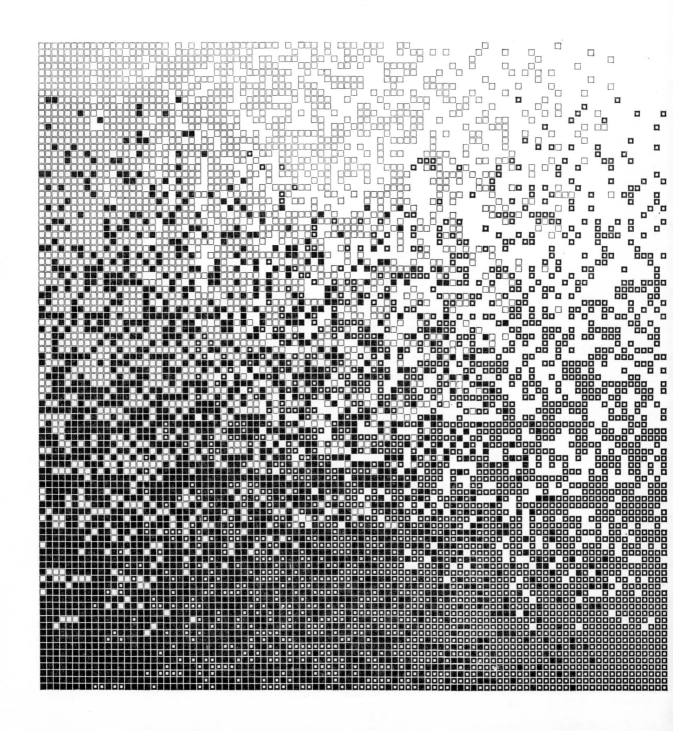

In his subsequent paintings, however, the optical effect has gradually diminished, although for some time the use of undulating vertical bands of colour gave the picture a sense of movement. In his more recent paintings Kidner is working with the interrelationship of simple geometrical forms. Form and structure have finally won out.

The other British artist mentioned above, Schmidt, also took up painting comparatively late in life. Like so many artists whom we have considered, he was interested in serial music. He was fascinated by the mysterious effects which the use of a serial technique produces. He confines himself to small units of primary colours either juxtaposed or slightly superimposed. The effect is like that of an enlargement of the four-colour separation of a colour print somewhat out of alignment. This creates a colour moiré effect rich in subtly graded colours. Working with a system, as he does, has the advantage that, for a time at least, the results are unpredictable —'good taste could be subverted'—and he does not have to decide when the picture is finished: it is finished when the system has been worked through. He is inventive in devising methods of random selection in the choice of colours and the number and size of the units. Schmidt's work exemplifies the curious and somewhat paradoxical fact which we have already encountered in the work of certain continental artists, that a combination of the systematic and the random can produce effects which Schmidt does not hesitate to call 'magical'.

Before closing this section a word must be said about another artist (though he is reluctant to call himself that) who has been doing some remarkable research into the effects of colour mixture, Sidney Harry. Harry has been in charge of the textile department at the Bradford College of Art for many years, but only comparatively recently and almost by accident he began intensive research into colour. The results of this research have been briefly outlined in Chapter 3. Harry is only now beginning to put the fruits of his dicoveries to artistic use. It is impossible to predict what the outcome may be, but it is hardly going too far to say that on the merits of his discoveries so far he has earned a place alongside Chevreul and Rood and those other investigators of the optical effects of colour.

Other British artists engaged in optical painting or relief are: Richard Allen, Margaret Benyon, John McLean, John Pearson and Christopher Shurrock.

American Op

Op art has not developed in America to anything like the extent that it has in Europe. It has been suggested that the reason for this lies in the lack of a tradition of geometrical abstraction in America. When European artists reacted against gestural painting, geometrical abstraction offered them an alternative and though they reacted against it in the form in which it was being practised, they were reacting against a living tradition. American artists had to work out their own alternative to Abstract Expressionism and, as so often happens, they carried over and even exaggerated some of the principles of the art against which they were reacting, in particular a respect for the picture surface. Sidney Tillim speaks of Op art as 'Post-Cubist' and the kind of art practised by Noland, Newman, Stella and Louis as 'Post-Abstract-Expressionist'. This is a useful way to describe them, though the implication that being 'Post-Abstract-Expressionist' is somehow more advanced than being 'Post-Cubist' (presumably because Cubism came earlier) is not justified. If one wants to speak this way, it could be argued that, since the American artists remained within the cubist tradition in their treatment of the picture plane, they are less advanced. But this kind of speculation is not very profitable.

FIG 52
Peter Schmidt *Programmed Squares II* 1967, letterpress print 13¼ × 13¼ in.
Lisson Gallery, London

M

As I have tried to show, in the case of some of the works of the 'Colour Imagists'—Davie, Feeley, Feitelson, Kelly, Liberman, Louis, Noland, Poons and Stella—it is often difficult to draw the line between them and Op painting proper. The same might be said of two Canadian painters, Molinari and Tousignant, though some of the latter's target pictures seem quite clearly Op. The real borderline case is Poons. Though I would not go as far as Judd in saying that he is the only one who has done something with optical effects, optical effects do play an important part in his painting. The truth is, perhaps, that the painted-in 'after-images' cancel out the optical effects, and even the hopping about of the small ovals takes place in depth as well as across the surface. But a line must be drawn somewhere, and the artists listed above will doubtless be glad to find themselves on the non-Op side of it.

Though there was not what might be called a living tradition of geometrical abstraction in America—at least none comparable to that in Europe—there were isolated pockets, mostly of artists of European origin. Albers had been at Black Mountain College from 1933 and at Yale from 1950. Two of the leading American Op artists, Richard Anuszkiewicz and Julian Stanczak studied under him. Other artists seem to have arrived at Op independently, which is not surprising given that an interest in geometrical structure, however it may arise, can lead to the discovery of optical effects. These artists include Tadasky, John Goodyear, Henry Pearson, Bill Kommodore and Francis Celentano. Kommodore has described how he discovered Op:

The 'accidental' discovery in 1963 of after-images in some paintings of squares causes me to realize that this was the only way form can develop. This has been followed by a feverish exploration of the many possibilities that opened up.

Anuszkiewicz studied at the Cleveland Institute of Art before going on to Yale to work under Albers. It is a measure of the influence that Albers had on

his work that on leaving Cleveland he should have been given a prize for a still-life in which he had combined 'the textural feel of grained wood, dried leaves, faded silk ribbon and minute observations into a sensitively integrated picture'. A key to the new direction his art was to take is given by a paper he wrote in 1955 while still at Yale entitled 'A Study in the creation of Space with Line Drawing'. Radiating lines have formed the basis of most of his work since. His earlier paintings such as *The Well at the World's Eye* (1961) which gives a strong impression of receding space are more illusionistic than optical. But from 1963 he has become increasingly interested in colour mixture through contrast (*Union of the Four*, 1964) and in the irradiation of coloured light (*Luminous* and *Division of Intensity*).

Line drawing has also absorbed Pearson ever since he was in the Air Force in 1944–5.

I became almost hypnotized by the beauty of the lines and their symbolized masses, which over an entire earth surface maintained a constantly varying association with one another not abruptly altered or severed but forever in a changing relationship.

When, in 1959, he tried to draw landscapes, he could not make the lines illustrative. They became pure abstraction, no longer mountains, valleys and 'illusions'. Although his lines may suggest cracks, wrinkles and bulging cushions, any specific representation is entirely unintentional.

Mine is a strictly surface art, not at all consciously *trompe l'œil* . . . I am creating . . . surface movement. Even if they move in depth to some eyes, they still work out on the surface.

He did not want to be considered part of the Op phase, as he calls it, but there is no denying the marked optical vibration in the shimmering lines of *Black and White*.

Kommodore (who was born in Athens as Vasileios Konstantinou Koumoundouros but became an American citizen in 1947) is yet another artist who works with line structures and like Anuszkiewicz,

FIG 53
Henry Pearson *Black and White* 1964, 78 × 78 in.
Stephen Radich Gallery, New York

FIG 54
Bill Kommodore *Sun City* 1966
72 × 64½ in.
Howard Wise Gallery, New York

obtains a high degree of luminosity with them. He worked under Rothko and Rickey at the Hans Hofmann Institute. Since his discovery of Op described above, he has worked with all kinds of optical effects but he treats them quite explicitly as means of expression and not as ends in themselves. As he says:

My large creative output has not been the mere application of 'new' concepts (flicker, vibration, after-image) but has resulted from the realization that the expression involved is the only one suitable to the way I feel about the world and about art.

Both Tadasky and Celentano explored the optical effects of concentric circles. But, whereas Celentano's circles, such as *Kinetic Painting no. 3* discussed above, produce flashy and almost textbook effects, Tadasky's are quieter and more subtle. Tadasky (Tadasuke Kuwayama) comes from a background of skilled crafts in Japan (his father is a well-known maker of shrines) and this shows itself in everything he does. His target paintings, whether in black and

white or delicate colours, have an hypnotic effect. They induce a sort of contemplative mood in keeping with much of the art of his country of origin. While Tadasky explores the seemingly endless possibilities of his targets, Celentano is interested in the optical possibilities of contrasting black and white triangles as well. His aim, he says, is

to create a totally positive interplay of elements by absolute separation and opposition. To create radiation induced by a rigorous order of triangular units. To destroy substantial and individually perceived elements by radial acceleration into minute and imperceptible aggregates.

Goodyear, Levinson and Stanczak are concerned with interference of linear structures. Stanczak works on the flat surface and creates undulations and apparent overlapping by the juxtaposition of finely drawn lines. The surface buckles and flickers as if a wire mesh was being forced into a space too small for it. The effect is often spoiled, however, by the use of anaemic colouring. Levinson makes straightforward and often very beautiful moiré structures in

low relief. He has more recently made structures of perspex rods backed by luminous tape which flash and glow as they catch the light or as the spectator moves before them. Goodyear also works in depth (plate 64). A series of two to four wooden grills, curtains or 'gates' slightly touched with colour are suspended by invisible wires in front of a coloured background or light-source. As they swing forwards and backwards they produce a luminous flicker such as one gets when a brightly coloured wall is seen through a railing as one flashes past it. The lights reflected from the different coloured layers mingle, and the whole effect has been rightly described as brilliant and airy.

Besides these individuals, America has one group, 'Anonima', which was founded in 1960 (at the same time as the Groupe de Recherche) but unlike the other groups is still going strong. Unlike them too it has always acted as a truly anonymous team. Strictly limited perceptual problems are set and these must be completed in a limited time—for example, overlap, size-change or brightness ratio. The results are hardly encouraging to those who believe in group artistic activity and may show the wisdom of those groups which decided to disband early. Although Anonima is open to all who are prepared to work to its programmes, the principal members are those who founded it in Cleveland: Ernest Benkert, Francis Hewitt and Edwin Mieszkiewski. Mention should also be made of Reginald Neal, British by origin, but long resident in America, Lynn Leyland and Strobel.

Among the artists working in Op outside Europe and the United States, mention must be made of the Argentinian Eduardo MacEntyre, and two Japanese, Toshihuo Katayama and Yayoi Kusama.

Applied Op: a footnote

There is one feature of Op which must be mentioned however briefly. That is its impact on the world of advertising and fashion design. Sooner or later in some form or another almost every work of art is likely to serve the ends of commerce, but so far none have done so with the rapidity of Op. The paint was hardly dry on the canvas when it was on to the bill-board. Op was a gift from the gods to the adman. His main concern is to catch eye, and here was a form of art which did that beyond his wildest dreams. The most enduring and most elegant use of Op in advertising is, perhaps, the Woolmark.

In many cases the application of Op in fashion and industrial design was crude. Actual paintings were taken over with the minimum of alteration and no thought for the way the picture would operate in its new surroundings. A notorious example of this was the use made of Steele's *Baroque Experiment*. In 1965 it appeared, repeated many times on a gown in *The Tatler* with the caption: 'Optical art—the *trompe l'œil* play of patterns in black and white—stolen from the smart art scene and put on to fabric'. But, even more revealing, it reappeared the following year on a bikini in a full-page ad in *The New York Times*, this time under the caption: 'take it off (this is *last year's* swimsuit)'. No wonder Steele writes rather ruefully:

I should hate to have missed any of the life experiences which the Op Art boom brought: seeing girls actually *wearing* my paintings and so on . . . But it was quite evident from the nature of our reception that our moment in the sun/circus-ring would be brief. I knew that the most celebrated of my paintings was also the least subtle and was irked by the feeling that the positive issues underlying my work had been muddied and obscured, if not actually impaired, at least for a time, by what was happening.

One artist, however, accepted the situation and collaborated with commerce. Alviani actually designed Op dresses which were made up by Germana Marucelli (plate 65). The result was that for once the optical effects were related to the movements and figure of the wearer and did not, as was often the case, compete unflatteringly with them.

9 Critical assessment

Almost as strange as the public reaction to Op was its reception by the critics, particularly in the United States. Few movements since the early days of Cubism have aroused such hostility from artists and critics. One cannot help feeling, on reading some American critics, that they somehow resented the intrusion of a form of art which was largely European in origin. I do not mean that their judgements were always faulty or that Op art is beyond criticism; the inadequacy of much of this criticism lay in the reasons supporting these judgements or the total absence of reasons. However, it is not my purpose to examine this phase of American criticism, though it is almost as interesting a phenomenon as Op art itself.

It was generally assumed that the aim of Op artists was to pursue optical effects as ends in themselves. Any artist who met with approval, such as Albers, Vasarely or Poons, was considered to use optical effects as means, not ends and so presumably was not really an Op artist. 'If their works should set up optical vibrations', wrote Barbara Rose of these artists,

then these were means and not ends . . . Optical art, on the other hand, has these effects as ends in themselves.

Lucy Lippard writes in much the same vein when she says that optical effects 'held no interest for most serious artists, who were more likely to be concerned with form, colour and the poetic and formal expansion of painting than with perceptual effects *alone*'. (My italics—have we here a definition of a serious artist?)

Once it was assumed that Op artists were interested only in optical effects, it was easy to dismiss their work. 'Purely "optical" art,' says Barbara Rose, 'based on textbooks and laboratory experiments, theory, equation and proofs, is empty and spiritless, though it may jangle the nerves and assault the eye-balls.' And she goes on:

'Op' art, *in its strictest sense*, has provided exactly the 'nouveau frisson' to engage the jaded sensibilities of today's museum audiences. It is more immediate than the movies, more brutal than TV, and takes less time and thought to experience than the theatre . . . You know absolutely that you have gotten the message once nausea or vertigo set in. (Italics mine.)

To this list of defects inherent in Op 'in the strictest sense' Lucy Lippard adds dullness, which is due to its predictability, to its 'meticulous illustration of such standard propositions as the vibration and after-image produced by close-valued colours (all those endlessly spinning targets)', etc. Op paintings, in other words, are nothing more than textbook illustrations drawn from psychology and the basic design course (this latter fact is confirmed by their historical origins in the Bauhaus).

The scientific pretensions of Op have been commented on by others besides the American critics. In reply to a question put to them in the Ohio questionnaire ('If your aim is to ascertain or achieve "knowledge of the visual phenomenon", isn't it still in danger of being mere optical effect?') the Groupe de Recherche said: 'This question is more concerned with works now called "Op" than those of the G.R.A.V.' But American critics hasten to point out that as a form of scientific research Op is primitive: 'Scientists and engineers . . . make some of the most effective Kinetic and Op art today' (Jack Burnham); 'most Op and Kinetic art is absolutely elementary in scientific terms' (Lucy Lippard); 'Perhaps the ultimate criticism of optical art is the one we might make first: that the best of it was done by a scientist (Oster)' (Barbara Rose).

But, supposing for a moment, that Op art as it actually exists (not as it might be), is nothing more than an assault on the senses, pseudo-scientific research, a glorified form of basic design—a complaint to which even Albers, in Lucy Lippard's opinion, is open—what's wrong with that? Firstly it is not painting. Barbara Rose speaks of 'every kind of non-painterly painting', and Poons says

'Now it is easy to forget about painting and just make one of these optical things.' And why is it not painting? No explicit explanation is given, but the reasons can be extracted from various remarks. In very general terms, it is not concerned with 'form, colour and the poetic and formal expansion of painting' which, in Lucy Lippard's view, are the interests of serious artists. More specifically she says:

Whereas conventional Op Art did introduce chromatic dissonance as the vehicle of eye-rocking vibrations which destroyed the picture plane, it lacked the substance of a more strongly rooted formal dissonance which manipulates both colour and plasticity.

Sidney Tillim develops this idea in a more painstaking analysis. Broadly speaking, he says, Op painters, along with Vasarely, Albers and Herbin, 'share a common defect—a lack of relation between active colour and passive structure'. They restrict the expansion of colour in a field by imposing a structure which does not arise from the optical effect itself. 'Rather, the optical effect is contained within a foreign and somewhat belated but expedient system of planes and shapes. In a word, 'they have failed to "open" the grid and create a new kind of pictorial space without violating the picture plane with their illusionistic perceptual mirages'.

Tillim, however, is prepared to make concessions to their intentions, which he understands well enough: 'To the intention of rescuing art from psychology and autobiography and asserting a primarily visual experience there can be little objection.' His complaint ultimately becomes a rather trivial one: 'the bulk of optical art does not yet give pleasure.' But Barbara Rose is not so conciliatory. In a slashing attack, which swipes at Pop art *en route*, she says:

Op art, however, goes Pop art one better by being considerably more mindless . . . And here is the crux of the matter: Op art has no expressive content. It is expressively neutral, having to do with sensation alone.

Since we are left in the dark as to what is meant by 'mindless' here, I can only assume that it is the assertion of a primarily visual experience free from psychological and autobiographical accretions to which, Tillim says, there can be little objection.

One last criticism which is levelled at Op by critics on both sides of the Atlantic, and which is implicit in what has so far been said, is that it is childish and trivial. I have already suggested that this may be one reason why the development of an Op art movement was so long delayed. Max Bill, as we have seen, regarded kinetic art in general as a sort of trickery. Jack Burnham, speaking of Object art says: 'In the most elementary fashion Object sculpture is Optical Art—though stripped of the childish ambiguity of graphic illusionism'. But by far the wittiest things that have been said about Op are contained in a passage by Robert Melville which deserves to be quoted at some length:

Only twenty years after Mondrian's death geometrical abstraction has descended to the lower depths of illusionism. Not quite the lowest depths . . . There are no grapes for birds to peck at; only circles that turn into squares, colours that change places, flat surfaces that glide or heave . . . There are even grounds for believing that Mondrian himself, after a lifetime of inflexible devotion to the absolute beauty of rectangles, and primary colours, was on the point of indulging an idle curiosity about the deceptional uses of abstraction, rather like St Anthony watching a walking jug out of the corner of his eye.

There is some substance to these objections in so far as they apply to some works. Superficiality and dullness are to be found in every form of art, and there is no doubt that a number of works—chiefly those which attracted most popular success—are little more than visual trickery, clever enough in its way. This as Melville says is the temptation. They quickly yield up anything they have to offer, though Soto is perhaps a bit severe when he says that *most* optical paintings 'have a great deal of surface drama but no density'.

But the objections we have been considering are not directed against this or that picture or group of pictures but against this form of art as such. There is always something odd about the *a priori* condemnation of any form of art whether it be naturalism, expressionism, geometrical abstraction or whatever. But in this case the oddity is even greater since it is not at all easy to see to what kind of works —to say nothing of what actual works—it could refer.

Take the assertion that Op artists pursue optical effects as ends in themselves. Which Op artists do this? Though one should not, perhaps, put too much reliance on what artists say they are doing, no Op artists to my knowledge would admit to pursuing optical effects for their own sake. On the contrary, they explicitly deny this. As the authors of the catalogue introduction to the Nouvelle Tendence exhibition state they are, 'not content to evoke movement but [want] to put it to work'. 'I use optics,' says Kidner, 'as a means to an end that is bigger—in short a good painting. Optics is a tool as perspective was.' 'Most of us regarded this "power" as just one new and exciting weapon (to pursue this doubtful analogy) in our armoury and by no means the sole object of our work,' writes Steele. The reader will judge for himself whether they have succeeded in making anything worth while with these new 'means' but quite clearly if their sole aim was to produce optical effects the scientific diagrams e.g. the McKay figure, do it much better. So far from having gotten the message when vertigo sets in, in most, if not all, cases, the message will have been completely lost.

While on the subject of scientific diagrams, it is true that they have been a source for some Op paintings, though clearly not all—just as perspective was a source for Renaissance painters; but few people, I think, would dismiss Renaissance painting as a whole as nothing more than an exercise in perspective. A comparison between the diagrams

and pictures in this book (the Bauhaus experiment makes a particularly interesting comparison) confirms this. Besides, in the case of some artists, Bridget Riley, for example, there is a distinction between the experimental and finished stages of the work. In only the broadest possible sense could these experiments be called scientific. If they are, then every time a painter mixes paints on his palette he is doing a psychological experiment. Stein has this to say about experiments:

Our approach resembles the scientific approach in as much as the experiments can be repeated or developed, since they have been executed with controlled elements. But the latter is a closed cell, whereas our experimentation is open, and incorporates more varied and less specialized factors than a scientific programme.

As Fénéon remarked about Seurat's use of science: 'If Monsieur X were to study treatises on optics all his life he could never paint *La Grande Jatte*.' And Vantongerloo: 'If I paint a problem in physics, I shall violate the plastic principle as much as if I had painted a story.'

As for Op art not being expressive, this may be true of those works which adhere rigidly to the principles of programmed art, but it is certainly not true of works by Soto, Vasarely, Bridget Riley, Group Zero, Stanczak, Kommodore, to quote only a few who have made statements on the subject. What these, and most Op artists are doing, is giving a visual equivalent of certain aspects of nature— heat, energy, the action of light—by causing us to experience through visual and pictorial means something of the effects of these 'immaterial' or invisible forces. We have seen this in the case of Soto's 'Vibration Structures', Vasarely's *Supernovae*, Bridget Riley's *Static* and *Late Morning*, and Uecker's *Spiral*. Stanczak sums up this aspect of Op art when he says: 'I do not try to imitate nature. I use visual activities to run parallel to it.'

This leaves Op art still open to the objection that it does not go beyond sensation or that, at best, it

only conveys one sensation by means of another; it has no emotional or thought content; it does not convey any ideas. It certainly does not convey ideas in the crude way in which some Victorian moral narrative paintings did. Nor may it be easy to verbalize the ideas it conveys. But it does not follow from this that no ideas of any kind are conveyed. Soto regards his works as 'signs', that is, things which point beyond themselves or sum up a whole range of phenomena, as Mondrian's crosses summed up the basic forces of nature. He says:

Works for me are above all *signs*, not material things . . . I demonstrate abstract data and concepts. It would be a mistake to see in the very work before you the object of my art. *The work is there only as a witness, a sign of something else.*

There is no reason why a sensation cannot sum up a whole range of experiences. The fact that it does this more directly and immediately (by 'acquaintance' as it were) than a description does not disqualify it from being a vehicle for ideas. But leaving this aside, one may ask what is wrong with an art form which produces pure sensations, that is, sensations with no literary or other associations. After all, music is an art of pure sensation in this sense. It is presumably no accident that so many Op artists appeal to the analogy of music in describing their aims. Of course music is an art of ordered sounds and not mere sensations in the sense of random booms and bangs. But so is Op art an art of ordered sensations: this is precisely what is meant by saying that it does not use optical effects as ends in themselves but as means. The fact that one is forced to experience these sensations *as sensations* (as Webern or Boulez forces us to experience sounds as sounds) and not as reminders of objects of everyday experience and of the emotions and thoughts associated with them, does not reduce them to the status of mere sensations like spasmodic flashes of light or sudden blurring of images. 'Pure' sensations are not to be confused with 'mere' sensations: 'pure'

sensations are sensations freed, as far as possible from associations; 'mere' sensations are isolated, unrelated, unstructured and usually momentary flashes or bangs.

This brings us to the most serious objection against Op, namely, that it destroys the picture plane and hence is not, strictly speaking, painting. This may be true but it is beside the point, and hence not a valid criticism, unless some reason can be given why the violation of the picture plane must be regarded as a sort of artistic suicide. To say that something is not painting or not painterly is not in itself a condemnation, unless it was the intention of the artist to make a 'painterly-painting'. The mere fact that the artist puts paint on canvas does not commit him to make painterly-paintings. It may be extremely distasteful to his fellow artists to see him 'abuse' the medium in this way, and it is not surprising that so many painters violently dislike Op art. It is open to the Op artist in his turn to spurn the painter who adheres so lovingly to the picture plane. But the critic should do better than that. If his criticism is to stick, it must start with comprehension, that is, it must be based on a knowledge of what the work is attempting to do, not on its failure to achieve what it never attempted.

In my view—a generally held one—those works are most satisfactory which are less immediate in their optical activity, which make demands on the spectator and require his cooperation. Thus, to take the target pictures as an example, Apollonio's seems more rewarding than Celentano's, Tadasky's more than Apollonio's. As Hewitt says:

The quality and depth of the experience depend on the willingness to perceive and persistence to overcome certain levels of frustration.

Yet the targets by Fangor and Sedgley are immediate in their appeal but yield more on further acquaintance. What many critics fail to realize is that in lightly dismissing Op paintings they may

often be commenting on their own impatience as much as on the poverty of the painting. Paintings like Muller's *SD65*, because of the extreme simplicity of the elements, may seem at first sight to be utterly banal, but, after a moment, things begin to happen. Most Op art is there to be used by the spectator and should be judged by the possibilities for development which it affords rather than on its immediate impact. There need be no limitation in principle to the optical expansion of a painting, though in practice a picture may be very limited.

Having said that, it may then be asked: what has Op contributed to our visual experience? In the matter of colour contrast and colour induction the work of the Impressionists has been carried forward. Some of Bridget Riley's recent pictures and Cruz-Diez's 'Physichromies' and 'Transchromies' are particularly successful in this. The value of this sort of work does not lie in the mystery or trickery by which we are made to see colour quite differently from the normal pigment colours used: that is beside the point. What is important is that, by refraction, radiation and juxtaposition, these artists have been able to produce colours outside the range of pigment mixture, colours of intense brilliance and luminosity and great delicacy which seem to have no material base but hover in space like light: in short, disembodied colour.

In another way too they have carried on the work of the Impressionists, namely, in dissolving the physical object and presenting the spectator with perceptual objects rather than with objects of perception. To put this another way, in place of pictures of grapes which birds can peck at you have pictures which you can bump your nose on when trying to locate them in space. In other words, Op artists, and Soto in particular, do not give us a substitute for our everyday space with the objects which are in it, but create an intangible perceptual space which cannot be easily related to ordinary space or the objects in it.

In doing this Op artists have reduced the distance between the spectator and the work: it is no longer something over against him, but much more the product of his own perceptual processes. The Op artist creates a sort of perceptual environment. Instead of putting the spectator over against or even into a work of art, Op art forces him into an intangible world of his own which envelops his whole visual field. It is an experience analogous to flying through cloud: the ordinary signs by which we orientate ourselves are momentarily in suspense. It is akin also to an imaginary or dream world, except that it is not a flight from direct perception.

The creation of this intangible world calls for cooperation on the part of the spectator, but the claim that it makes him an active participant rather than a passive admirer can be greatly exaggerated. There is a degree of active participation in all forms of art; it varies according to the experience, training, sensitivity and critical acumen of the individual. In apprehending any work of art what is called active participation is merely a greater awareness of the processes which are at work. What is of interest is not the degree of participation but the fact that the work has become more like an event than a finished product.

This is an important aspect of Op art. It introduces the element of time. Instead of building up a set of relationships between elements which can be apprehended more or less simultaneously, it permits the artist to relate visual experiences in a temporal sequence. It has the added advantage that he can work with simple elements; the richness and complexity lies in the possibilities for development rather than their structure at any given time. This may answer Tillim's objection that the structure is not a product of the effects.

This in turn permits the element of indeterminacy and randomness. Instead of a single instance of a principle of order or a series of distinct realizations of the same principle, we have a situation in which

the various realizations can take place successively in the one work. In this respect, however, Op has so far been rather unfruitful. Either the possibilities for development are limited and hence interest is quickly lost, or the difference between one realization and another is so slight that they are not worth pursuing and interest is hardly aroused.

Many of the advocates of Op art see in this very aspect another virtue, namely, an expression of the scientific outlook of our time. If this is so, then it is no more than a fringe benefit, and in any case is a non-artistic consideration. But if this and other aspects of Op—the visual equivalents of various forms of energy, for instance—add to the artist's expressive resources, then it may be an artistic benefit too.

In outlining the contributions that Op art has presented there is no suggestion that it is a superior form of visual art. It would be ridiculous to suggest that a picture which represented objects in space or presented geometrical forms on a plane surface was by that very fact of less value or more primitive than a picture devoid of reference to objects and unstable in its surface structure. Each deals with different visual phenomena and offers a different set of artistic possibilities. It is what artists do with these possibilities which matters. On the other hand, it seems equally absurd to dismiss Op as inferior to other forms of art, particularly when we consider that it is in a line of development (not necessarily of progress) that holds a fairly central position in Western art. Certainly Op has its temptations, and its immediate popular appeal should make one cautious. As Poons says, it is easy to do 'one of these optical things': easy to make a hit with them, perhaps. But it is no easier to paint an Op painting of real worth than to paint *La Grande Jatte*. Bridget Riley is surely right when she claims:

I am absolutely certain that optical painting has added something to the language of formal art . . . which cannot be ignored or eradicated . . . In the same sense that Cubism added something to a concept of space which having been assimilated cannot subsequently be discounted.

PHOTOGRAPHIC ACKNOWLEDGEMENTS Plate 27 photograph by J. C. Crispoldi, Paris. Plates 7, 12, 18, 19, 36 photographs by Deste Photography, London. Figure 29 photograph by Fotosiegal, Ulm. Plate 40 photograph by Maren Heyne, Dusseldorf. Plate 63 photograph by Robert Horner, London. Plate 48 photograph by Graham Keen, London. Plate 61 photograph by J. Masson, Paris. Plates 15, 22, 32, 58 photographs by André Morain, Paris. Plate 29 photograph by Eric Pollitzer, New York. Plate 38 photograph by Nathan Rabin, New York.

Figures 12, 15, plate 31 photographs by John Webb, London. Plate 34 photograph by C. H. Wood, Bradford.

The author is grateful to the Denise René Gallery, Paris, for permission to reproduce the works of Josef Albers, Getulio Alviani, Antonio Asis, Martha Boto, Toni Costa, Narciso Debourg, Hugo-Rodolfo Demarco, Lily Greenham, Richard Lohse, Richard Mortensen, François Morellet, Horacio Garcia Rossi, J.-R. Soto, Luis Tomasello, Victor Vasarely, Jean-Pierre Yvaral.

Bibliography

Albers, Josef *Interaction of Color* 1963 Yale University Press, New Haven

Bann, Stephen, Reg Gadney and Frank Popper *Four Essays on Kinetic Art* 1966 Wittenborn, New York

Boring, Edwin G. *Sensation and Perception in the History of Experimental Psychology* 1942 Appleton-Century-Crofts, New York

Carraher, Ronald and Jacqueline Thurston *Optical Illusions and the Visual Arts* 1966 Studio Vista, London; Reinhold, New York

Compton, Michael *Optical and Kinetic Art* 1967 Tate Gallery, London; Arno Press, New York

Gregory, Albert *Construction, Colour and Moiré* 1965 Wittenborn, New York
Eye and Brain: The Psychology of Seeing 1966 Weidenfeld and Nicolson, London
Overlap 1967 Wittenborn, New York

Hill, Anthony *Data: Directions in Art, Theory and Aesthetics* 1969 Faber and Faber, London; New York Graphic, Greenwich, Conn.

Itten, Johannes *The Art of Color* Reinhold, New York

Luckiesh M. *Visual Illusions, their Causes, Characteristics and Applications* 1966 Constable, London; Dover, New York

Parola, René *Optical Art: Theory and Practice* 1969 Reinhold, New York

Pellegrini, Aldo *New Tendencies in Art* 1967 Elek, London; 1966 Crown, New York

Popper, Frank *Origins of Kinetic Art* 1968 Studio Vista, London; 1969 New York Graphic Society, Greenwich, Conn.

Rickey, George *Constructivism: Origins and Evolution* 1967 Studio Vista, London; Braziller, New York

Selz, Peter *Directions in Kinetic Art* 1966 University of California Press, Berkeley, California

Taylor, John F. A. *Design and Expression in the Visual Arts* Dover, New York

Vasarely, Victor *Vasarely* 1965 Griffon, Neuchâtel

ARTICLES

Albers, Josef 'My Course at Ulm' *Form 4* April 1967

Castellani, Enrico and Piero Manzoni *Azimuth 2* 1960

Clay, Jean 'Soto' *Signals*, November 1965
'Vasarely; A Study of his Work' *Studio International* May 1967
'Cruz-Diez' catalogue introduction to a one-man exhibition at the Denise René Gallery, Paris, 1969

'Soto' catalogue introduction to a one-man exhibition at the Stedelijk Museum, Amsterdam, 1969

Ehrensweig, Anton 'Bridget Riley' catalogue introduction to a one-man exhibition at Gallery One, London, 1963

Gardiner, R. L. 'On the Relation between Mathematics and the Ordered Patterns of Op Art' *Scientific American* July 1965

Gerstner, Karl and Michel Fauré 'Nouvelle Tendence' catalogue introduction to the exhibition at the Musée des Arts Décoratifs, Paris, 1964

Groupe de Recherche d'Art Visuel: catalogue introduction to their exhibition at the Denise René Gallery, Paris, 1962

Groupe de Recherche d'Art Visuel: texts, translated by Reg Gadney and Stephen Bann *Image* Winter 1966

Land, E. H. 'Experiments in Color Vision' *Scientific American* May 1959

Linton, Norbert 'Michael Kidner' catalogue introduction to a one-man show at the Grabowski Gallery, London, 1962

Lippard, Lucy 'Perverse Perspectives' *Art International* March 1967

'Lumière et Mouvement' exhibition catalogue, Musée d'Art Moderne de la Ville de Paris, 1967

Melville, Robert 'Op Eye' *New Statesman* April 1966

Osborne, Harold 'On Artistic Illusion' *British Journal of Aesthetics* April 1969

Oster, Gerald and Yashumori Nishijima 'Moiré Patterns' *Scientific American* May 1963

'Op Art: Pictures that Attack the Eye' *Time* October 1964

Riley, Bridget and Maurice de Sausmarez 'A Conversation' *Art International* April 1967

Rose, Barbara 'The Primacy of Colour' *Art International* May 1964
'Beyond Vertigo: Optical Art at the Modern' *Art Forum* July 1965

Seitz, William C. 'The Responsive Eye' catalogue introduction to the exhibition at the Museum of Modern Art, New York, 1965

Soto, J. R. and Guy Brett 'Dialogue' *Signals* November 1965

Steele, Jeffrey 'Cicerone' *Anglo-Welsh Review* Winter 1967

Sylvester, David 'Bridget Riley' *Studio International* March 1967

Thompson, David 'The Paintings of Bridget Riley' *Studio International* June 1968

Tillim, Sidney 'Optical Art: Pending or Ending?' *Arts Magazine* January 1965

Index